★★★ AMERICAN SON ★★★

AMERICAN SON

★★★ *My Story* ★★★

OSCAR DE LA HOYA

with STEVE SPRINGER

An Imprint of HarperCollins*Publishers*

HarperCollins books may be purchased for educational, business, or sales promotional use. For information please write: Special Markets Department, HarperCollins Publishers, 10 East 53rd Street, New York, NY 10022.

FIRST EDITION

Designed by Susan Yang

Library of Congress Cataloging-in-Publication Data
has been applied for.

ISBN 978-0-06-157310-1

08 09 10 11 12 WC/RRD 10 9 8 7 6 5 4 3 2 1

The credit belongs to the man . . . who, at the best, knows in the end the triumph of high achievement and who, at the worst, if he fails, at least fails while daring greatly so that his place shall never be with those cold and timid souls who know neither victory nor defeat.

═══ PRESIDENT THEODORE ROOSEVELT ═══

CONTENTS

PREFACE

From the window of my uncle's car, I saw my dream home.

I was only thirteen, just a teenager from East L.A., whose family, like so many others in the neighborhood, struggled to eke out a living. I was embarrassed that we often had to survive on food stamps and ashamed to admit the clothes on my back left my closet pretty much empty.

No, the road to my success wasn't always paved with gold.

But the one thing no one could deny me was my dreams. When I spotted that huge home in Pasadena, I told myself I would live there someday. Just a kid with a wild idea.

Well, through my corporation, I recently bought that very house for an investment.

So many of my dreams have come true, from winning an Olympic gold medal to fulfill a promise I made to my mother before she died, to winning titles in six weight classes, to building a business empire, to having the perfect family.

I couldn't have done it without the efforts of so many. There were those who planted my family roots in Mexico and those who

transplanted those roots in this country. There was my mother, who inspired me, and my father, who first put the gloves on me, and a family that has always supported me. There have been promoters, matchmakers, publicists, trainers, cut men, sparring partners who have prepared me, and opponents who have challenged me. There is Richard Schaefer, who has been the key to putting the gold in our ever-growing Golden Boy enterprises. There have been valued investors and business partners who have shared in our financial pursuits. There is Raul Jaimes and Eric Gomez, boyhood friends who are still with me in my adult endeavors. There are countless employees who toil vigorously in relative obscurity in my various businesses.

And finally, there is, above all else, Millie, the love of my life, and my precious children.

I have been truly blessed.

I only wish I could bestow such blessings on others as well. That is why I am writing this book. I hope, through my story, that you, the readers, will be inspired to make your own dreams come true, whatever they might be.

While I chose boxing, you might select other sports or completely different avenues, like medicine, law, politics, or business. It doesn't matter. What does matter is the three *D*s: dedication, discipline, and desire in pursuit of your goals.

Don't ever give up.

I've been knocked down on occasion, and not just in the ring, as you'll discover when you read this book, but I've always found a way to get up and fight back. You make mistakes, you learn, and you grow from that. That's what life is all about.

Finally, for those who do choose to pursue their dreams in the ring, there is a special message in this book.

All too many fighters wind up broke, sometimes losing their homes, their health, and their dignity. Unfortunately, they often have neither the education nor the proper guidance to avoid the vultures hovering out there, waiting to swoop in.

It doesn't have to be that way. I am determined, through Golden Boy Promotions, to change that. It can be done. The future of boxing is in our hands. We, the fighters, can take control.

I want to see a day when managers and promoters stop taking advantage of boxers. I want to see a day when boxers have proper health care and a retirement plan. I want to see a day when boxing can compete with the major sports—baseball, football, basketball, hockey—in terms of providing benefits for its participants. We are working toward these goals through Golden Boy Promotions, but we need the fighters to work with us.

Maybe, with this book, I can encourage boxers to say, "I'm going to fight for myself just like Oscar did."

Life itself is a fight, so the lessons learned in the ring can be applied to one's very existence. Boxing made me a hungrier, more ambitious person. It taught me everything I know.

Grateful for what the sport has given me, I want to give something back. Hopefully, in these pages, I will. I want to send a message that will empower the fighter, along with people from all walks of life—the gardener, the dishwasher, and even the stockbroker on Wall Street.

If I can do it, you can do it.

—Oscar De La Hoya

★★★ AMERICAN SON ★★★

A PROMISE MADE

What mother wants her son to be a fighter?

But considering that my grandfather Vicente was a fighter, my father, Joel, was a fighter, and my older brother, Joel Jr., was briefly a fighter, we had no choice but to be fighters. When I say "we," I'm talking about my mother and me.

We were a team.

She learned to love the sport. She'd go to my fights and overcome her fear that I was going to get hurt.

When I was in the sixth grade at Ford Boulevard Elementary School, my class was asked to write an essay on what we wanted to be when we grew up. We then had to get up and read our assignment aloud. Kids said they wanted to be doctors, policemen, firemen.

I got up and said I wanted to be an Olympic gold medalist in boxing. The class burst into laughter. They thought I was kidding. One kid said, "Yeah, right, you're from East L.A. How are you going to be a gold medalist?"

The teacher thought I wasn't taking the assignment seriously, so she punished me by keeping me after class.

I started crying, telling her, "I'm not kidding. That's what I want to be."

When I was twelve, I had this poster from the Olympic Games—I don't even remember where I got it—and I signed it *Oscar De La Hoya, '92 Olympic Gold*.

I still have that poster today.

Around my family, that became the goal: Oscar goes to the Olympics.

Whatever my goal, it became my mother's goal as well.

When I would go running in the morning, she would get up with me to make me a little breakfast before I left. That meant having something on the table before I went racing out the door at 4:30 A.M.

When my amateur career started to take off, I began to get noticed in the neighborhood. I remember being so excited because my name started to appear in our small local paper. No picture. No real story. Just an occasional line saying I had qualified for a tournament or won a trophy or knocked some guy out. To me, however, it was like being on the cover of *Sports Illustrated*.

I told my mother about it and she was thrilled for me, but it was kind of sad because she didn't read English and those references to me were only in English-language papers.

She didn't need to speak English to be my number one cheerleader. Her Spanish served her just as well. She was my inspiration even before I saw her fight a battle that was much tougher than anything I ever faced in the ring.

I didn't find out she had breast cancer for a while after she was diagnosed.

I remember I had come home from school—I was seventeen at the time—and my mother came up to me in our living room,

crying, and gave me a big hug. She was trying to hold it in and be strong.

I said to her, "What's going on? What's wrong?"

Instead of answering, she asked me if I could apply some cream, from a jar she had in her hand, to her back. I scooped up a handful of the cream and reached down under her shirt to spread it across her back.

It was then that I felt something rough, like a scab. Her whole back was like that.

I said, "What's this?"

She hugged me again and now I'm crying.

She said three words I will never forget: "I have cancer."

I have never been hit harder in my life.

I started hugging her through my tears and telling her it was going to be okay. All of the emotion that had been missing in our household burst free. I told her we were going to get through this. I believed it.

Obviously, I wasn't educated about the disease and she had been very effective in keeping things from us. She wore wigs or hats to hide the fact that her hair had fallen out.

One time, when I finally noticed she had no hair, she said she had shaved it so it would grow back thicker.

My mother had been a heavy smoker. She would send me to buy cigarettes when my father wasn't around. Every two or three days, she'd tell me she needed more. I remember she smoked Kent cigarettes and they cost $1.05 a pack.

As time went on, my mother was getting worse and worse. And the doctors weren't being very positive about her condition.

At that point I decided to quit boxing, hang it up. I felt like I couldn't do it anymore even though the Olympics were less than two years away.

My mother spent her final days in the hospital, where I would visit her every day.

There was one time she didn't even recognize me. I walked into her hospital room, filled with relatives and friends, and she said, "Who is this person? What are you doing here?"

I told her, "It's me. It's your son."

I turned, walked down the hallway, and had a good cry. I knew it was the medication and her worsening condition that were causing the mental lapses, but it still hurt deeply. Especially because she knew everybody else in the room.

When next I saw her, that sparkle of recognition was back in her eyes. We held each other and cried together.

One day we were together five, six hours, even enjoying a few rare laughs. It was then I noticed that on the finger where she normally had her wedding ring, she was wearing a ring with a little diamond in it, a championship ring I had won in the bantamweight division at the 1989 National Golden Gloves tournament.

It was the first championship I had won on a national level, but to my mother, it was like a world championship. Her son had achieved success in a world she couldn't imagine. How much additional joy would she have gotten out of putting my gold medal around her neck, or seeing me win professional championships in six weight classes? At least she had the thrill of wearing that ring.

Although seeing it sparkle on her finger made me feel good, I told her I wasn't boxing anymore. Not even training.

"What for?" I said. "I want to be here with you."

She started lecturing me, telling me that I had to do it, that the Olympics had been our dream, hers and mine. She said, "I want you to go even though I'm not going to be there."

When she said that, oh my God, it was like somebody had stabbed me in the heart.

"You have to be strong," she said. "You are going to go to the Olympics and win that gold medal."

The very next day, following my normal routine, I was coming back with lunch for her, taking the elevator to her room. As I looked around, first in the lobby and then in the elevator, I realized the people—all family, lots of aunts and uncles—were all crying.

No one had to tell me what had happened. No one wanted to tell me.

But I knew. I felt it.

I went running to her room and found she had indeed passed.

My mother, Cecilia Gonzalez De La Hoya, was dead at thirty-nine.

It was October 28, 1990, the most devastating day of my life.

It was the only time I ever saw my father shed tears. And it was only one tear. One tear.

Obviously, he loved her, adored her. They had been together for twenty-five years. But he's a strong man, one who doesn't show much emotion. His generation had to be tough.

When I saw that tear, I thought, *My God, he's really hurting inside.*

I didn't think about boxing for a couple of weeks after that. Then one day, I was coming home from school and my mother's words came into my head. I could hear her talking about the Olympic dream.

And I said to myself, *You know what? I'm going to do it for her.*

Once again, she had inspired me, even in death.

A PROMISE KEPT

As the adrenaline coursed through my body, I could feel the suffo-
cating force of the grief that had enveloped me dissipate. I felt free
and strong for the first time in months, no longer shackled by the
exhausting effects of anguish and inactivity.

Looking back, I compare it to that scene in one of the *Rocky*
movies where, after his wife, Adrian, comes out of a coma and im-
plores her husband to win an upcoming fight, Rocky's trainer,
Mickey, yells, "What are we waiting for?"

I had thought that was corny at the time, but now I was living it.
What was I waiting for?

I jumped up and ran out of the door of my house, heading for the
gym five miles away. I ran the whole way, becoming more anxious,
with each thrust of my legs, to put on the gloves and spar with
somebody, anybody.

When I got there, I got into the ring with Rudy Zavala, who
later became a good pro fighter. But that day, I gave him a beating.
Something came over me. I was letting out all my anger, my frus-
tration. I kept hitting him even after the bell rang. Even after the

trainers yelled at me to stop. I didn't want to stop. I just kept on going even as I started crying. Finally, I pulled back, sobbing.

After that, I got back to work, back to serious training.

But I always found time to go to the cemetery. I would be there every other day by myself, sometimes for hours. I would lie down beside my mother's grave and talk to her.

One day, I felt like she actually responded with her blessing. It was like she was saying, *Go win that gold. You are going to do it.*

It certainly seemed as if I had a chance, considering the success I had enjoyed as I moved up the amateur ranks.

Entering a Golden Gloves tournament in Lynwood, California, I found myself in my first competition against the big boys. I was placed in a sixteen-and-older division, meaning that, as a sixteen-year-old, I could theoretically face someone twenty-five or thirty.

That could have been an intimidating situation, but the experience I had gained by sparring against pros had armed me with seasoning well beyond my years.

As a result, I made a big splash. I knocked out four of the five guys I faced. And the only reason I didn't knock the other guy out was that he was on his bike, backpedaling all over the ring to stay out of my reach.

By then, I was competing at the national level, so I also made several trips to the Olympic training center in Colorado Springs.

In the meantime, my trainers kept coming and going. After leaving the downtown gym, I briefly trained under Al Stankie, a former cop who, in 1984, trained another gold-medal winner from my area, Paul Gonzales.

Al was a good trainer who would make you work like there was no tomorrow. But, plagued with a drinking problem, he was unpredictable, crazy.

One afternoon during my high school days, I was sitting in our living room with my mother and brother watching television. All of a sudden we heard the screech of brakes, footsteps running hurriedly up to our screen door, a furious rattling, and in walked Stankie. Without so much as a word to any of us, he stormed into our kitchen, pulled open the refrigerator, grabbed an egg, cracked it on the sink, poured the yolk into a glass, added orange juice, gulped it down, slammed the glass down on the sink, and stormed right out the door.

Still not a word spoken.

I caught him before he could get into his car. He just looked at me and said, "Son, we've got to go train."

Stankie used to get money from strangers by telling them he needed it to live on while he trained the next great Olympic star.

He didn't last long with us.

With Stankie gone in 1991, we turned to Robert Alcazar, the man who had been there all along, waiting for his chance.

Robert had heard about me long before he met me. He and my father were coworkers at an air-conditioning-and-heating plant in Azusa. Since they were also both ex-fighters, their conversations centered around the ring.

My father mentioned that his son was a rising amateur boxer. Robert would eventually play a key role in determining just how high I would rise. After I had bounced from one trainer to another, it was my father who decided that the man he worked with every day would be the best choice to work with his son every day.

Since Alcazar didn't have a home gym, we moved around a lot after his arrival.

I had been moving around quite a bit even before he took his place in my corner. Robert came on board in the midst of a string of

successes that stretched around the globe. After winning at 119 pounds at the Golden Gloves in 1989, the victory that earned me the ring my mother had worn, I won the United States Amateur 125-pound championship in 1990, a gold medal in that weight class at the 1990 Goodwill Games, and the United States Amateur 132-pound title in 1991 before heading for the 1991 world championships in Sydney, Australia.

I had not lost a fight since 1987, when I entered the ring for my first match against a German fighter named Marco Rudolph.

He was quick and slippery. Like many Europeans, Rudolph had the point-scoring system figured out. He would get inside, land a punch or two, and get out. Get back in, another quick punch, and out again. I spent the whole match chasing him, but I never caught him.

I didn't catch him on the judges' scorecards, either. Rudolph beat me 17–13.

I was crushed. I didn't lose very much as an amateur, only five times in 228 matches, and I never knew how to handle it. This loss was particularly bad because it was right before the Olympics.

I went to my hotel room in Sydney after the fight and refused to come out until the tournament was over. We're talking about an event that had two more weeks to run. But I stuck to it, two weeks of voluntary, solitary confinement. Nothing would ever surpass the bitterness of that defeat. It was the worst time in my life in terms of my career.

My coach, Pat Nappi, would come to my door, yelling and screaming for me to come out, but I wouldn't talk to him.

I was too depressed to face the world. I had been the darling of the U.S. team, a favorite to win gold, and here I was eliminated while my teammates were just getting warmed up.

I didn't have any family or friends with me in Sydney, and at

first, I was afraid to tell the people back home what had happened. Especially my father. I was really scared of his reaction. Ultimately, I did tell him, and once the news spread that I had lost, I passed my remaining time in Sydney sitting on the phone with people back home when I wasn't just watching TV mindlessly, hour after hour, day after day.

It was a rough time for me. I wouldn't forget Marco Rudolph. But I also wasn't about to forget my vow to my mother. Upon returning home, I regained my resolve and finally shook off the sting of that loss.

Battling my way back into the win column, I qualified for the Olympic Games in a box-off by beating Patrice Brooks, a lefty.

I had made it. In front of a large group of family and friends, I had reached the Olympics.

Even as the excitement set in, however, so did the realization that I had only taken the first step on what would surely be a brutal journey to get to that Olympic victory platform.

En route to Barcelona, we trained in Hawaii and North Carolina, strengthening both body and mind for the task ahead.

Nevertheless, I was scared when we finally got to Spain, not because of the opponents I might face, but because of the pressure, the pressure I had put on myself by vowing to come home with gold for my mother, and the pressure others put on me because I was the poster boy for the whole U.S. squad.

I was the one on the cover of the boxing magazines and the one who did most of the interviews and photo shoots. Whenever the call went out for publicity assignments, my name always seemed to come up first.

Among the U.S. coaches, however, it was different. My name didn't come up when they talked about the favorites for Olympic

gold. I felt that since I had lost to Marco Rudolph, I was just another fighter to them. When Rudolph beat me, it was like everything went downhill in terms of impressing them.

Rudolph was the favorite in Barcelona, with the Cuban, Cuban Julio Gonzalez, considered a strong contender as well. I was not being talked about as much, even though I had beaten Gonzalez a year earlier.

That gave me an even stronger fire in the belly to work hard.

But deep down, I remained petrified. The nagging thoughts wouldn't go away. What if I failed? What if I let everybody down? Worst of all, what if I let my mother down? That was on my mind constantly.

The day we arrived in Barcelona, everybody was excited. The city, right on the ocean, was beautiful. Staying in the Olympic village, we found ourselves walking shoulder to shoulder with star athletes from all sports. Remember, that was the year of the first basketball Dream Team for the United States. Here we were running into people like Magic Johnson and Michael Jordan.

The first night, the whole boxing team wanted to go out on the town, celebrate, sightsee, sample the nightlife.

I wouldn't budge. "No," I said, "I'm staying here. I'm not going anywhere. I'm here for a job. I'm taking care of business."

I was so focused the whole time I competed. I would only leave my room to fight, eat, train, and then it was back to the isolation of my four walls. I would write letters, rest in bed, or simply concentrate on my next match. That's all I did. I was scared something might happen if I went out with the guys. I would not let anything derail me.

Some of the other guys would sneak out of the dorms, and stay out late. Everybody had their own way of dealing with the grueling schedule before us and the heavy stress that enveloped us.

Once the competition began, my fear of failure disappeared with one exception, repeated over and over. It would hit me just before I stepped into the arena. In those split seconds before I would climb the two steps to slide between the ropes, I would ask myself, *What if I lose?*

But once the opening bell rang, I had all the answers.

My first match was against Adilson da Silva of Brazil, a guy who hit hard. I hit harder, knocking him down in the first round. I was feeling good.

In the second round, however, I was also feeling blood from a cut under my left eye. It wasn't serious, but what if the referee thought it was? That was in the back of my mind.

Our whole team felt as if there was a bias against the Americans, felt as if any excuse might be used to cost us a match. One of our fighters, Eric Griffin, clearly won his fight, but got screwed over by the scoring system. Guys on the U.S. team were dropping left and right.

In the third round, the ref ordered the time clock stopped and motioned the ringside physician over to examine my eye. I was thinking, *My God, it could be over right here just when I'm starting. Some doctor I don't even know can kill it for me.*

When the doctor allowed me to go on, it was a big, big relief.

With the threat of a stoppage still hanging over me, I stepped it up. I landed some body shots, threw some uppercuts, and as a result, I sliced da Silva open. With my opponent's blood gushing from several cuts, the ref again stepped in to stop the fight. But this time it was to award me my first Olympic victory.

One down, four to go. Time for a meal and back to my lair.

My second opponent was Moses Odion of Nigeria. This guy was tall, maybe six three, a southpaw and lanky, a Paul Williams–type

fighter. I found it really hard to get inside to do damage. Especially hard after I hurt my right thumb. It got to the point where I could hardly use my right hand at all.

As if all that wasn't tough enough, I was still adjusting my fighting style to earn more points in the complicated scoring system utilized by the Olympics. In that system, a judge must hit a key on a device in front of him every time he thinks an effective punch has been thrown. For a fighter to get credit, however, at least three of the five judges must hit their keys almost simultaneously when the punch lands. That can penalize U.S. fighters who often use their speed to put together two-, three-, or four-punch combinations. It is usually not possible for a judge, no matter how well intentioned, to hit his key fast enough to score every punch in a combination. As a result, a skilled boxer who can produce a high volume of effective punches can be robbed of any advantage he has over a slow, methodical fighter whose style allows him to land only one blow at a time.

Trying to adapt in the middle of a tournament is like trying to change your golf swing in the middle of a round, rather than on the driving range. But I had to do it. I had been fighting in a pro style, landing a lot of combinations, but I wasn't getting rewarded by the judges.

So there I was, facing a tough opponent, armed with only one good hand and a style that could prove a recipe for defeat. Odion wasn't exactly cooperating, either. He was holding excessively while peppering me with his jab.

All I could do was turn it loose and become more of a brawler than a boxer. I waded in and pounded away at Odion, not the smoothest of approaches, but at that point I didn't care how I looked as long as I scored points.

I scored more than enough, winning 16–4, to get my hand raised again in victory.

It was painful to raise my right hand because of the injured thumb. I wasn't going to indicate anything was wrong, of course, because the last thing I wanted to do was let my next opponent know he had an advantage, that he didn't have as much to fear from my right side as he did from my left.

I went to our team doctor who iced the thumb and subjected it to electrical stimulation, but it still throbbed.

Fortunately, I didn't have another match for two days, a forty-eight-hour window I could use to reduce the swelling and regain some flexibility in the thumb.

Next on my dance card was Toncho Tonchev of Bulgaria, an opponent who worried me because he had already beaten Julio Gonzalez in an earlier match. Tonchev was a little shorter than me, which meant he might have been five, six inches shorter than Gonzalez, but he had still been able to beat the Cuban. That's why I was concerned.

That concern soon turned to relief. As tough as the Bulgarian was, his style was ideal for me. Not at first. He came out strong and I could feel his punches. I was only ahead 7–6 after the first two rounds.

But by the third round, Tonchev, continuing to stand in front of me with little movement, might as well have had a bull's-eye hanging from his neck. The two-day break had allowed the swelling in my thumb to subside enough to bring my right hand back into play, but I didn't even need it. Given a stationary target, I picked Tonchev apart with left hooks in that final round, a round I won 9–1 for a final score of 16–7.

I was in the semifinals, Olympic gold within view.

The responsibility for getting that most cherished of all medals rested solely on my shoulders. I'm not knocking the Olympic coaching staff because they have an entire team to worry about, so they don't have much time for specialized training. Nobody sits down with you and reviews a tape of your next opponent. They don't know your style, much less that of the guy you will face. Training by that point in the tournament consists of going to a gym and working out under the watchful eye of three coaches. They are training you to make and maintain your weight. For the rest of it, you are on your own.

I, however, wasn't totally on my own. Robert Alcazar had come to Barcelona to give me any help he could. Whether it was flying or driving thousands of miles, Robert made sure he was always available when I needed him.

I took advantage of his presence in Barcelona, twice breaking my self-imposed exile in my room to sneak out of the village after the 9 P.M. curfew and meet him. I went through two security checkpoints to make it down to the beach area where Robert would pick me up. He took me to his hotel room, where we brushed up on my technique.

That's not standard procedure according to the Olympic handbook, but I didn't care. Any edge I could get within the Olympic rules, I was going to take. It gave me reassurance to know Robert was there to help me through this process.

I think my Olympic coaches suspected I was going off campus for some extra help, but they looked the other way. Because of the success I was having in Barcelona, they treated me special.

In the semis, I met Hong Sung-Sik of South Korea. This guy was a dirty fighter, a brawler, more of a wrestler than a boxer.

Sung-Sik was penalized three points in the match for infractions of the rules, but I stooped to his level and was also penalized three points. I felt there was no alternative but to match his tactics if I wanted to survive. Sung-Sik would rush in and use his head or his elbows to try to injure me. He probably would have used the stool in his corner if he could have reached it.

A fourth warning can mean automatic disqualification. Sung-Sik got his fourth, but the referee allowed the bout to go on.

In the final half of the final round, the match was still close. Would the gold medal be elbowed out of my grasp by the South Korean? With Sung-Sik hanging on—literally—to steal the match, the referee separated us and warned him once again.

Still no disqualification.

In the final seconds, I took matters into my own hands, landing a clean shot to squeeze out an 11–10 win. It was not only my toughest fight of the Olympics, but one of my toughest fights ever.

I looked up at the ceiling of the arena, but I didn't really notice it. What I was really looking at was an image of mother in my mind. *Wow*, I thought, *she really is looking out for me. She has to be.*

My father was mad when the fight was over, mad that it had been so ugly. I felt only wonderment at escaping with a victory, along with the excitement of knowing that when I stepped back into the ring the following day, it would be for Olympic Gold.

My opponent? I wouldn't find out until the next day. That might seem hard to believe, especially for those back home who have the advantage of seeing all the competition on television. But when you're in that environment, it's different. Once the competition had begun, I was so preoccupied with my own fights, so anxious to get back to my room and rest up for my next match, that I

hadn't followed the daily results. I didn't know who was winning and who was being eliminated.

I think the coaches liked it that way. They treated us as if we were prowling tigers confined to a cage, our aggressiveness building. When we were released to fight, that aggressiveness would hopefully emerge in ferocious fashion, unencumbered by the burden of overanalyzing a particular opponent. They did not want us slowed by mind games.

But there was no way my mind was going to be at ease when I walked into the arena for the gold-medal match and learned the identity of the other fighter.

It was my old nemesis, who had beaten me a year earlier at the world championships in Australia, the opponent who had driven me into seclusion and haunted my dreams, Marco Rudolph.

I had never been able to put Rudolph out of my mind. When I got to Barcelona, I checked the brackets to see if and when our paths might cross again, but I had lost track of him.

I knew he made a living as a cook at the Branitz Hotel in his hometown, Cottbus, Germany, and I was determined to send him back to the kitchen along with the demons he had unleashed upon me. But all that resolve melted when I actually saw his name next to mine on the bout sheet.

My first reaction was, *The dream is over. This is the guy who beat me.* Why wouldn't he do it again?

I started panicking. I talked to myself, pleading for composure, trying to convince myself that this time would be different.

When I came out for the gold-medal match, I was pretty much alone, as far as my teammates were concerned. All the others had been defeated, and once the fighters lost, they would go their own way, not sticking around to support the survivors. Instead, they went out to party and have a good time.

I had an American flag in my hand as I approached the ring. My aunt Irma handed me a Mexican flag and told me, "Hold this in honor of your mother. She was Mexican."

For my mother? Of course.

But as I prepared to slip between the ropes, a U.S. Olympic official blocked my path. "If you take that up there," he said, pointing to the Mexican flag, "we are going to disqualify you. If you win, we will take the gold medal away from you."

I kept moving. Come on, if I won the gold, who would dare take it away?

When I got in the ring and saw Rudolph for the first time since Sydney, I think I was more scared than I have ever been in my life. My heart was pounding like a drum. All the time I had spent giving myself a pep talk was wasted. I had built this guy up in my mind so much that when I saw him in the flesh, he looked like a monster to me.

Once the bell rang, though, my heart stilled, my mind sharpened, my determination overwhelmed my doubts, and I was able to concentrate on the game plan I had devised for him. No more running after Rudolph, trying to cut the ring off as I had the first time. This time, I would lie back. Let him come to me. Let him attack and I will counterpunch, piling up points. That might leave him desperate to catch up.

Sure enough, I took the early lead, but Rudolph stayed in the fight, trailing only 3–2 as we headed into the final round.

With just over a minute to go, he threw a right hand, which I dodged, leaving him open for a left hook, which I planted right on his chin.

Boom, he went down.

It was quite a sight for me. Marco Rudolph, my conqueror and tormentor, lying on the canvas before me.

He got up, but that knockdown had shot me into a 7–2 lead and I would not be caught, that score holding up to the end.

I remember that final bell ringing like it was yesterday. Looking into the crowd, I could see my family, led by my father, jumping up and down in joy. I, too, felt the happiness, but I couldn't seem to express it. I couldn't jump for joy. I couldn't cry. It was like I was frozen. I was in shock. I had no expression on my face. I just couldn't seem to let any emotion out. I didn't know how to react. Should I be happy because I won the gold? Should I be sad because my mother was not there with me?

On the victory stand, the gold medal around my neck, the national anthem playing, and the American flag waving, I looked over to where my family was sitting and I saw my mother right there with everybody else, cheering me on. I could see her clearly in my mind's eye as if she was real. She was oversize, towering over everybody else, towering over the ceremony, towering over me.

But still, I couldn't get my feelings out.

Finally, when I came down after the ceremony to do an interview with Fred Roggin for NBC, right there, it finally hit me. He asked me about my mother and I started bawling, my emotions spilling out in those tears like a dam overflowing.

At last.

I remember telling Fred I was so sorry I was crying.

When I got back home to L.A., I found a reception beyond what I could possibly have imagined. I figured my whole family might be at the airport to see me bring home the gold.

Well, sure enough, they were there, but they were joined by thousands of other people. I remember driving down the 405 freeway with what seemed like hundreds of cars following in a celebratory caravan.

When we got back to East L.A., back to the neighborhood, the

whole block where we lived was full of people. Cameras everywhere. It was crazy. Omigosh. We had radio stations broadcasting live from our living room half the night.

I was overwhelmed. We celebrated for the longest time. I wore the gold medal everywhere I went.

What I really wanted to do was visit my mother with that medal, but I didn't want people to follow me to the cemetery. They might have. There were cameramen everywhere I went for days after I got home.

I finally told them, "Look, can you please give me some time? I want to go to the cemetery and give the gold medal to my mother. And I want to do it alone. Can you respect my wishes?"

They were very nice about it, going along with my request but not with me on my sentimental journey.

When I got to the cemetery, I laid the gold medal down on Mom's grave and stood there for hours, talking to her, reminiscing, crying. I thought about all the things I could have done for her, all the things I could have bought her if only she had still been alive. I thought about the house I would have bought her, the clothes, the shoes, anything she wanted.

I envisioned her seated in the crowd at my fights, cheering me in happier times. And I thought about all the pain she had endured in her final days.

I remember speaking out loud in the quiet of cemetery: "Why can't she be here? Why did she have to leave?"

All these years later, I still think about what it would be like if my mother was here.

As good as my life has turned out, I think it would have been even better if she was here. I think I wouldn't have had kids out of wedlock. I think my life would be more organized.

I've learned from everything that has happened to me, good and bad. You make mistakes and you grow from those experiences. But with her around, I would have grown a little faster.

She really stressed values. She was always on top of me, making sure I did the right thing.

Yes, she and I thought of the gold medal as the ultimate goal, but she wasn't a person who cared about money or material things. She really didn't. To her, the medal represented a great accomplishment, achieved through hard work. That was what would have been important to her.

I think if she had watched me excel as a professional fighter, she would have convinced me to retire at an early age, do it a long time ago. She would have stressed my future well-being over more belts and greater glory.

That was my mother, always putting things in perspective.

THE CLEANEST
WINDOW IN MEXICO

Manuel Gonzalez never met Gustavo Díaz Ordaz, but they shared a common vision.

Both saw Tecate as a Baja California haven, a picturesque town offering relief from the rough terrain of the Sierra Juárez mountains and the industrial, heavily populated centers in Tijuana and Mexicali on either side.

It was Díaz, running in the 1964 Mexican presidential race, who called Tecate *la ventana más lipia de México* or "the cleanest window of Mexico." Four years later, Gonzalez saw much the same, a place to give his mother and his siblings a better life.

Life had not been easy for Candelaria Gonzalez, my grandmother, and her four children—Manuel, Amparo, Cecilia, and Evodio Jr.—to the south in Sonora. Born in Durango, Candelaria had met her husband, Evodio Sr., in Ixpalino, a town in the state of Sinaloa. When the couple split up in 1956, Candelaria took her kids to Sonora, while Evodio, a farmer, stayed behind.

As a single mother, Candelaria survived by selling tamales, breads, and candies, by working as a maid and ironing clothes.

In 1968, Manuel, then a farmworker of twenty-four and the head of the family, succumbed to the charms of Tecate.

The oldest border town in Baja, and originally named Zacate by Yuma Indians, Tecate was a farming community by the early 1800s. It became best known for the Tecate Brewery, founded in 1943.

My grandmother still lives in Tecate today, in a house I bought for her. Along with her three surviving kids, she has fourteen grandchildren and thirty great-grandchildren.

Among the Gonzalez offspring, the one who spent the shortest time in the family's new home was Cecilia, my mother. While she was still living in Sonora, her aunt Maria Candelaria came to visit from her home in L.A. and asked my mother to come join her. My mother, about to turn eighteen, was thrilled by the prospect. She hadn't seen her father since she was five, and her mother and siblings were departing for a new life of their own in Tecate.

After obtaining a visa, she headed across the border to live with her aunt in Los Angeles, where she found work in a zipper factory.

Along with her two cousins, my mother would take a bus every morning from East L.A. to her job downtown. She didn't notice the man getting gas across the street from the bus stop until he drove up and asked the young ladies if they needed a ride.

My father, Joel De La Hoya, introduced himself and the young ladies piled into the car. Like my mother, my father had also been born below the border and come north to live with family.

The De La Hoyas were farmers in Durango. Vicente and Guadalupe had ten children, my father being the oldest. When he wasn't in the fields, Vicente pursued his passion, boxing.

He was the first of the De La Hoyas to come to America, leaving behind Guadalupe, who had no desire to give up her simple life

in Mexico. Settling in East L.A., Vicente worked as a mechanic while briefly continuing his boxing career. The highlight was a match at the legendary Olympic Auditorium in downtown Los Angeles.

When my father was sixteen, his father sent for him. My father arrived in the United States in 1955 and was enrolled in Roosevelt High School. Upon graduation, he started at the bottom of the job market, literally, digging graves at a San Gabriel cemetery. After three years, he became a sheet-metal worker for the next five years.

My father was late to work the day he took the Gonzalez girls downtown, but he had no regrets. Soon my mother was a regular passenger in his car as they began dating.

After eighteen months, my father asked my mother to marry him. By then, she was working as a singer, traveling as far north as San Jose to perform. My father was concerned that marriage could deny her a career.

"I don't care about that," she said. "I want to marry you."

My father had a dream career of his own that he wanted to pursue. Like his father before him, he loved to box. He had a 22–2 record as an amateur.

His transition to the pros, however, began disastrously. All he had to show for his first three fights were two losses and a draw. But then he regained his lost style and reeled off nine straight victories. He even followed his father's footsteps into the Olympic Auditorium, fighting there as well.

My father took a job at an air-conditioning-and-heating plant in Azusa, where he did everything from working on the machinery to serving as a shipping clerk. Being the sole support of a growing

family left no time for continuing his fanciful pursuit of a career in the ring. He would remain at the job in Azusa for a quarter century, his boxing days becoming a dim memory.

Whatever hopes my father had of glory in the ring would have to be passed down to his two young sons.

MY LAST FIGHT,
AT AGE FOUR

Memories of Mexico will always be special to me because they are my first memories. Even though I was born in East L.A., I was nurtured by family trips across the border to visit relatives.

The first words I heard were Spanish ones. My father spoke more often in English, but my mother wasn't fluent in the language. She understood it, but couldn't really communicate without the comfort of her native tongue.

There was never any danger of that being a problem for me because, in my neighborhood, if I tried to speak with my friends on the block or in school in Spanish, they would laugh at me, point their fingers, and say in a mocking manner, "Look, he speaks Spanish."

You quickly learned to stick to English if you wanted to be cool and fit in.

Boxing is also lodged in my mind as one of my early experiences, but it isn't a pleasant memory.

Every weekend, we would go to my uncle Lalo's house a few blocks away for family gatherings. The women would hang out in the kitchen, doing the cooking, the men outside around the garage,

having a beer. That was the "man" area. That garage, minus a door, served as a sort of playhouse for the men. My uncle had a pool table in there, so guys would be playing, laughing, swigging their beer, bragging after sinking that last ball, or demanding a rematch after losing. It was all good fun.

When they tired of that, the men turned to more serious competition: boxing. There was certainly no gym in that backyard, but they had gloves and that's all they needed.

My brother, Joel, two years older than me, would get laced up and mess around with some of my cousins.

I never did. Not at that point. I was just over four years old.

One Sunday, two of my uncles really went at it. It was a vicious fight, at least to my tiny eyes. I saw blood and I got scared.

When it ended, they looked around for fresh blood.

"Let's put George in there," someone said, referring to my cousin, who was then six.

Who could they put him in with?

All eyes turned to me.

I was terrified. I had nowhere to hide. My uncles, and even my father, were all pushing me out there, assuring me I could do it.

Do what? I had never put on a pair of gloves before. Didn't matter. I had no choice, so I reluctantly, sheepishly, stuck my hands out and watched in horror as those bright red leather weapons were strapped onto my tiny hands.

Now what? I didn't know what to do.

In contrast, George was a son of Uncle Lalo, meaning he had had access to the gloves, had put them on before, and at least understood the concept of throwing a punch. That made me a heavy underdog, considering I was making my ring debut against a veteran. Not a crafty veteran, but certainly craftier than little Oscar.

Sure enough, the predictable happened. *Boom,* he popped me in the nose and that was it.

I went down, tears flowing.

When I got up, I ran to my father. Everybody else was laughing, but I think he was just embarrassed.

And on that low note, my boxing career began. And ended, as far as I was concerned.

★ ★ ★ V ★ ★ ★

COMEBACK AT SIX

I had no idea where my life would take me. That's not something you think about at four. But I could have told you this much. I was not going to be a fighter. I would never, ever put boxing gloves on again, I vowed, after that afternoon in the backyard of Uncle Lalo's house.

I was crying so much after that punch in the nose that the laughter around me quickly stopped. My uncles were sympathetic.

My father was not.

"Don't cry," he said sternly.

No hug.

To my uncles, he said resolutely, "You watch. I am going to take him to the gym and he'll be back."

Not right away. Oscar–George II never happened.

I didn't want to be a fighter. I was petrified. I hated it, but I had no choice.

Ultimately, my father was right. I did come to love something that had seemed so abhorrent to me. And that love did start in the gym. That's because I didn't connect the two at the time. The gym was just a fun place for me as a young child, a place to run around

with all the other little kids there, a place to climb in and out of the ropes, to awkwardly jump rope or reach up with my small fists and attempt to move a heavy bag that seemed like a skyscraper from my tiny perspective. To me, the gym was a big playground.

My father wisely let six months go by before even broaching the subject of boxing. He said we were just going to go down to the gym to watch what was going on.

We lived on McBride and the gym was at Atlantic and Olympic. It wasn't very far, just a few blocks, but back then, it seemed like it took an eternity to get there.

My brother, Joel, was already hitting the heavy bag and sparring. I just soaked in the atmosphere.

Then one day, my father had me put the gloves back on. It wasn't, he assured me, to fight anyone, but just to hit the heavy bag. Or sometimes, he would pick me up in his arms, get me level with the smaller speed bag suspended from an overhead beam, and have me play around with hitting it.

Nothing threatening

Perhaps because of that kid-glove treatment, I was starting to like it, little by little. It wasn't serious business to me. It wasn't as if I was being told to put on the gloves and train so I could get revenge on my cousin George. I didn't see it that way.

I didn't even know boxing was a sport at that point. We didn't watch the Friday-night fights on TV. The only thing I remember being shown in our living room was baseball. We watched the Dodgers every weekend.

The trainers at the gym encouraged all the kids by building a little platform we could stand on to reach the speed bag. Actually, in that gym, they had what we call peanut bags, little speed bags that would go super fast when you hit them. All the kids loved them.

Everybody went out of their way to create a friendly environment for the youngsters, make it a place we would look forward to visiting.

My mother didn't question my father's decision to make the gym a focal point of my youth. She never said, "What are you doing? He's not going to be a fighter." And for his part, my father never said, "I'm going to make Oscar a champion." It just wasn't like that.

My father didn't take me to the gym all the time. As a matter of fact, it got to the point where I thought he didn't take me enough.

By the time I turned five, I wanted to be in the gym so much that I would secretly follow my brother over there. He would go after school and my father would meet him after he got off work around 4 P.M.

I liked being with my big brother, but let's face it. To a seven-year-old, I was just an annoying little punk, someone he didn't like buzzing around him, so there was no way he was going to willingly take me with him.

Understood, but I wasn't going to be denied. The name of the gym, a converted fire station, was Ayúdate, which means "Help Yourself." And that's just what I was going to do. I would wait until my brother left, and then I would slink out of the house behind him, staying ten to fifteen yards back, hiding behind a tree or darting into a driveway, doing whatever was necessary to stay out of sight.

Once I got there, my brother saw me, but he was so involved in what he was doing that he didn't really think much about how I had gotten there. When you're seven, those things don't really concern you.

My dad didn't know that I was sneaking out to the gym, but he soon found out. When he walked in one day and saw me there, he

nodded, smiled, and said, to no one in particular, "Okay, guess it's time to take Oscar to the gym on a regular basis."

Initially, I was a southpaw fighter, but Joe Minjarez, the trainer at the gym, switched me over to the right side because it was difficult for him to work with me the other way. Not being a southpaw himself, he would have had to reverse everything he knew.

Being just a kid, I didn't know the difference. He told me how to stand and that's how I stood. Looking back, it was the best thing that ever happened to me because it helped me unleash my left hook and perfect my jab, my two best weapons over the years.

Playing around in the gym was one thing, but one day, I took the next big step: hand wraps.

Those are the protective gauze strips a fighter wraps tightly around his hands for protection before putting on gloves. My brother and I and four or five other kids were taken over to Prieto Reyes, a local sporting-goods store, by the trainers to get the wraps.

You could buy them for fifty cents each. That was big money for me, but it was worth it because I felt, once I had hand wraps, "Wow, I've made it as a fighter."

Of course I had no idea how to even put them on, but at least I had them.

Once I learned how to encase my hands in that cool gauze, I was ready to use them. I didn't have any other equipment. The gloves and headgear belonged to the gym and were used interchangeably by all the kids.

When I got my turn, I started sparring, that unpleasant day in Uncle Lalo's garage chalked up to the immaturity of a toddler. After all, that was two years ago. Now I was a mature six-year-old.

After sparring for two or three months, I got my first fight at the

age of six. It was at Pico Rivera Sports Arena, a multipurpose build-
ing featuring everything from concerts to horse shows.

We would go down there on Saturday mornings, my father, my
brother, and I. The kids would weigh in and then go off to play. The
coaches would huddle and try to match us up, putting together kids
of equal weight as close as possible in age and build. Sometimes
they were able to make a match and sometimes they weren't.

On that particular Saturday, my father was trying to get some-
one to face my brother, but it didn't happen. There wasn't a suitable
opponent.

But there was for me, little Oscar, weighing all of 56 pounds.

It wasn't like I had been pushing my father to get me a match. I
had reached a point where I didn't mind getting punched and I
liked messing around with the other kids during those long days at
the gym, stretched even further when the adults disappeared to
drink beer and hang out.

My father, however, thought it was time, even at my tender age,
to move up to the next level, to get competitive. My brother already
had one or two fights under his small belt.

I was at the top of the bleachers overlooking the ring, running
around with my friends, when my trainer, Joe Minjarez, yelled at
me to get down. I had a fight.

I was excited. Time to emulate the big boys.

It was kind of funny. I had no equipment, no shoes, no shorts,
and certainly no gloves. I had to borrow all of my brother's stuff.
The shorts came down to my calves. The boots were about four
sizes too big. They were so long that they curled up in the front like
the shoes of an elf. The socks they gave me, tube socks, had to be
rolled down again and again just to get them below my knees. I

looked like a soccer or baseball player more than a fighter. The gloves? They were so big they practically came up to my elbows. And on top, I had a T-shirt with a 7-Up logo.

And that's the way I went off to war for the first time.

Before I stepped into the ring, which was outside on the dirt surface where the horses usually romped, my father pulled me aside and said, "Move your head. Throw hard punches."

When the bell rang, I wasn't the least bit nervous. I went right at my opponent, throwing punches as my dad had told me and laughing. To me, it was fun, a rush. Boxing had gotten into my blood.

To my dad, it was very satisfying. After giving me the last-minute advice, he became very quiet once the fight started. He wasn't one of those parents who continually scream at their sons during a fight, yelling about using the jab, throwing the hook, and keeping the energy level up. No, he just sat there, almost serenely, with his arms folded, taking pride in the fact that it was his son on the attack.

They stopped the fight a minute into the first round. My opponent, who hadn't landed a single punch, had had enough.

I couldn't get enough. I wanted to do it again.

FOOD STAMPS
AND MUGGERS:
LIFE IN THE HOOD

From the outside, we looked like a typical Mexican-American family. We didn't have any more or any less than the other households in our East L.A. neighborhood.

On the inside, though, there was something lacking, something very essential in the nurturing of a child. Maybe that was typical, too, of our neighborhood. We never talked about anything. We never had conversations around the house. I remember saying just a few words to my mother at a time and that was it. My parents never sat my brother and me down and talked to us about the birds and the bees or any problems we might be having. They never offered to help us with our homework. They simply said, "We're the parents and you listen to us and that's it."

The thing I regret most is not telling my mother I loved her. She never told me she loved me, either. I knew she did love me and I'm sure she knew I loved her, but we never had that kind of communication. I don't know if it was deemed embarrassing to say it, or just not part of who we were. I don't want to say our household was cold, but there really weren't any emotions in evidence. My parents didn't know how to express themselves, especially my father. It's only

recently that he has told me he loved me and has given me big hugs. I finally feel he's proud of me.

Dinnertime was a good example of what it was like back then. Most of the time, my father would have dinner by himself. I would eat after I got home from the gym and I don't know when my brother got around to dinner. As for my mother, she was the one doing the cooking. She would wait until the last person had eaten, then, when we all wandered into the living room to watch TV, I would glance back into the kitchen and see her eating by herself.

I am determined not to make the same mistakes with my kids that my parents made with us. I shouldn't even say mistakes. It was just part of the culture.

I grew up in a tiny, second-floor apartment containing a living room, kitchen, two bedrooms, and a half bath barely big enough to accommodate a shower. The whole apartment was barely big enough to accommodate the four of us.

The kitchen had a table that seated four, but took up most of the space in the room. It was a typical kitchen for that time and place, containing a linoleum floor, a refrigerator, and a stove.

My brother and I shared a bedroom, sleeping in bunk beds. He was the older kid, so he took control of the decor, plastering the room with posters of heavy-metal groups. I had no say whatsoever.

We had a pleather sofa in the living room. What's pleather? Fake leather. There was a big mirror on one wall with a cross hanging down. The prized object in the room was a twenty-inch color TV with two antennas jutting out of the top, their original form twisted and turned from constant adjustment. It would be pathetic in comparison to today's gadget-laden big-screens, but in that neighborhood in those days, it was like having a movie screen at your personal disposal. Yes, there were only seven channels and you actually had

to walk up to the set and change channels by hand, a primitive concept to my own kids, but whether it was watching Dodger games or entertainment shows, that TV was our window to the world, proof there was life beyond McBride Avenue.

The walls of the apartment were all white, there were no rugs on the floor, and cheap "antiques" could be found in every corner, a very fifties look.

We had our share of rats and roaches. There were so many roaches that we didn't even try to kill them. We thought of them more like pets. We didn't know any different.

There was a small driveway on the side of our building that we turned into a makeshift baseball field. We cut off the top of a broomstick to make a bat, got an old tennis ball, and we were set. It wasn't exactly Dodger Stadium, but we were happy.

That was our world. We never left the neighborhood, living innocently in our little bubble. One time, when I was a kid, my mother and I went to the doctor on the bus. When we got off at the wrong stop, we were lost. My mother didn't speak English, so we just wandered around for what seemed like hours. In reality, we were in Montebello, not that far from home. Eventually, she called some relative who picked us up.

Sometimes we had to live on food stamps. They were brown in color, each worth a dollar. My mother would send me to the little corner store with a booklet of stamps to buy eggs, tortillas, and a big can of beans. If the place was crowded, I would hang in the back until it emptied out before pulling out my stamps. I was embarrassed.

For years, I carried one of those food stamps around in my wallet so I would never forget the value of a dollar, how precious food and the basics of life are to those who don't have them, and to never forget how far I had come.

It was only recently that I lost that old food stamp when someone stole my wallet in Las Vegas. After the story of the theft ran across the country, we received hundreds of food stamps in the mail at the Golden Boy offices. Now I have plenty of food stamps to choose from for my new wallet.

My father tells me that I shouldn't go around saying we got food stamps because it's not true. The truth is, he didn't know because my mother never told him. The idea that the man of the house was working his rear end off to provide for his family and we needed food stamps to get by would have been unacceptable to my father. He had too much pride to allow that. So my mother kept it from him.

When my sister, Cecilia, was born a dozen years after I had come into the world, we moved to a duplex on Mcdonnell Avenue. We lived in the back behind my uncle Vicente. Even though it was only a block away from our old apartment, for us, it was like moving to Beverly Hills. There were no apartment buildings on our new block, just duplexes. The cramped conditions we had existed in gave way to what seemed like wide-open spaces. We even had a little front yard with a small porch.

While we had more space on the property, we had less in the unit itself, leaving only one bedroom. The garage was converted into an extra room where my brother and I slept. My infant sister stayed in my parents' bedroom.

Ceci brought warmth to our household. As the little baby of the family, she had my father wrapped around her tiny fingers. It was not easy to get to him, but she did. And not just to him. She was loved by and close to everyone.

We had one car, a late-seventies, light gray Monte Carlo. To me, as a young child, it seemed so huge, almost like a tank. I thought it was embarrassing, not cool at all.

My father didn't worry about what was cool. He was just happy to be able to afford wheels. He had a tough, demanding job, but he never complained, always taking a lot of pride in being able to take care of his family. We may not have been rich, but thanks to him, we had a roof over our heads and the freedom to hang out in the gym, where I was able to hone the skills that would enable me to provide for the family in a way my father could never have dreamed of.

He took comfort from being able, when his tedious day was done, to head to the gym to watch his sons work out. That gave him a great deal of joy. It brought back memories of his own father seeing him fight and of the days when he himself could spend the majority of his time in a gym, honing his own skills.

My mother was the quintessential homemaker. No matter how small our living space, she was constantly cleaning, dusting, washing dishes, doing our laundry. She would take all day to clean. My brother and I would wonder, *How many times can she clean this place?* She was meticulous. This was her nest and she was determined to maintain it as a comfort zone for her growing family.

My mother cooked like there was no tomorrow. She always made chorizo and eggs for breakfast, carne asada or some other kind of meat along with beans for dinner. And you can be sure there was salsa on the table. She was known for her homemade salsas, along with her tortillas and guacamole.

Every other Saturday morning, we would go shopping at Johnson's Market, where she would buy an average of $45 to $50 worth of groceries. I made sure I went with her before I went to the gym, because it gave me the opportunity to slip over to the candy section, where I would get a few sweets to pop in my mouth and a few more to stuff in my pocket.

My mother never worried that I'd have a weight problem. For one thing, I was a very active child, especially after I made the gym my second home. Second, I was a kid who didn't like to eat. I'd pick at the food or push it across the plate, using my fork or a tortilla as a bulldozer. Anything to avoid putting it down my throat. My mother didn't buy that, so I had to sit at the table until I had swallowed everything in front of me. That could take over an hour, considering my lack of enthusiasm for the task in front of me. Didn't matter how long it took. Didn't matter if the food got cold, which it always did. I was locked into that chair until it was gone.

It was home cooking or nothing with the exception of trips to the homes of relatives. In all my years growing up, we never went out to a restaurant to eat. Not one time.

In my teens, I once stopped off at a little Chinese restaurant near our house and picked up takeout. But that was a onetime thing.

Along with her cooking, my mom took pride in how she looked and acted. It was important to her to try to be the perfect person. Even though she stayed mostly around the house, her hair would be perfect, her makeup on just right even as she went about her cleaning. She wanted so much to look elegant even though she couldn't afford to buy elegant things. She didn't have the money to go to a beauty shop, but she would dye her hair once a week, always coming up with a new shade of blond. That matched her light complexion. She had pretty brown eyes, a very beautiful person.

She was about five-four, five-five, and may have weighed 150 pounds or a little more, heavyset, but she never obsessed over it. She was confident in her appearance, and rightfully so. And she was able to pass that confidence on to her children. Dressing right and looking right has always been important to me.

My mother always brought laughter to the house. She had a loud laugh, the kind that made you want to laugh with her. When she would get with her friend, Maura, who was like a sister to her, or one of her cousins, or her aunt Hermila, they would be loud and boisterous, enjoying life in their own little world.

One time my father got off work so early that he beat me home. My mother got into the family car, turned the radio up full blast, and started listening to her favorite music, *rancheras*. She was singing so loud I could hear it when I got within a few houses of my own.

At first I was kind of embarrassed. *Mom, what are you doing?* I thought. *All the neighbors can hear you.* I was a high school student then, very self-conscious. But then she motioned for me to get into the car with her and we starting singing together. Soon we were laughing and having a great time.

That's the moment that comes to mind first when I think of her, before she got sick, before the agonizing final months of her battle with breast cancer. I picture the two of us in that car, singing a duet, enjoying each other's company, seemingly without a care in the world.

I never had to do chores as a kid. My parents wanted me to excel in school and in the gym as well, so that was my life. As long as I kept busy at those two places, my mother was happy to handle the home front.

It was nice, but no chores also meant no allowance, not that my parents could have afforded to give me one anyway. I became known on the school grounds as the kid who never had any money.

There were lines for food and other lines for school supplies. In one, you could buy cookies or brownies or other snacks; in the other,

pencils or notebooks. It didn't matter to me. I never got in either line because there was no way I could buy anything.

That never failed to amuse my classmates, who loved to make fun of poor Oscar. If you had told them I'd be known as the Golden Boy someday, they would have laughed even harder.

At the end of summer, when all the stores had back-to-school promotions, I might get a notebook and some pencils. That was about it.

Because money was tight, my parents never took us shopping for clothes. I had only one pair of jeans and I just kept wearing them and wearing them until I got sick of them and sick of my friends pointing at them and grabbing their stomachs in laughter.

To change things up, I occasionally wore my mother's pants to school, a fact I never got around to telling her. One time I wore a bright red pair, very tight on me, with a zipper in the back. You can imagine how that went over with my friends. I lasted two periods in school, then left.

After that, it was back to my good old jeans.

I have to admit, starting when I was about nine, I went to a Kmart on several occasions and stole a pencil and some erasers. I just stuffed them in my pocket and walked out. I was scared, but that didn't stop me. I needed them for school. I can't imagine what would have happened if my parents had found out.

Actually, I can guess what my mother would have done. It's funny. My father was very, very tough on my brother and me, very intimidating, but he never laid a hand on us. It was my mother, believe it or not, who handled the physical punishment. She would take off her shoe and throw it at us, or spank us with a belt. Those spankings made us cry when we were small, but as we grew older, it was no big deal.

One time, as she was spanking me, I started to laugh. She pulled me off her lap and said, "Okay, I'm going to tell your father to whip you when he gets home from work."

That got my attention. I was scared enough to quickly wipe the smile off my face and replace it with a look of contrition.

Normally, I couldn't wait for my father to get home because that meant a trip to the gym. That time, however, I was in no hurry to see him because I knew it meant a trip into the bedroom for an up-close and personal look at his belt.

Finally, I heard the dreaded sound of his car pulling up and the door opening. My mother greeted him in tears, pointing to me and saying, "He won't listen to me."

A dark look of anger crossed my father's face. He took me by the arm into the bedroom I shared with my brother and slammed the door. By then, I was shaking.

In the room, the frown on his face faded. He broke into a big smile and started chuckling. What was going on? I was feeling equal parts confusion and relief.

Slowly my father unbuckled his belt and pulled it out of the loops on his pants. Now I was really puzzled.

"Look," he whispered. "I'm going to hit the bed with this belt real hard. And every time I do, you make noise like you're in pain, okay?"

Okay.

Wham! Bam! My father pounded that belt down on the bed several times. Each time I give out an anguished yell.

All of a sudden there was my mother, standing in the doorway, watching the whole scene. She was not the least bit amused.

While my father could be the good guy in a situation like that, it didn't lessen my fear of crossing him. He was very strong-willed,

very tough in the way he talked to you. It was his way or no way. I respected him, but I feared him.

The intimidation factor remained for a long time, after I won Olympic gold, after I turned pro, even after I was making more money than him.

I remember one night, after I had bought a house in Montebello for myself and the rest of the family, I tried to sneak home with my friend Raul after a night of drinking and clubbing, fearful that my father would catch me.

I had gone out with friends after beating Paris Alexander in Hollywood in my third professional fight. Raul and I got dropped off at the house around 3 A.M. We asked to be let off down the block because I didn't want my father to see me. He would not approve of my coming home that late, especially considering I was intoxicated.

I had had security cameras installed around the property, so Raul and I tried to chart a course to my room that would avoid the eye of the lens.

Here I am, soon to turn twenty, and I'm still acting like a misbehaving grade school kid. My father's towering presence could affect me like that.

When we reached the perimeter of the house, Raul and I got on our stomachs and crawled forward as if we were soldiers trying to get under a barbed-wire barricade. We made it to the house, but every door was locked.

We were so drunk that after crawling around for a few minutes, we would stop and take a short nap before resuming our reconnaissance.

Through the shades, we could see my father watching TV in a first-floor room. My bedroom was on the second floor. We figured if

we could just get there, we could claim in the morning that we had been there all along.

There were pillars in front of the house that served as supports for the balcony off my bedroom. I pulled a chair over, got on it, and strained to reach the balcony's railing.

The combination of being drunk and standing on a rickety chair left me about as steady as a fighter getting up from his third knockdown. But with Raul putting his weight on the chair to anchor it, I finally steadied myself enough to get a firm grasp on the railing and pull myself, legs kicking, over the top, collapsing onto the balcony.

I listened for a minute, fearful my father had heard me, but when his heavy steps didn't come plodding up to the second floor, I figured we were home safe.

More luck. The outside door to my bedroom was unlocked. Now all I needed was to get Raul up there. He got on the chair, but faced the same problem I had, a drunken climber on a wobbly foundation. I reached down, straining to grab his outstretched arm.

All of a sudden I froze. Raul looked mystified, because the chair felt steady and yet I looked unsteady. When Raul turned around, he understood.

Holding the chair for him was my father.

I could never get away with anything with him around, though I didn't try to get away with much. My brother and I were both good kids. So were most of the friends I hung around with. We were the innocent kids on the block. We didn't want to get involved in anything bad.

My father's definition of a bad kid? Eric Gomez. Why? Because Eric, whom I've known since I was five, was always on his skateboard in the street and I wanted to be right there rolling alongside

him. In my father's eyes, that made Eric a bad kid because my father was afraid I'd get hurt emulating Eric.

That's not to say there weren't kids in the neighborhood who really were bad. Those were the gang members, including some who asked me several times to join them when I was thirteen and fourteen. I didn't need my father to tell me that was a bad idea. I knew those guys were into more than skateboards.

There was so much gang activity in our area that my brother and I didn't go out at night. Certainly not alone. The farthest I might venture would be our corner liquor store to pick up a gallon of milk. But I would only go with my brother or a neighbor.

As my amateur career progressed, gang members began to recognize me. That's when they stopped putting pressure on me to join them. Instead, they protected me because they respected what I was doing in the ring.

My protection was assured by the godfather, a man in his sixties with white hair who would walk around the neighborhood aided by a cane, no shirt on, tattoos everywhere. He was THE guy.

One day I ran into him on the street. He nodded at me and said, "Don't worry about nothing. We are looking out for you."

At the time I didn't know I needed help. I was naive. But as I got older, I came to appreciate the fact that they had put out the word to leave us alone. When I say us, I mean the whole De La Hoya family. Shootings were happening down the street, cops were constantly patrolling, and helicopters were cutting through the night air above us, but our home was always immune to danger. It was like we lived in a protective dome.

For that, I guess I can thank the man with the cane.

My unique status in the hood was never demonstrated more dramatically than the traumatic night that began with a seemingly

innocent walk over to the home of my girlfriend Veronica Ramirez, a block from my own house. It was eight o'clock, a seemingly safe and peaceful time.

Wearing a leather jacket and carrying a camera, I had gotten within a few houses of my destination when this truck came roaring up. With squealing brakes, it came to an abrupt halt and about eight guys wearing ski masks jumped out. There were guns everywhere. They put one to my head and I thought I was going to die right there at the age of fifteen.

"Give me your jacket," one demanded. "Give me your camera."

"You got a wallet?" said another muffled voice.

"Yeah, take it," I said.

It all happened in a blur. Next thing I knew, the truck was racing down the street and I was alone again on a peaceful night.

Feeling like I was going to pee in my pants, I raced over to Veronica's house and we called the cops.

When I finally got up the nerve to go back on the street, I hurriedly walked home, constantly looking over my shoulder, taking a different route just to be safe.

As I arrived, an aunt, who was staying with us, told me, "Oh, your friend just came by and dropped off some stuff he said you left at his house."

There was my jacket, my camera, and my wallet.

"What the hell is this?" I blurted out.

The next day I found out the muggers had been a few guys from the neighborhood who had not known it was me in the dark, and had only learned my identity when they opened my wallet.

Maybe I should, once again, have thanked the man with the cane.

That wasn't the end of my experience with gangs. Long after I had

moved out of the neighborhood, another gang tried to move in on me.

I was already a pro when I got an unsolicited offer from an unexpected source, a new fan base I discovered lurking in the shadows.

It was at a club in West Covina where I had gone with Raul and some other friends, about twenty of us in all. I was single, carefree, and, with five pro fights behind me, pretty well known in Southern California.

This blonde came over to me and started talking and soon we were out on the dance floor.

No big deal. This wasn't the first woman who had ever approached me.

As we became friendly, she flashed a big smile and said she had somebody who wanted to meet me, pointing to a table in the corner.

Again, no big deal. People often wanted me to meet their relatives and friends.

She led me through the darkened room, past the gyrating dancers, to a crowded table and pointed to one guy, probably in his late thirties, who seemed like the leader of the group.

He introduced himself and said, "Can I buy you a drink? As a matter of fact, I'll buy you all the drinks you want. I can take care of you."

There was nothing unusual about him. He wasn't adorned in tattoos or gaudy jewelry. He didn't speak in a loud or abrasive manner.

I thanked him, figured he was a fan with a lot of money, and went back to my table.

As I sat down, my friends started whispering, "Do you know who that is? That's the Mexican Mafia. They must have identified you."

Having heard of them, I became scared. The blonde wouldn't leave, choosing instead to hang next to me. And the drinks kept

coming, ordered courtesy of that other table. I felt pressure. Even when I went to the restroom, I felt they were watching me.

Sure enough, when I glanced over at that table, several guys were staring at me. They wanted to continue the conversation. I didn't.

A part of me thought it was exciting, an adventure. But I knew it was an adventure that had to be cut off immediately if it was to have a happy ending.

Time to make a run for it. Raul and I decided my friends would surround me and we would march out of the club in that formation, a twenty-man battering ram.

I counted to three and we stood up and headed for the door like a wild herd. I felt relief when the cool night air hit me, but not for long. Glancing over my shoulder, I saw my new friends come racing out of the club in my direction, anxious to continue our discussion.

There were probably a thousand people in that club when we left. Seconds later, it was practically empty, the crowd spilling into the street and chaos ensuing. Most of the people probably didn't even know who I was. They had just seen my group pursued by my wannabe buddies and followed to see where the action was.

The action wasn't going to be in my direction. One of my friends had already reached his car and started the engine, and I ran over and jumped in. His tires screeched as he backed up, banging somebody in the leg as we accelerated.

We made it to my house in Montebello without further incident, ten of us piling into the living room, laughing and high-fiving, replaying our exciting night over a few beers.

After about an hour, the group started to break up. Most of the guys left and I went up to my room on the second floor. I lived in a cul-de-sac, the guys having all parked in the semicircle. I could hear

their engines starting and could see their lights go on through my shades.

I glanced out the window and froze. There, in the middle of my street, standing perfectly still, the cars pulling out around her, was the blonde from the club, staring at my house, focusing on my window. It was eerie.

I didn't come out, and she eventually left.

I later heard that group was indeed the Mexican Mafia and that they were interested in handling my career. They never tried to contact me again.

And I never went back to that club in West Covina.

MY ROOTS

To this day, my Mexican roots tug at my heart and Tecate holds a special allure for me. Mexico brings back warm memories of family bonding and emotional ties that I never experienced at home.

It was so different when we made the three-hour drive to Tecate to visit my maternal grandmother and her family. We usually headed across the border in the summer, sometimes staying for weeks at a time. Either my father would get time off from work, or my mother would take us, driving the car herself.

Our Mexican relatives—aunts, uncles, and tons of cousins— awaited our arrival each time with great anticipation, wondering what riches we might be bringing with us, clothes for the adults, coins for the kids that my mother or father would press into their eager little palms. The whole town would turn out when our car pulled up. They saw us as the rich relatives, coming from America, where they imagined the streets were paved with gold. We may not have been rich back home, but in Tecate, we were royalty.

It was funny. Soon after we arrived, we were all just family again. But when we prepared to leave, we were perceived anew as the gringos, heading back to that magical place known as California.

It's not that our relatives were putting us down. Our other life in America was never perceived as a negative.

As a child, I might not have understood the concept of two different countries, but I knew we were heading into a different world when we came to Tecate. The roads were dirt and so was the floor in my grandmother's house.

There was one bedroom and a kitchen. That was it. My grandmother would give her bed to us and we would all sleep in it, the whole family. Or sometimes my brother and I curled up on the floor. I don't know where my grandmother slept, probably on the floor in the other room. She didn't mind. We were the guests and she wanted us to have the bed.

I never met my grandfather. I didn't know where he was, and as a youngster, I never asked.

Those long stretches at my grandmother's place were happy times. I would be awoken at dawn by the roosters on her property. I jumped up knowing what awaited me: my grandmother's delicious breakfasts. Everything she cooked tasted great, but her specialty was tamales. They were amazing.

Because there was no indoor plumbing, we had to use an outhouse in the back to take care of business. Before we went down there, we walked to the well and filled up a bucket so that, when we were done, we had water to flush. We were bathed in a metal tub with the well water.

I remember one time, when I was about nine years old, I had to go to the outhouse around nine in the evening. If there wasn't a full moon, the nights down there were frightfully dark, especially to a kid, because there were no lights.

My grandmother's mother, Candelaria, lived near the outhouse

in a cabin. She was very old, a mysterious figure who never left her abode, not even to eat. Food was brought to her.

On that night, I had forgotten about my great-grandmother as I made my way down the rock-strewn path, gazing up at a sky filled with more stars than I could ever see in the smoggy air back home.

The path to my destination led past my great-grandmother's cabin. The noise from the main house had faded as I neared the outhouse.

All of a sudden I felt a cold, bony hand grip my wrist. It was my great-grandmother. Having latched on to me, she made this low, guttural sound, almost like a growl. It was about as close as she came to talking.

It was so scary for a young kid. If I could have, I would have leaped back to the main house in a single bound. But I couldn't get free. She wouldn't let go. I started screaming, alerting my relatives, who finally came running to release me.

The conditions in my grandmother's house may have been primitive compared to my parents' home, but there were times when I wished Tecate was my home because my aunts and uncles down there were openly loving and caring, able to show their feelings for me far more easily than was the case in my own house. I had conversations down there, long, deep conversations that enabled me to open up about my own feelings. Those were the conversations I so desperately missed at home.

Tecate wasn't our only destination in Mexico. We would also go to Durango, near Mexico City, to visit my father's family. It took us twenty-four hours on the road to get there.

My paternal grandmother, who was separated from my grandfather, lived in a bigger house with more relatives in the area than

we found in Tecate, aunts and uncles and cousins. And this grand-mother even had a bathroom in the house, the ultimate luxury.

The social environment was the same as Tecate. There would be as many as ten people sitting around a table, drinking hot chocolate, eating the Mexican-style breads, talking, laughing, and interacting. I couldn't get enough of those gatherings.

Even my parents got into the spirit down in Mexico, becoming more open. It gave me the opportunity to say things I would never say back home. Even telling my parents I loved them? I would think about trying to sneak that in.

But I never did.

Border control was a lot looser in pre-9/11 days, but my parents were still cautious about going through customs. They would warn us to be sure and say "American citizen" to the customs officer.

My mother always had a hard time with that because, even after she had become an American citizen, she still struggled with her English. She always got nervous as we approached the border. She would sit there in the front seat, repeating over and over again, "American citizen. American citizen."

Just before the border crossing on the U.S. side, there was a small building with a sign that read AMERICAN MARKET. It was the last thing you saw before you pulled up to the customs booth.

One time in particular stands out in my mind. My father, brother, and I had confidently declared "American citizen" without a second thought, as we always did. Then it was my mother's turn.

The customs officer leaned in to the car and looked at her. Nervous, she blurted out, "American market. American market."

My brother and I started laughing, but the customs officer didn't see the humor. He made us get out and undergo questioning while they searched our car.

I had another funny moment at the border with my friends years later after I had won the gold medal. About ten of us, including Raul, went down to Cancún and, while there, purchased about twenty boxes of Cuban cigars.

On the way back, we were coming through a tunnel leading to the checkpoint. As we got closer, we could see the customs officers. They looked mean and serious, and most alarming of all, they had dogs sniffing for illegal items. Cuban cigars would certainly be on that list.

We were worried, but Raul said he'd take care of it. Fine, we handed him the bag with the cigars.

Then we started picking on him. "Raul," we yelled out, "what do you have in that bag? Cigars? Cuban cigars?"

Raul, who is usually the calmest guy in any situation, started sweating and snapped at us, telling us to shut up.

Fortunately, when we reached the customs officers, one of them recognized me.

"Hey, champ, what's going on? Don't worry about it," he said, waving us through. "Just go."

That we did. One of the dogs went after Raul, sniffing that bag, refusing to back off, but Raul kept his head down and just walked faster and faster until we were out of sight. It wasn't easy keeping a straight face as we watched him try to tell that animal to get lost.

Just another reason to smile when I think of Mexico.

★ ★ ★ VIII ★ ★ ★

TACOS AT DAWN

I was nothing more than a flailing six-year-old, dressed like it was Halloween.

Looking back, though, my first fight proved to be much more, proved to be the moment I took my first tentative steps on a trail blazed long ago by my grandfather, and later followed by my father. That Saturday afternoon at the Pico Rivera Sports Arena, I added a link to our family chain and forged a lifelong bond with my father, a bond subsequently tempered by the heat of battle; though strained by the demands of a warrior existence.

Of all the battles I have fought in my career, none has been as tough as my struggle to gain my father's approval. He was raised in a culture where the difference between winning and losing in the ring could mean the difference between adulation and despair in life. For him, praise generated overconfidence and lack of discipline. He was always more worried about my next fight than elated over the last one.

In a way, he was right. Victory can be fleeting in boxing, defeat permanent.

None of that went through my mind after that first match, of course. I was just a youngster who had learned how much sweeter winning was than losing.

I was given a trophy I brought home to my mother. I also showed her the additional spoils of my victory. Some of my uncles had been ringside, and when I came down the steps, they rewarded me with money. One gave me a quarter, another fifty cents.

Boy, that opened my eyes. You could make money doing this?

I loved that and I loved all the attention I received, but I think the biggest bonus I got out of that fight was the first hint of approval from my father. It was not verbalized. That wouldn't be the case for a long, long time. All he said to me was, "Good job, but you can do better."

But I could tell he was very proud. Our family and some of his friends were there and I saw a look on his face that let me know he was thinking, *Yeah, that's my kid.*

After that, the fights came fast and furious. I would sometimes have matches on both Saturday and Sunday, but always at least once a week. Occasionally, we would be transported to other gyms as far away as Santa Fe Springs.

No matter how well I had done in a fight, though, I knew that when I got home, I would receive a big lecture from my father. He would get in a boxing stance and show me how I should have done this or shouldn't have done that.

I got my first pair of gloves when I was ten. An uncle, Jose Luis Camarena, took me to buy them. He was one of the uncles who fought in Uncle Lalo's garage. Jose Luis wasn't very good with the gloves on, always getting beaten up, but he was great at shopping for them.

My stockpile of equipment continued to grow. As the champion of

my neighborhood, undefeated for several years, I needed the right look, so my parents began to dress me in red satin trunks. My mother wanted red because she said it was good luck and would make me angrier and stronger, like the bull seeing the red of the matador's cape.

I also got my own shoes and socks and a tank top. No more 7-Up T-shirts. I even got my name on my shorts, with iron-on letters.

I was always trying to take my brother's clothes because I had so few of my own. I would wait until he left for school, grab something of his, put it on, and then avoid the route he had taken.

One day, when I was about nine, he caught me and started beating on me in the kitchen of our apartment on McBride. I gave him a left hook to his body and he went down like a sack of potatoes.

He never bothered me again.

My brother had received all the attention from my father in the beginning because he was supposed to be the Golden Boy. People used to say he was better than me, but in the end, he just didn't like boxing. So he quit at the age of fourteen or fifteen after just four fights. He lost them all. To this day, if you ask him, he'll tell you he got robbed in all four, but I think it was just that his heart wasn't really in it.

My uncle Jose Luis begged my brother to stay in the sport. He even tried to bribe him with a motorcycle. Didn't matter. My brother wanted out.

He preferred baseball, a sport he was great at before he blew his arm out pitching.

I would follow my brother to the diamond, wanting to be with him and, perhaps, even be his teammate. As much as I had learned to love boxing, I was still intrigued by what big brother was up to.

One Saturday, when I was eight, I was playing in a game with him at Salazar Park. He was pitching and I was at shortstop.

That lasted about five minutes. Suddenly, out of the parking lot, came my father, an angry look on his face. He marched right onto the field, oblivious to the fact that a game was going on, grabbed me by the arm, and escorted me off the diamond.

"Come on," he said firmly, "this is not for you."

I started crying. I didn't understand. I just wanted to play.

I was wasting my tears. Emotional displays did not work on my father. Nor did you ever argue with him.

That was the premature end of my baseball career. There was only one glove my father wanted to see me wear, and it didn't have webbing.

With my brother out of the picture, my father turned his full attention to me. I was the chosen one.

It wasn't just my father. I was the focus of my extended family. They would support me and buy me equipment, all of them anxious to have a part in the making of Oscar.

I could sense that my brother was hurt by all the attention I was getting. As he faded into the background, I think he regretted for the first time that he hadn't stayed in boxing.

It was kind of like the movie *La Bamba*. I was Ritchie Valens and he was the older brother, Bob Morales.

I've always included my brother in all of my training camps, but I've felt his resentment toward me. That's certainly understandable.

It's funny how it is reversed now. My brother and my father are very close. They hang out together, drink together, do a lot of things with each other. I have a good relationship with my father, but I can sense he's closer to my brother.

Back in my youth, however, my father was focused on me as I continued to have success in the ring, filling up the house with my trophies. Eventually, I would win more than two hundred.

Through all of those years, my father pushed me to run. No matter where I was in my career, he believed in focusing on conditioning from my first waking moment. Open eyes, hit the road.

When he woke up at 4:30 A.M. to leave for his job in Azusa, he would bang on my door and yell out, "I'm going to work and you have to go run."

That scenario lasted a few months and then it became automatic for me. A kid waking up at four-thirty in the morning to go running? That was unheard of. But I did it.

I can remember the sights and smells of dawn as I raced through the neighborhood, my headphones under my hood, my music coursing through my soul. I would run by a food stand and see the people huddled around in the breaking dawn, eating their tacos. I would make my way around the cemetery and back home, about two miles in all, on a run that took me about half an hour.

From age six to nine, I was fighting in the peewee division among the local kids. When I turned ten, I gained amateur status.

Throughout that period, Joe Minjarez was my trainer, as he was for all the kids in that gym. He worked us, but he made it fun. After we finished training for the day, he would give us each a quarter or thirty-five cents to use in the little ice-cream shop across the street. When the other fathers and trainers hung out in the back of the gym, drinking beer, Joe stayed with us.

At fourteen, I thought I was about to take the biggest step of my young career. Our boxing team was going to Hawaii to face a team of kids. It was beyond anything I had ever imagined, getting on a

plane and flying thousands of miles to a distant shore for a boxing match. This was something the pros did.

Six kids were to be selected by Joe. When the list was announced, however, I wasn't on it. I was stunned. Stunned wouldn't begin to describe my father's furious reaction. He just lost it.

I don't know what my father said behind closed doors with Joe, but I just shrugged and thought, *Oh well, it would have been cool.*

To be fair to Joe, there was another kid in my weight category—85 or 90 pounds—who was also very good and was older and had more experience than I did.

My father didn't want to hear it. We walked out of that gym and never returned.

We moved to Resurrection Gym, where my new trainer was George Payan. I knew all about George because he had also been at Ayudate. George was tough and ran his operation military style. It was like being in boot camp. He had us running several miles a day. There weren't going to be any side trips to get ice cream under this guy.

But he was good and he knew boxing. Though I was sorry to lose Joe, the move was the best thing for me. I was turning thirteen and needed the added discipline. The new environment was also good for me. Resurrection was a bigger gym, with more fighters, tougher competition. Some pros even worked out there, guys like Paul Gonzales, who would go on to win Olympic gold, and Joey Olivo, a former WBA light-flyweight champion. It felt like I had left the friendly neighborhood gym for the big time.

In Ayudate, I drew a crowd whenever I sparred. I was one of the stars and could justify that status by my ability to dominate just about anybody they put in there with me.

In less than a year at Resurrection, I was sparring with professional fighters. My days of domination were temporarily over.

Olivo was the first pro I faced. He was twenty-nine and had been a world champion. I was fourteen and my world was the neighborhood. But I wasn't intimidated. Close to 100 pounds by then, I loved to bang and felt confidence in my punches. That confidence soared when I found I could actually hold my own with Olivo. I would go five, six, even eight rounds with him.

I became the boy wonder in that gym, receiving all the praise my father had tried to keep from my ears.

Back at Ayudate, we would spar three rounds and then scatter. Joe would have one of us on the heavy bag, another on the speed bag, yet another jumping rope. He told us to stay at it until we got tired.

Under George, there was no such thing as getting tired. He didn't want to hear about it. And nobody went off to do their own thing. We worked out as team in a regimented routine. We would run five miles together, George included. When we jumped rope, it was for ten seconds and we were expected to increase our speed over that brief span of time. We were there to work.

After George's relentless workouts and my challenging sparring sessions, facing opposition my own age in various tournaments sometimes seemed like a break. After feeling Olivo's punches for five rounds, nothing I faced from another fourteen-year-old was going to faze me.

That began to change, however, as I moved up to tournaments like the Golden Gloves and encountered other talented fighters my age who were also being groomed for stardom. There were four of us considered the elite fighters on that circuit, myself: Shane Mosley, Pepe Reilly, and Ruben Espinoza.

Three of my five amateur losses were to those guys, and each time, it was like the end of the world.

My father didn't take it well, either, always blaming me. He said I didn't train hard enough or I was messing around too much away from the ring. It was never a case of maybe the other guy being good. It was always my fault. I think it was just that he knew how good I was, and he felt I should beat anybody I faced.

I think my father wanted to live his dreams through me. He was a fighter and my grandfather was a fighter, but they never really made it.

My father didn't do it because he saw dollar signs above my head. Neither of us imagined I'd become the Golden Boy and make millions. It was just for the love of the game, for him to see his son excel at a level he never attained.

When I was fourteen, I would go to the gym, go running four or five miles afterward, and then, when I got home, there was my father in the living room with the boxing mitts on, waiting to work with me and show me a few moves.

Father-son relationships in boxing—the father usually serving as trainer and perhaps manager as well—almost never work. The normal clash of egos in the corner along with the natural clash of egos between a father, who has wisdom to impart, and a son, who thinks he already knows it all, has too often proved disastrous.

I have to give my father credit. He never got caught up in all that. He never tried to work the corner or train me or have any type of hands-on involvement in my career. He was always content to remain behind the scenes. He let his feelings be known, but he did so from the background and I respected that.

While my peers between the ropes treated me with respect, I was sometimes treated with disdain out on the streets. As my reputation

grew, teenagers sometimes challenged me to a fight. Not gang members. As I said, they stayed away. It was just fellow students or guys in the neighborhood looking to make a name for themselves.

It wasn't going to work with me. I never used my fighting skills to confront anybody. As a matter of fact, I never had a street fight. Never.

To be honest, I was scared. I didn't know how to fight in the street. I didn't like the uncertainty of it all, the fact you could find yourself on the ground forced to wrestle rather than box, the frightening possibilities of a no-holds-barred confrontation, the realization that one opponent could quickly turn into two or three as friends piled on, and, the ultimate nightmare for me, getting hurt seriously enough to endanger my career.

Once, when I was fifteen, a couple of guys tried to throw punches at me, see what I had. I just ducked and dodged and walked away. They yelled, "Ah, you're nothing. You're not a fighter."

They could say anything they wanted, but there was no way I was going to play their game. If they wanted to put on gloves, yeah, let's go. I liked the comfort of the ring, where the rules were set and a referee was there to enforce them.

The closest I came to a street fight was a scuffle involving some friends that I tried to break up. When I got in the middle, somebody threw an elbow that left me with a black eye. When my father saw that, he gave me a big lecture on protecting the fighting machine I had worked so hard to perfect.

While I wasn't fighting on the streets, I was boxing at an ever-higher level in the ring as I reached the age of fifteen. I was traveling to Arizona, competing in regional Golden Gloves tournaments.

While that afforded me high visibility in the amateur boxing world, I was certainly no Golden Boy at Garfield High.

If I had been a leading receiver on the football team or a hot-shooting guard in basketball, I could have been a star on campus, my letterman's jacket serving as a babe magnet.

Instead, until my senior year, I was barely seen and rarely heard, even when I wasn't away at tournaments—the quiet, shy type. I had few friends and no girlfriends. While everyone else was running around, having a good time, I was off in the corner by myself in my own world.

I always got the brush-off from the in crowd. With my Olympic dream swirling around in my head, I would look at them and mutter to myself, "Okay, fine, we'll see how it all turns out." At that point, however, there was no guarantee I had anything but pipe dreams. Maybe I was fooling myself.

By my final year, however, my cover was blown. I had become a prominent amateur boxer, well known in the neighborhood, with an occasional mention in the newspaper.

That increased my popularity, but what ultimately brought me out of my shell was Veronica Ramirez, the most beautiful girl in school.

I met her through a new friend I had made, Javier, another outsider who had transferred from another school and spoke only Spanish, pushing him even further to the fringe. Our mutual isolation gave us a bond.

We both had our eye on this girl with long, flowing hair, a pretty face, a nice personality, and a gorgeous figure.

It was Javier who first talked to Veronica. When he introduced her to me, we clicked instantly.

Of the girls I dated long enough to introduce to my mom—I think it was a total of three—Veronica was her favorite. My mom would tell me, "This is the one for you."

After Veronica and I had been dating for a while, I went to

Colorado Springs to train for a national tournament. In the past, when I had a major match coming up, I had tuned out the world.

Not this time. I was so in love, I would call her several times a day—every half hour, if you can believe that, during one stretch.

My teammates got so sick of hearing about her that they would look for an escape route when I started talking about my Veronica. When I pulled out my picture of her, as I inevitably did, I would empty the room.

When I returned home, the first thing I wanted to do, of course, was see her. She lived only a few blocks away.

When I got to her parents' house, I could see something was wrong. She was obviously upset, had been crying, and was unusually quiet.

Then she dropped the bomb on me. "It's over," she said. "I can't see you anymore. I can't take this. Why did you do this to me?"

At first I couldn't even speak. Finally, the words tumbled out, my voice getting higher as anxiety gripped my body.

"What are you talking about?" I said. "I didn't do anything."

There was nothing I could say to change her mind. As far as she was concerned, we were finished.

I stumbled down the street like a zombie. I couldn't figure out how this had happened, how my dream relationship had turned into a nightmare without warning, without any discernible cause.

I was heartbroken, crushed. I had lost my first love.

A few months later, I learned the truth. One of my teammates in Colorado Springs, perhaps jealous, perhaps just mischievous, had gotten Veronica's phone number and had his own girlfriend make a crank call to her.

"What are you doing?" the girlfriend told Veronica. "This is my

man. Oscar is with me. We're sleeping together. You can't see him anymore."

It may have been a joke to my teammate, but it was a big blow to me.

I didn't talk to anybody else about what had happened, not even my parents. I didn't know how to approach them with something like that.

And just who was the prankster who had such a good time at my expense? Raúl Márquez, who would go on to win the International Boxing Federation 154-pound championship.

I was hurt that it was him because we had become good friends during the time we trained together. When we later talked about it, I laughed because I didn't want to show him that deep down, it had gotten to me. I wasn't going to tell him Veronica had been the woman of my dreams and he destroyed what we had.

I was never able to resume my relationship with her. She was a really good person who hadn't previously been exposed to that kind of thing and this whole episode was so strange to her that she didn't really want to deal with it.

It took me years to get over her, but once I did, all hell broke loose as far as my relationship with women was concerned.

As for Veronica, I didn't have the chance to see her around school again because, with my amateur career kicking into high gear, I was on the road most of the time. I did my schoolwork under the supervision of tutors in the various cities in which I competed.

Veronica crept back into my mind three years later on my way back from Barcelona after winning the gold. I imagined her in the crowd, waiting to greet me.

There was indeed a huge crowd to herald my return, but no Veronica. That's when I was finally able to relegate her to the past.

I thought to myself, *The hell with it. Look at all that I have now. Veronica? I can get five just like her if I want.*

If I had stayed with Veronica, maybe I would have ended up with her and would not be with Millie. I believe things happen for a reason.

I finally saw Veronica again several years ago at the home of a mutual friend. She's happy, married, and has kids. We said hi, laughed, and reminisced about the good old days. She told me she was happy for me, for what I had accomplished, and I told her I was happy her life turned out the way it did.

But I never told her the phone call was a prank.

While Veronica was constantly on my mind during those high school years, so were the Olympics. Remember, Paul Gonzales, who had won Olympic gold in 1984, was training at Resurrection. When he would enter the gym, it was like the president had arrived. His trainer, Al Stankie, would march in first and yell out, "Clear the place. Paul Gonzales is coming in."

As a kid, you are in awe watching a guy you have seen win the gold on TV sparring in the flesh right in front of you. If that didn't inspire you, nothing would.

My training was soon taken over by Manuel Montiel, a real character. He would sit on a stool in the middle of the ring with his mitt in the air for the kids to punch with their gloves. He loved to drink, so when one of the trainers would announce he was going out for a beer run, Montiel would reach into his pocket with his free hand to count his change while the kids slugged away at the mitt in his other hand. It was a hilarious sight.

One day, I said good-bye to Resurrection. I didn't know what had happened, but I was being transferred to a gym in downtown L.A. owned by Carl Damé, head of a construction company, and I

didn't ask questions. My father said I was switching gyms, so I switched.

Marty Denkin, a familiar boxing figure in Southern California who has served as a referee, a member of the California State Athletic Commission, and has been in several boxing movies, was a recruiter for the downtown gym. I later found out Marty had paid Montiel $1,500 to release me.

I certainly didn't get any of it. Nor did I sign anything because I wasn't going to endanger my amateur status.

I liked the gym, but it was a hassle for me to get there. I had to take a bus, and the trip took ninety minutes each way. I was traveling alone, coming home at night when it could be dangerous.

The solution was simple. I was sixteen and had gotten my driver's license. All I needed was a car. The people at the gym, anxious to keep me, agreed to get me some wheels.

I may have been a star on the amateur circuit, but I was like any other teenager when it came to getting his first car. I was fired up.

In all, gym officials were going to give out three cars to their three prime fighters. One would go to Reggie Johnson, who had won a world title. Another to a promising Mexican fighter, a professional who had had five or six fights. The third car was to be mine. Johnson was given the money for a *BMW*. The Mexican pro got an almost-new Camaro. The third car was a torn-up, old Mercury.

Marty told me my car was that broken-down piece of junk.

I was heartbroken, my jaw dropping as I looked at that hunk of rusting metal. My father looked at me, looked at Marty, and began to fume.

I knew the routine by now. My father told me to pack up my gear because, once again, we were moving on.

NOISE MONITOR
FOR BUDWEISER

I wasn't always the Golden Boy.

My attempts to earn money before I became a boxing star were embarrassing.

When I was about nine or ten, there was this older guy at the Ayudate gym—a kid around 12—who told me he was making good money selling ice-cream bars called *paletas* from a cart he would push around the neighborhood, ringing the cart's bell to let people know the paletas had arrived. My friend wanted to know if I wanted a cart of my own.

I said, sign me up. He told me I had to show up at this warehouse at six o'clock the next morning. That meant missing school, but all I could see were coins dancing in my head. Who needed school if I could become rich?

I met him after my morning run and was given fifty paletas and a cart to stuff them in. I was to sell the paletas for fifty cents each, with half going back to the dealer and the other half in my pocket.

Great deal. That meant I could make $12.50 for the day. Big money for me.

I knew I had to be careful planning my route, making sure I didn't go anyplace where I might be spotted by someone who knew me, especially my mother. After all, I was cutting school.

I figured out a route that would get me to one rival school in the neighborhood by breakfast and another by lunch. This was going to be easy money.

By the time I pushed my cart out of the warehouse, it was almost eight. An hour went by. Nothing, not a single sale. Another hour. Still nothing. People would say, it's too early, too cold, too expensive, too whatever.

I remained full of energy, still thinking I was going to sell all the paletas.

Another hour went and I was starting to get hungry. The hungrier I got, the better those paletas looked. Maybe, I thought, I'd eat one. Just one. It would be my lunch and I'd still have a profit of $12.25. Boy, it tasted good.

I pulled up to a school at lunchtime, parked my cart by the gate, and rubbed my hands in anticipation. It was getting really hot. Surely I would clean up now.

Still nothing and I was still hungry, so I ate another paleta. Down a dollar.

Enough with the schools already. I decided to go to a car wash where I'd find older people, people with money. I sold five paletas there. All right, I figured, I was rolling.

There were only a few hours left, and again, I couldn't find any customers. Depressed, I ate another paleta.

I lost track of how many I wound up eating, but by the time I brought the cart back to the warehouse, I owed them fifty cents.

Okay, so maybe I wasn't a great salesman. Next, I tried washing

dishes on the weekend at a restaurant owned by my aunts. That seemed simple enough. I would get paid with coins: pennies, nickels, and dimes. At the end of the day, it came out to three dollars or maybe three and a half.

The problem was, we would all sit down after work—my aunts, cousins, a few other people in the restaurant—and play dominoes for money. And I usually wound up losing everything I had earned.

When I was sixteen, I finally got a job that paid me decent money. Because I was an Olympic prospect by then, I qualified for an employment opportunity through USA Boxing, the sport's national governing body for amateurs.

I got $900 every two weeks for working for Budweiser, an Olympic sponsor, at their San Fernando Valley plant. At first they didn't have anything for me to do. I would walk around and say hello to the employees and that was about it. I was so bored, I would find a deserted area and sleep for two hours.

Finally, they gave me a job title. I was a noise monitor. They told me to walk around the huge complex and tell them where it was the loudest. They instructed me to use a scale of one to five, five being the noisiest. They said, write down a number every ten steps.

I went ten steps and judged the noise level at a five. After ten more steps, I figured it was down to a four, and so on. I did that all day, but I never wrote down where I had been standing. I just turned in a piece of paper with a bunch of numbers on it.

They didn't care. It was better than paying me to sleep.

I finally began to make some serious money as I moved up the ladder in the amateur ranks. I might get $1,000 or $1,500 for winning a tournament, all allowable under the rules. The most I ever

made was $2,500. I gave some of my earnings to my family and some I spent on a brand-new camera, a bike, a jukebox, and some clothes.

I was on my way to a highly lucrative career. Not bad for a guy who started out eating up all the profits.

★★★ X ★★★

SHYSTERS ON MY DOORSTEP

Amateur to pro?

Gold medal to Golden Boy?

There was no question in anybody's mind that one would follow the other, that I would cash in on my success, take advantage of the fame and fortune that beckoned to me, and pursue championship belts with all the resolve and vigor I had demonstrated on the long path to Barcelona.

Not necessarily.

What was a foregone conclusion in everybody else's mind wasn't even a strong likelihood in mine. Honestly, I didn't want to continue fighting in the days immediately following Barcelona. What for? I had fulfilled my dream. I did it for my mother and that's it.

What would I do? I wasn't sure. I was really into architecture—I've always liked drawing, creating something—so I was playing around with the idea of going back to school and taking drafting classes. I had been in a few of those in the past and had developed a passion for putting visions on paper. It intrigued me.

Everybody around me continued to whisper in my ear that I had to go on in boxing, my father being the loudest, but I remained

unconvinced, content to soak it all in and continue considering my options.

Having put so much of myself into my quest for gold, maybe I just needed a little time to step back.

Then one day, I woke up and felt like my mother was talking to me again, this time telling me to continue boxing. I can't really describe how it happens, but I often feel like my mother has guided me.

I wasn't thinking of a long career in the ring, certainly nothing like the one I've been fortunate to have. I just wanted to win a world title. A single title. That would be my dream, fulfilled separately from the one my mother and I shared. Get a world-championship belt to match my medal, make a few dollars, get out, maybe buy a house, become an architect, and live happily ever after.

The most money I could ever have imagined making in the ring? Maybe $50,000.

Believe me, I had no idea my life would turn out the way it has. Never in my wildest dreams could I have foreseen this.

Even before I decided to turn pro, I had calls left and right from everybody and their mother in boxing, from Don King to Bob Arum, to just about every other promoter and manager in the business, to those who were first trying to get into the business. Mostly, they called on the phone, including King. How they got my number, I have no idea.

At that point my father and I weren't sitting around, waiting for the next knock, saying to each other, "Okay, we won the gold. How much money can we make?"

One of those pursuing me was a fight manager named Shelly Finkel. He had been around even before I went to Barcelona, telling me he would help me out with whatever I needed.

I thought, *Cool.*

Shelly wasn't just talk. He gave me money on occasion for living expenses, for shoes to run, equipment to use, which was more than any of the others did.

When Evander Holyfield fought Buster Douglas in 1990 at the Mirage in Vegas, my father and I were Shelly's guests at the fight. Before the opening bell, my father, with tears in his eyes, pulled Shelly aside and told him my mother was seriously ill with cancer and he didn't have money for the medical bills. Shelly gave my father what he needed and later paid for him, several other family members, and Robert Alcazar to go to the Olympics.

Shelly also paid the funeral expenses for my mother. In all, he laid out about $100,000. I was extremely grateful and felt obligated to him. I thought, *This is the nicest man I've met as an amateur. He's done a lot for me. Of course I'm going to go with him if I turn pro. Why wouldn't I?*

I didn't know Shelly had paid for the funeral. That generous act wasn't relayed to me until years later. Just another example of being shielded, by my father and Robert, from the kind of information that would have enabled me to be more involved in key decisions early in my career. If I had been aware of the funeral arrangement, I would have signed with Shelly in a heartbeat.

Instead, a mob of opportunity seekers descended upon me after I brought home the gold, elbowing their way into my face with ever-more-fabulous offers. Everybody had a big-deal, million-dollar contract and all sorts of other things. Each guy told me his deal was better than that of every other guy I had talked to.

I was naive, out there having a good time and not worrying about any of it. I left it up to Robert and my father.

Robert made the decision to turn Shelly down. Robert felt the $200,000 he was offering wasn't enough. Shelly also said he would

match any other offer we received, but Robert thought we should continue to field offers. Robert was the brains behind my operation at that point. He had been a fighter, so when he warned me about the pitfalls of going with the wrong people, I listened.

We eventually repaid Shelly the $100,000 he had given my family.

Ultimately, Robert decided we should go with fight managers Robert Mittleman and Steve Nelson. They were offering a million dollars in the form of a house in Montebello, a car, and some cash, Robert told me, plus $250,000 for my first fight. Included would be $75,000 for my father and $25,000 for Robert.

My eyes got as big as saucers. Remember, I was still a nineteen-year-old who was happy if he had beer money.

The coup de grâce was the car.

They had found my weakness. A car had been a deal breaker for my father and me at Marty Denkin's gym, it was the way my future business adviser, Mike Hernández, would lure me in, and again, it was an attractive selling point in the case of Mittleman and Nelson. They got me a brand-new 1993 Acura NFX, a sharp sports car.

When I saw that car, I figured, *This is it.*

I soon learned Mittleman and Nelson, lacking the money to back up their offer, had asked Bob Arum to share some of the expense with the stipulation that Bob would become my promoter.

They went to see him at a house he was renting in Malibu. When Bob agreed to put up $250,000, Mittleman got so excited he stripped off his shirt, ran down to the water, and, with the rest of his clothes still on, jumped into the ocean.

When Mittleman and Nelson first told me they would manage my career and take care of me financially, I started to think I could make a lot of money as a professional fighter. I told myself, *This could be the start of something good.*

I did get the house, but the car was leased, and my first professional purse was only around $40,000.

Throughout my relationship with Mittleman and Nelson, it seemed I was always getting some of what they owed me with a promise that the rest was on the way.

I signed a contract with them in September of 1992, with my first fight scheduled for November 23 at the Forum in Inglewood. It was exciting to know I was going to be a prizefighter, going to test myself against the best in the world.

My first opponent, Lamar Williams, may not have been in that category, but the credentials of the Erie, Pennsylvania, lightweight were much more impressive than those normally associated with a fighter selected for a big name looking to make a big splash in his pro debut. Williams was 5–1–1. And he was twenty-four, a grizzled veteran from the perspective of a nineteen-year-old like me.

Hardly a tomato can awaiting me in the ring.

I may have been unhappy that I hadn't timely received all the promised money from Mittleman and Nelson, but they scored points with me, nonetheless, by the expenditures they made to prepare me for the match, elaborate compared to my amateur days. For a six-round fight, they sent me up to Big Bear for six weeks, got me a cabin, a chef to cook my meals, a gym run by Larry Goossen to work out in, and sparring partners, who included Gabriel Ruelas, a future champion.

Sparring with pros was nothing new for me. Remember, I had been doing that since my early teens in the Resurrection Gym.

Switching from an amateur style, geared to pile up points in a complicated scoring system, to a pro style, where power and finesse can be better integrated, was also no problem for me. I preferred the pro style from the beginning. It was tougher for me to switch to

the amateur method for the Olympics than it was to switch back for the pros.

I didn't study Williams's style as I would do against opponents later in my career. I didn't look at a tape of his previous fights, didn't even know if any existed. Robert and I just concentrated on me, on my style, on doing what had been successful for me in the past, and doing it for a longer time. Remember, I was used to fighting three rounds in the amateurs. Now I might have to double that workload. That was the biggest concern.

I trained hard for that fight. It may have been only six rounds, but the hype was what you might expect for a championship match. I didn't feel any pressure as fight time approached. Knowing that a loss at the Olympics would have destroyed my mother's dream . . . that was pressure. To this day, with all the big fights I have had, I have never again felt pressure like that.

Heading into the pros, I was thinking more about how much easier my life, and the lives of family members, would be now that I was going to make some money. The pressure of winning as a pro didn't sink in until later.

I came down from the mountains a few days before the fight and stayed in a hotel next to the Forum. There was a constant stream of well-wishers in and out of my room in those final days, but all the people and the talk and the hype failed to shatter my calm. I knew I was prepared and was confident I could succeed at this level. I was like a caged animal that had been watching his prey for some time and was ready to pounce.

When they finally opened my cage and let me out into the ex-hilarating atmosphere of the Forum, I have to admit I was surprised. Despite all the buildup, I still thought this fight wouldn't be much different from what I had experienced in the amateurs, a few

hundred people in the seats with family and friends in the forefront loudly cheering me on. Maybe there would be as many as a thousand on hand.

When I walked out, heard them playing "Sangre Caliente," a song I had requested, and saw the crowd of over six thousand . . . that's when I got nervous.

Among those in the crowd was my grandfather Vicente. What was going through his mind? He had felt the thrill of being a fighter himself, the excitement of watching his son take that same pressure-packed walk into an arena as a prizefighter, and now he was watching a third-generation De La Hoya carry the name into the ring.

I can only guess how my grandfather felt because we never discussed it or much of anything else connected to boxing. He wasn't one to get into a boxing stance and tutor me on the fine points of the jab or the left hook. He wasn't one to analyze my career. All he ever said to me was, "Good job."

He would just sit in his seat and beam. But his very presence reminded me I was being entrusted with a precious family tradition.

Once I got into the ring, that feeling faded. Beating Williams wasn't what was on my mind. I was thinking about the after-party. I was thinking about how I would get even more money for my next fight after winning this one. That gave me a feeling of elation as I listened to the referee's introduction.

Williams was an afterthought.

I was introduced as the Golden Boy, a nickname I had been hearing since Barcelona. When I stepped off the victory platform at the Olympics, my uncle Vicente, was among the many friends and relatives awaiting me.

"Hey, Golden Boy," he said.

Vicente explained that, to him, I still had the face of a young boy, but now it had a shine to it, supplied by the bright medal around my neck.

Like that medal, the name would hang on me for a lifetime.

When I started fighting professionally, John Beyrooty, a sportswriter for the old *Los Angeles Herald Examiner*, picked up the name and put it in print. It turned out there had been a boxing movie called *Golden Boy* starring William Holden, and then the name had been passed on to a colorful Los Angeles fighter named Art Aragon.

Now it was mine.

Before the first round was over, Williams was officially an afterthought. After two knockdowns, I landed four more punches— double jab, right hand, left hook—and he was out.

In making a leap from the amateurs to the pros, a leap I had heard so much about, I thought it was going to be more memorable, more difficult.

When my hand was raised, I thought, *Is that it? I should have turned pro a long time ago.*

NEON WARRIOR

While that shiny gold medal put a smile on the faces of my family and friends, to my opponents, it was a beacon to zero in on and destroy. By beating me, they could win gold in their own right in terms of larger purses along with a brighter future. So while I was using my early fights to hone my skills, the man in the opposite corner was strictly looking for blood.

I had to be careful.

At least I was getting fair reward for my efforts.

Bob Arum was first presented to me as the man who was going to financially back Mittleman and Nelson, enabling them to make good on their offer to me. Beyond that, I didn't know who Bob was.

But I came to appreciate him very quickly. While Mittleman and Nelson were in arrears with my first purse, that changed when Bob took over as my promoter. I'd be told what my purse was going to be, and sure enough, when the fight was over, that's what I'd get.

My second fight was against Cliff Hicks in Phoenix. I was on the undercard with Michael Carbajal in the main event.

After showing in my first fight that I had the power to be successful at the pro level, I next wanted to demonstrate I could be a

two-fisted fighter. Having relied primarily on my left hook in the past, I concentrated in training camp on using my right hand more frequently and effectively. It paid off. I knocked Hicks out with the right, again in the first round.

Two fights, two rounds. Not bad.

My next opponent was Paris Alexander. I was about as concerned as I would be if I was fighting Paris Hilton. I didn't study film of my opponents in those days or worry much about their style. I stopped Paris in the second round in a match fought at the Hollywood Palladium.

In my fourth fight, I was facing an opponent named Curtis Strong, fighting live on network television in San Diego on a Saturday afternoon. It was a huge date for me at that point in my career, a great opportunity.

Everything was going great until the Wednesday night of fight week. That's when I felt this bump on the back of one of my legs. It really hurt. It felt hard when I touched it, so I figured it must be a bad bruise.

I told Robert we should get a doctor to look at it. On Thursday night, a local physician agreed to make a house call at the cottage I was staying in.

He told me I had a really bad ingrown hair on my leg and he wanted to operate.

By that time, my leg had gotten so bad that I was limping, so I told him to go ahead and do the surgery. I couldn't fight like that anyway. If we had to, we would postpone the match.

I asked the doctor how he was going to do it. Were we going to go to his office, or to a hospital?

"No, no," he said. "I can do it right here in the room."

Uhhh, no.

Next thing I know, he's pulling out his bag, telling me to lie down on the bed, and giving me a towel to bite on.

For some reason, I agreed to do it. Don't ask me why.

Right away, I was sorry. He literally carved out a hole in my leg the size of a nickel, three-quarters of an inch deep. I was in excruciating pain. He stuffed some gauze in the incision, put bandages on it, and taped the whole thing up.

The doctor told me it was going to be painful for the next few days and he thought I should postpone the fight.

Mittleman and Nelson, who were both in the room, blew up.

"What are you talking about?" they said. "He has to fight."

I didn't say anything while they were there. But once they left, I told Alcazar, "I can't fight. I can't even walk."

It was so bad, the doctor had left me crutches. How was I supposed to train?

Robert had no answer. The next morning, Friday, I didn't go on my usual run when I woke up.

While I was sitting around the cottage, I received a call from Mario Lopez, someone I knew at that point only from seeing him as an actor on TV. He lived in San Diego and had heard I was there. He came over with his family and we took some pictures together.

I told him I probably wasn't going to fight because I had had surgery on my leg.

He said if that was the case, why not go over to Tijuana? That sounded pretty good. We were practically next door.

We didn't get over the border until Friday night. It was pretty funny. Here I was still using my crutches.

But we had a good time, I might have even had a beer or two, and we didn't get back until four or five in the morning. It was so late, I wound up staying at Mario's place.

When I woke up, I went back to my cottage, and who was waiting for me there? Yep, both Mittleman and Nelson.

They screamed, "What are you doing? What's going on?"

It was about seven or eight in the morning by then and the fight was at two in the afternoon.

Didn't matter where I had been or what time it was, they said, I had to fight. This was national television, they stressed. They told me they had talked to Bob and he felt the same way.

They finally pressured me into going ahead with the match. I wore bicycle shorts under my trunks to make sure the gauze and tape didn't fall off, a real possibility once I started sweating.

I never did get any additional rest that day, but once the bell rang, it was like I had had eight hours of sleep. It was amazing.

I was lucky enough to stop Strong on a TKO in the fourth round.

Still, I wouldn't recommend having surgery on your hotel bed.

My fifth fight was De La Hoya–Mayweather. That's right, before Floyd Jr., before the richest fight in boxing history, before an event that resulted in 2.4 million pay-per-view buys, there was another De La Hoya–Mayweather battle, cheaper to watch, harder to sell, tougher to remember.

That's because the opponent was not Floyd, but Jeff, a brother of Floyd Sr., my future trainer.

At the time, though, it was huge for me, my first real test, I was told. Mayweather was twenty-eight, had been in twenty-seven fights and was 23–2–2. Eight years younger and having fought twenty-three fewer fights, I seemed like a mere boy going in against a savvy, skilled veteran. I was confident, however, that there was no such disparity in our respective skill levels.

As would be the case fourteen years later, that De La Hoya–Mayweather match was also held in Las Vegas. It was the first time

I saw the neon lights of a town that would become synonymous with my fights.

My grand arrival in the lobby of a glitzy, high-rise palace, towering over the strip, a two-story penthouse suite awaiting me, was far in the future. When Mittleman and Nelson brought me to Vegas for that 1993 fight, they put me in a rinky-dink motel. Really nasty. My room was way in the back, practically out in the desert.

Fortunately, the manager of the establishment recognized me. "Hey, champ," he said, "what are you doing here? You're a gold medalist. You should be staying in a suite in some nice joint."

He was under no illusions about the quality of his place.

I tried to act like it was no big deal, but he was insistent.

"Let me take care of you," he said.

That he did. The next thing I knew, I was in a penthouse suite in the Frontier Hotel, living like a king. I could order anything I wanted from room service. That was big stuff for me in those days.

Mittleman and Nelson knew nothing about this until I was already settled in my luxurious new accommodations. They are my managers and I needed a motel manager to upgrade me.

Once they found out about it, Mittleman and Nelson, who were still in that dump, told me they needed to move over to be with me.

"Fine," I said, "check with the guy at the motel. Maybe he can take care of you, too."

I had gotten a taste of the good life that would await me in Vegas in future years, but the city's main attraction remained tantalizingly out of reach on that trip. Being only twenty, I couldn't get into the casino.

I tried, oh, how I tried. I would kind of slink in and sit down quickly at a slot machine so as not to draw attention to myself, but that's exactly what I was doing. I was quickly escorted out. Gold

medal? Undefeated fighter? Motel manager with connections? The pit bosses were not impressed.

I had better luck in the fight against Mayweather. He had the family traits I would come to know so well: slick moves, fancy defense, sneaky fast.

For the first few rounds, it was difficult for me to figure him out. I had come up against the first real challenge of my career. I stayed aggressive, plunged forward, and got to him in the fourth round, winning by TKO.

Bob Arum and his matchmaker for his Top Rank Boxing organization, Bruce Trampler, were not putting me in against the typical lineup of stiffs most young prospects get to learn against. I was being moved fast, but that was fine with me. Having sparred with pros all the way back to my teens and having battled the best amateurs in the world en route to Olympic gold, I wanted new challenges.

That I got. Less than a month after beating Mayweather, I found myself in Rochester, New York, facing Mike Grable, who was 13–1–2.

That was the first time Trampler supplied me with tapes for Robert and me to study. As the talent level of my opponents continued to rise, it was time to stop focusing solely on myself.

It had seemed strange traveling across the country for the first time as a pro to face Grable, but I soon felt like I had never left L.A. People recognized me from the Olympics everywhere I went in Rochester. When I entered the arena, it seemed like everybody was rooting for me.

Grable was as good as his record, taking me to the limit for the first time as a pro. I won an eight-round decision. He was strong as a bull, and though I knocked him down twice and got a standing eight-count in the final round, I just could not knock him out.

It would have been different if I had been able to wear Reyes gloves, which are geared for power. Instead, all they had were Everlast, which I wore for the first, and last, time.

No matter who I was up against in those early days, I felt I had a guardian angel accompanying me into the ring. That angel's name was Cecilia Gonzalez De La Hoya. After every fight, I would thank my mother for watching over me, guiding me, and protecting me.

With my next opponent, Frank Avelar, I ran into my first trash talker. He taunted me in the days before the fight, his confidence bolstered by a 15–3 record. Avelar mocked my Golden Boy nickname and vowed to knock me out. And it wasn't only him. He had a big, noisy family there trying to get into my head as well.

While Avelar and his family were annoying, I had a bigger problem for that Lake Tahoe fight: my weight. It was the first time I struggled to make 130 pounds since I had turned pro. It got to the point where all I would eat for breakfast was a couple of egg whites, followed over the ensuing hours by a minimal amount of water and a few oranges. That would be it for the whole day.

My crash diet took care of my weight problem and Avelar took care of my motivation. He wouldn't shut up at the press conference. I kept my cool, but deep down inside, I was so angry that all I could think about was knocking him out.

Outwardly, I was polite and wished him luck. He needed it. I stopped him in the fourth round. His family didn't have a thing to say after that.

Back then, I wasn't a main-event fighter, my match usually staged after the main event. Those fights are called crowd chasers, but in my case, they were crowd keepers because there were very few empty seats for my matches. My name was always on the marquee

because there was no fighter better known than I was in the entire show.

That wasn't, however, the case for my next fight, a match against Troy Dorsey in Vegas. In the main event that night, George Foreman was fighting Tommy Morrison.

I always fought whoever they put in front of me, but Dorsey was the first guy I thought might be a little too tough for me, considering it was only my eighth fight. It wasn't his record that got my attention. He was 13–7–4. But he had been in there with guys like Jorge Paez, Jesse James Leija, Kevin Kelley, and Calvin Grove.

Every time Dorsey threw a punch, he made a grunting sound that could be heard through much of the arena. He got that from his days as a kickboxer.

I decided I had to quiet him down early. His kickboxing and the fact that he was used to going twelve rounds meant he was well conditioned. The longest I had ever gone was eight rounds, and that was on only one occasion. I didn't want conditioning to be a factor late in the fight.

It wasn't. I came out aggressive, looking for an early knockout. It was a perfect approach against Dorsey, who had an in-your-face style as well, but was so cocky that he kept his hands low. With a target like that, how could you miss? I didn't, getting in several clean shots.

Nothing. I couldn't move him. He just kept coming. And I kept swinging.

Finally, I reached back, way back, like a golfer extending his backswing, and put everything I had behind a left hook that landed squarely on Dorsey's right eyebrow, splitting it wide open, blood spewing.

The ringside doctor ruled that Dorsey could not go on and I had a first-round TKO.

But it was a hollow victory because that final blow injured ligaments in my left hand, causing damage that would plague me, on and off, for some time.

Still, I was back in the ring two months later in Bay St. Louis, Mississippi, to fight Renaldo Carter on the undercard of a Roy Jones fight.

I had thought the difficulties with my hand were over when the pain subsided after a few weeks, but the week before the Carter fight, I reinjured it while sparring. I didn't tell anyone, not even Robert. I figured I'd find a way to compensate.

Robert, figuring my hand was still tender from the original injury, tried to add extra gauze when he put the wraps on in my dressing room prior to the fight. There is always an observer from the opposing camp to watch the process. Carter's man alertly spotted Robert's tactic and protested. Robert had to tear the wraps off and start all over again.

Robert tried to shrug the whole thing off, telling Carter's man it wouldn't make a bit of difference. His guy was still going down. I tried to put up a brave front as well, but deep down, I was concerned because my hand was hurting.

I really got worried once the fight started because I couldn't throw my trademark jab. Every time I flicked my left wrist, the pain shot through me. What was weird was that there was no pain when I used that left hand to throw a punch I called "my 45," because it came in at a 45-degree angle, somewhere between a hook and an uppercut. I guess it had something to do with the angle of my arm. All I knew was that in that position, my left hand could still be effective.

With a dependable alternative, I gave up on the jab, relied on the left hook and the 45 punch, and used my right hand as well to

produce on-the-button combinations. I knocked Carter down three times, stopping him in the sixth round.

For each fight, I returned to Big Bear to train, but with my next match in Beverly Hills against Angelo Nuñez, my training site was moved to an El Monte gym near where Robert lived. Being back so close to home, I could have slept in my own bed, but Robert was afraid that would make me too comfortable so close to the fight, so I was put up in a hotel in Hollywood.

If Robert, or anybody else around me, had known what was going on, they would have preferred sending me home. Every night after training, I would go back to my hotel, invite my girlfriend over, and have her spend the night. At one point she was with me for two weeks without going home. What a training camp.

I wasn't worried. I had fought nine times and had eight knockouts. I had started to think I was invincible, so I slacked off.

I soon learned how foolish I had been. When I stepped into the ring against Nuñez, I was not 100 percent. Not close to it. I was feeling bad, weak.

I felt even worse when I learned the fight, a black-tie charity event in the ballroom of the Beverly Wilshire Hotel, would be watched by a celebrity-filled audience, including Danny DeVito and Tony Danza. Great, here I was with a chance to show the hometown stars I was a rising star myself and I might have blown it.

When I struggled in the first few rounds, Robert was exasperated. "What's going on?" he asked me in the corner. "Wake up. This is not you."

No kidding.

For the first time in my career, I started to panic. In the past, I had always remained confident because I knew I had the talent to

overcome whatever was thrown at me. But this time I had overcome myself because of my late-night antics.

I could feel the fatigue draining me. Once again, I reached back for my 45 and *wham*, just like the Carter fight. Again, a crushing blow. Again, a skin-shattering cut, this time over the left eye of my opponent. Again, the fight was stopped, this time in the fourth round. Again, my hand was hurting.

As I sat in my dressing room, my left hand immersed in a bucket of ice, I felt more relief than elation. If that cut hadn't opened up, who knows what would have happened.

I never told Robert about my secret roommate, but the important thing was, there would never again be anything to tell. I had dodged a bullet that would have resulted in a self-inflicted wound. I was not invincible. I would not soon forget the helpless feeling of trying to fight through fatigue on weakened legs. It would be a while before I violated the rules of training camp again.

I had another unpleasant experience in my next fight, my ninth and last match of 1993. For the first time I involuntarily visited a place I had sent so many others to—the canvas.

Moving up to the semimain event, I was facing Narciso Valenzuela in Phoenix. He didn't have a great record (35–13–2), but fifty professional fights meant a great many lessons learned.

I learned one myself when I got caught with a left hook and went down. I wasn't there long. It was a flash knockdown. I wasn't hurt, just embarrassed. And angry.

I felt like it was do-or-die. After I got up, I charged at Valenzuela, threw what seemed like a dozen combinations, and knocked him out, still in the first round.

At the time I thought the knockout was the biggest thing to

occur that night. Looking back, I realize the more significant moment happened afterward, a moment I couldn't appreciate until later. I was told to stay in my trunks because someone wanted to shoot some photos of me. Still sweaty, I was led over to a short, older man.

"I want to take a few pictures of your face, capture this moment as you come out of a fight," he told me. "My name is Richard Avedon."

I didn't know who he was, didn't dream he was a world-famous photographer, didn't understand what an honor it was for him to focus in on me. This was a man whose subjects ranged from Pablo Picasso to Jacques Cousteau to Lena Horne. And now he was turning his lens on me. I had transcended boxing without even realizing it.

The Valenzuela fight was my last under Mittleman and Nelson. I fired them because I was fed up.

I was given a suite for a fight in Phoenix and they weren't. Next thing I knew, they were in the suite and I was in the room meant for them. It must have slipped their minds that I was the one doing the sweating and the bleeding. I would be given meal tickets prior to a fight and they would take them.

It got so bad, Robert and I met with Bob to complain about Mittleman and Nelson. Bob was sympathetic, but, he said, as my promoter, he was reluctant to get involved with my managers. Ultimately, he agreed to do so and told Mittleman and Nelson I was extremely unhappy. They laughed it off, told Arum he was either making up the complaints or imagining them, and assured him everything was fine.

Mittleman and Nelson knew full well, however, that everything wasn't fine. When I kept asking questions, they asked themselves, who could control me?

The answer was obvious: my father.

They cut him in on the action, giving him 10 percent of their take, with the understanding that he would keep me in line.

It worked for a while. Not knowing about the secret arrangement, I listened to my father when he tried to calm me down.

But it only worked for so long. Then, toward the end of 1993, Mittleman and Nelson made their final mistake. Worried by the knockdown administered to me by Valenzuela, they brought in a trainer named Carlos Ortiz, a former champion with a brawling style.

They drove him up to my Big Bear training camp and told me he would work with Robert. Robert was fuming and I was just as unhappy. Especially when Ortiz tried to change my style in sparring to a face-first approach. Receive ten punches, then move away. That might have worked for a toe-to-toe fighter like Ortiz—he won championships at 140 pounds and twice at 130 and paid for it judging by the scars on his face—but it wasn't going to work for me.

Not only was I getting hit a lot, but I hurt my left hand, which ultimately forced me to cancel my next fight. I'm not exactly sure when the injury occurred, but I know I worked extensively on the heavy bag under Ortiz, something I wasn't accustomed to. The heavy pounding might have caused the problem.

What I had always appreciated about Robert was that he worked with the successful style I had already developed rather than trying to change me into his image, as Ortiz was attempting to do.

Robert and I started to ignore Ortiz and then, one day, we just refused to show up at the gym.

Mittleman and Nelson got the message: Ortiz was gone.

Then they got the whole message: They, too, were gone.

They started to get the hint when I made it plain I no longer wanted them in Big Bear, and then stopped talking to them altogether.

I called my father and told him.

"But they could ruin your career if you try to get rid of them," my father warned. "Look at what they are doing for you."

Oh, and by the way, he admitted, I also have a piece of you through them.

I wasn't really angry with him. I understood. Those guys had not talked my father into being against me, but merely into keeping me in line.

The line ended right there. We wound up reaching a settlement with Mittleman and Nelson.

Bob agreed with my decision to cut them loose.

"It had gotten to the point," Bob said, "where we were arguing more about meal tickets and suites than fights. It was hard to imagine. You have an Olympic gold medalist and you take his suite? How stupid is that?"

★ ★ ★ XII ★ ★ ★

STARVING FOR
RECOGNITION

These days, it seems, after fighters win a few matches, they already start talking about titles, start measuring themselves for championship belts.

I wasn't like that. Yes, I wanted to eventually place a championship belt beside my gold medal, but because I felt I was still learning my way around the ring, still adding to my arsenal of pugilistic weapons, I was content by the end of 1993 to remain an undercard fighter. I was undefeated through eleven matches and had won ten by knockout, but there was plenty of room for growth in my mind.

The problem was the potential growth in my weight. In my eleven pro fights, I had varied from 131 to 138 pounds. With my height at a little over five-ten, I figured I could eventually go as high as middleweight (160 pounds) as I aged. So if I could win a title at 130, I had a chance to pull off an unprecedented feat: championships in six weight classes (130, 135, 140, 147, 154, and 160).

I was still skinny enough to get down to 130 pounds, but not for long, even if I starved myself. So there was some urgency to get that initial title fight at 130.

First, I had a match scheduled against José Vidal Concepcion in Madison Square Garden, but that match had to be canceled because of pain in my left hand, the result of my disastrous sparring sessions under Carlos Ortiz.

When I called Bob Arum to tell him I couldn't fight, he went wild, as only Bob can, spewing out four-letter words and demanding I get in the ring anyway.

When he saw that wasn't going to work, he sent me to my orthopedic doctor, Tony Daly, who determined I had a hairline fracture. My parting gift from the Carlos Ortiz school of boxing.

When Concepcion went ahead with that fight date anyway, against a replacement opponent, I watched it on TV. The cameras zoomed in on outraged fans who held up signs mocking me for my absence.

What could I do? Even with all my success, I wasn't going to get into the ring with one hand tied behind me.

HBO had become interested in signing me to a long-term deal, which added still more impetus for a title fight. The name that kept popping up was Genaro "Chicanito" Hernandez, the WBA super featherweight champ.

Arum and Trampler weren't sure I was ready for Hernandez, but they liked the idea of a title shot. As an added touch, I was to fight at the Olympic Auditorium, where both my father and grandfather had boxed.

My opponent would be 130-pounder Jimmy Bredahl, a slick southpaw from Denmark with a 16–0 record, and the prize would be the WBO super featherweight championship.

James Toney was fighting Tim Littles on that same card for the IBF super middleweight title, but the promoters made a big, old fuss about my fight, turning it into the main event. I couldn't be-

lieve that, not with a guy like Toney on the card. It was exciting for me.

I had struggled again to make 130 pounds and, through my all-too-familiar starvation routine, had reached my goal by the time I arrived at the weigh-in the day before the fight. As it turned out, there was no weigh-in. Bredahl's handlers had protested, and rightly so, that under WBO rules, the weigh-in must occur on the day of the fight.

Everybody on my side raised hell, but that was clearly the rule. It was a crafty move on the part of Bredahl's handlers. They knew I had trouble making weight, and if they could get into my head by throwing off my schedule, by forcing me to starve myself for another seventeen hours, it could affect the fight.

Normally, after a weigh-in, a fighter replenishes his body with the proper food over the ensuing twenty-four hours, regaining valuable pounds, bringing himself back to full strength.

Not me. Not that time. I had to continue on my no-exceptions diet until morning, not a single morsel of food passing my lips.

I made weight all right, and then some. I came in at 128 pounds, but I was weak as hell. Art Aragon, the old L.A. fighter and the first to carry the nickname Golden Boy, once joked that he had lost so much weight in training, he was the first fighter to be carried into the ring. That's how I felt. Even my complexion had changed, a yellowish tint making me look sickly.

When I got off the scales, I was ravenous. I wanted to eat anything I could get my hands on, even though I knew that wasn't good for me. I gorged on a cheeseburger, fries, and a brownie with ice cream on it. Not exactly a weight watcher's diet, but I didn't care.

Strangely enough, it didn't hurt me. By fight time, I felt great. Maybe it was the adrenaline fueled by the title shot, the HBO

cameras, and the knowledge that I was fighting in the same build-
ing where two previous generations of De La Hoyas had fought.

That put added pressure on me because I didn't want to disap-
point my father or my grandfather. Not that I knew how they felt.
Neither one of them had talked to me about their fights at the
Olympic.

Walking into that building, I remembered being brought there
by my father as a little kid. While he was watching the fights, I
would join up with other kids from our gym and we would roam
around the building, encountering groups of youngsters from other
gyms, resulting in a lot of yelling back and forth over the superiority
of our respective places.

The task at hand, however, brought me back to reality. Bredahl
may have come in unbeaten, but he went out with a loss. The fight
was surprisingly easy for me, considering my prefight weight prob-
lems. I knocked Bredahl down in both the first and second rounds,
and on the advice of the ringside physician, the fight was stopped at
the end of the tenth round, giving me my first professional title. I
think the pressure I had put on myself over carrying the family name
back into the ring at the Olympic had worked to my advantage.

The feeling of winning a championship belt couldn't compare to
the gold medal. That was the highest moment of my life and always
will be. Still, in less than two years, I had reached my objective of
turning pro by strapping a championship belt around my waist, and
that was an impressive accomplishment. But not impressive enough
to make me content. I wanted more. I wanted bigger fights, better
opponents, more titles.

I loved boxing as a professional and the money wasn't bad, either.
For the Bredahl fight, my purse was $1 million.

Soon, however, I let the success and the money and the accolades

go to my head. I started to think of myself as this little celebrity. I got caught up in trying to build on that and market myself to attract an even bigger following.

My first title defense was against Giorgio Campanella in Vegas. I should have been focused on my opponent since he had a 20–0 record with fourteen knockouts. What was I focused on instead?

The music that would be played when I entered the arena and paraded into the ring. I chose "Hero" by Mariah Carey because that's the way I saw myself. I wanted my entrance to be a big production and I played it for all it was worth, waving to the crowd, blowing kisses, shaking hands. You would have thought I was running for office.

I was so busy playing the role of the hero that I kind of overlooked the fact that there was a guy waiting in the ring to take my head off. Watching me strut in probably made him even more anxious to spoil my act.

Campanella got my attention in the very first round by hitting me with a left hook he seemed to throw from left field. It sent me crashing to the canvas.

Fortunately, it was only a flash knockdown, but it got me refocused. I came out angry in the second round, angry mostly at myself, but I took it out on Campanella. I knocked him down in the second and, in the third, hit him so hard with a left hook that rather than going down, he wobbled all over the ring. I had never seen anything like it. I feared I had somehow messed up his brain.

Campanella was able to continue after a standing eight-count, but before the round had ended, his corner threw in the towel.

I had a title, an unbeaten record, and a lot of fans in my little corner of the world. My next fight would be a chance to expand my horizons, both geographically and artistically. I was to fight Jorge

Paez, El Maromero, one of the most colorful and popular boxers ever to come out of Mexico, for the vacant WBO 135-pound title. Even though the fight was in Las Vegas, this was to be my coming-out party in Mexico. It would give me exposure to die-hard fans below the border, present me with my first chance to be taken seriously in the land of my ancestors.

My reception, however, was not exactly what I had hoped for. Many Mexican fans saw me as the enemy. Paez was the established fighter, I was the young lion. He was a true Mexican fighter, I was a Mexican-American.

Paez would wear outlandish outfits and do somersaults in the ring, an entertainer as much as a fighter. That's not to say he couldn't fight. When I met him in July of 1994, he had a 33–4–3 record and could still hold his own, if not defeat, elite boxers.

He had me worried. For the first time I was facing an opponent I thought had a good chance of beating me. I think that had more to do with who he was than what he possessed in terms of skill. He was the first opponent I faced who I had watched and admired as a teenager. And it wasn't just me. My whole family loved Paez. Now I was going against him.

It was hard to shed that image of being a teenager and watching someone you regard as a heroic figure. You become an adult, that figure ages, and reality catches up to the image. Still, it's not so easily discarded from your mind.

For me, it only took a few punches to rid myself of that image. I was expecting a war—at least that's what it looked like on paper—but when I went to my trusty 45, I caught Paez flush on the chin in the second round. He did a flip and landed on the canvas. This wasn't one of his planned theatrical flops. This was a flop from which he couldn't get up.

I had a second belt for a slightly bigger waist. I was a champion at 135.

While I had had my doubts about that opponent, TV boxing analyst Larry Merchant expressed his doubts about my ability to effectively handle my next opponent, Carl Griffith. Griffith had a 28–3–2 record with one no-contest and, according to Merchant, perhaps the right stuff to take the shine off the Golden Boy.

That made it personal for me. I told Larry, "If Carl touches me with one punch, ONE PUNCH, I will walk home from Las Vegas to Los Angeles."

I flew home.

Griffith didn't lay a glove on me. I knocked him down twice and stopped him in the third round with a clean left hook. From the ring, I glanced down at Merchant sitting ringside and gave him an I-told-you-so look.

There was a strange connection with my next opponent, a tough-as-nails fighter named John Avila. The last name was familiar because my half brother, a son my father had before he married my mother, is named Joel Avila.

"Oscar," Joel Avila told me, "you know that's your second cousin you're fighting. He's my first cousin."

Blood is blood in the ring, whether or not it comes from a common source. I TKO'd John Avila in the ninth round, referee Raul Caiz stopping the fight because Avila had a welt over his right eye that had grown to the size of a tennis ball.

As we embraced, Avila said to me, "Good fight, cuz."

There wouldn't be a lot of smiles the next time I entered the ring. I was about to step up to another level of competition beginning with John John Molina. After I put Molina down in the first round, he resorted to dirty tactics, hitting me in the back of the

head and holding a lot. I found myself struggling to a greater degree than ever before.

If I had had more experience, or a more experienced trainer, I would have realized I was playing into Molina's game by engaging in his wrestling tactics. Instead of being hung up on showing I could match his strength—purely an ego thing—and his disregard for the rules, I should have moved outside and used my jab and my reach to pile up points.

It would have been a good time to go to plan B. But with Robert as my trainer, I didn't have a plan B. It was the first fight where I realized I had a serious problem in my own corner. The fighter is supposed to be calmed by the trainer in tough situations like that. In my case, I had to calm Robert, who was sweating more than I was. I think he was becoming overwhelmed as my fights got bigger and bigger. He just couldn't handle it.

Robert got into such a panic that he just started babbling incoherently as I sat on my stool awaiting what I had hoped would be a new strategy. It wasn't English, it wasn't Spanish. It was Alcazarish.

I survived to win a decision over Molina, but the experience made me realize, as I moved up to stiffer and stiffer competition, that I couldn't depend on my trainer to elevate me to an ever-higher level of expertise. I would be on my own.

THE MEN IN MY CORNER

Managers guide you, promoters hype you, publicists protect you, family and friends support you, and the media portrays you to the public, for better or worse.

But nobody is as important to a fighter as his trainer. It is the trainer who is with you on some lonely road in the middle of nowhere before the sun has peeked over the mountains, running with you or driving beside you, pushing you beyond exhaustion to exhilaration. It is the trainer who analyzes your opponent and designs your strategy. It is the trainer who runs your sparring sessions, determining the number of rounds, the weapons in your arsenal to be tested, and the sparring partners best suited to administer that test. It is the trainer who often works the mitts and wraps your hands. It is the trainer who cooks your meals and monitors your weight, keeps your mind focused and your body tuned.

And when all the other members of your entourage have exited the ring and the opening bell sounds, it is your trainer alone who will return to work your corner, with help if needed from a cut man, keeping your engine running, your spirits elevated, and your game plan on track, reminding you to throw your jab, launch your hook,

and stay alert at all times. It is his voice you hear in the heat of battle, his advice you heed. To a trainer, every opponent is beatable, every round winnable, and every punch thrown by the other guy avoidable.

When you win, your trainer is the first guy to hug you. When you lose, he's the last guy to leave you.

Over the years I've had all sorts of trainers, young and old, reserved and flamboyant, old school and New Age, each one indispensable at the time and unforgettable to this day.

I was happy Robert had stayed on as my first professional trainer after Barcelona because we had clicked from the beginning.

Robert was the best fighter in the world with his headgear on, according to his old trainer, Joe Chavez. Once the headgear came off, however . . . not so good.

That didn't affect me. Robert wasn't there to be my sparring partner. As a trainer, he was intense, worked well with the mitts, pumped me up in the corner, and was a likable guy, but his real specialty was the hand wraps. He did a great job wrapping your hands. That may sound like a pretty basic thing, kind of like tying your shoes if you're a baseball player, but believe me, it's anything but basic. A good hand wrap can protect those hands from injury, make you feel comfortable when the gloves are on, give you confidence, and allow you the freedom of movement to deliver crisp, sharp punches.

Ask any fighter. It starts with the hand wraps.

Perhaps because he was already friends with my father, Robert blended in nicely with our family right away. He became like an older brother to me. I felt he was looking out for me.

Slipping into the ring as a professional felt very comfortable with Robert in my corner because there wasn't much change from my

glory days as an amateur. My natural style was geared to the pro game, so we had used that style whenever possible in my amateur matches.

I take my hat off to Robert for that. He saw I had an effective style that fit me and he left it alone. Some trainers try to mold you into their concept of a successful fighter. It's either a case of the trainer feeling he knows better or wanting to stamp you with his style so he can take full credit if you succeed. That wasn't Robert. He saw the talent I had and realized that if I was indeed successful, plenty of credit would flow his way.

The flip side was that while he didn't change my style, he didn't improve it, either. We were just doing the same things over and over. I was getting in great shape and was focused and hungry for victory, but he wasn't giving me any additional tools to achieve those victories. While I appreciated the way he wrapped my hands, I desperately wanted him to show me new, innovative ways to use those hands.

By the time I signed to fight Rafael Ruelas in 1995, I had become predictable in the ring. When that happens, you leave a smart opponent all sorts of countermoves.

My father realized what was going on. Robert may have been his friend, but I was my father's primary concern.

Still, our mutual recognition of Robert's limitations remained unspoken between us. We were very loyal to Robert and tried to hold on to him as long as we could.

One side of me said, "I've got to change trainers. I've got to do something." The other side of me was saying, "I'm going to be nice to him because I genuinely like him. Why change? It would be hard on him. If I fire him, what would he do?"

It was becoming more and more difficult to stay with Robert,

though, as my opponents became tougher and tougher. I had to grow.

Bruce Trampler, Bob Arum's matchmaker, was the first to finally verbalize what more and more people around me were thinking. Maybe you should consider changing trainers, he told me. He would suggest another trainer, and the next day, that guy would be invited to my camp to observe.

The media would also bring the subject up, questioning the development of my defensive skills and whether Robert belonged in the corner of a world-class fighter, a level many felt I could attain with the right man tutoring me.

Robert was hardly oblivious to what was going on. He had always worried about being replaced, right from the beginning. From my first pro fight, he was looking over his shoulder because, I think, he knew he was limited in what he could offer to a fighter with so much undeveloped potential.

He never got over that jumpiness, the feeling that people were out to get him, that his replacement was always about to walk into the gym.

Robert's insecurity created friction between him and me. We never talked frankly about it because I felt it wouldn't have done any good. It would just have made him feel bad. He wasn't going to admit that he wasn't qualified to take me to the top, so what would be the point of confronting him?

As long as I was winning and moving up the ladder, I stayed with the status quo.

That didn't sit well with Arum and Trampler. They became more and more insistent that something be done.

When I continued to resist, they talked to my father and, even-

tually, even to Robert himself. They suggested a second trainer be brought in. Not to replace him, Robert was told. Not even to have the final say. Just a second pair of eyes to analyze and suggest.

Robert didn't see it that way. He went straight to my father, telling him Arum and Trampler were trying to undermine him. My father listened politely, but he wasn't about to buck Arum and Trampler if it wasn't in my best interests.

After I struggled to the win against Molina in 1995, the win in which Robert became incoherent in the corner, I gave in to the pressure. I wouldn't release Robert, but there would be a second trainer for my next fight, the match against Rafael Ruelas.

Jesús Rivero was brought on board.

Rivero, a defensive specialist, was a sixty-four-year-old Mexican native best known for training flyweight champion Miguel Canto, but that was mostly in the seventies. Rivero was retired, but was coaxed into returning by Rafael Mendoza, a boxing agent used by Bob Arum.

Robert was assured he would remain the head trainer, still the man calling the shots. Rivero is coming in just to tweak things a little bit, he was told. Not only will Oscar benefit from this, but you will as well.

And as an added bonus to keep peace in training camp, Rivero would stay out of sight of the press so Robert would still be the public face of the camp, enabling him to save face.

To Robert, it was a slap in the face, one he couldn't forget. Three years later, long after Rivero was gone, Robert cornered Mendoza in El Paso where I was fighting Patrick Charpentier, cussed Mendoza out, and then started choking him until he was finally pulled off by Eric Gomez.

It was really unfair to accuse Mendoza of undermining Robert. Mendoza merely suggested Rivero as someone who could help Robert out, not take his place.

Rivero's approach was going to be twofold. He was going to work on my defense and my mind. Nicknamed The Professor, Rivero was equal parts trainer, educator, and philosopher. He felt an increased awareness about the world outside of boxing would make me not only a more well-rounded person, but a better boxer as well, more deft in handling the mental aspect of my sport. The Professor wanted me to read Shakespeare, study religion, and become well versed about a variety of topics. He always had a book in his hands and he always wanted to put one in my hands as well.

Robert was infuriated. In the past, he had been able to question the credentials of any prospective trainer, shooting down his theories on boxing. But Shakespeare? What could Robert say about that?

He tried. Robert would blast The Professor again and again to my father and me, saying, "We don't need this. Look what is happening to us."

It wasn't as if he was talking behind The Professor's back. He and The Professor had been in each other's face since the day The Professor arrived.

I didn't like it. Instead of positive vibes, Robert was now bringing negative feelings into camp. It was distracting and disheartening. I would have a good day training and sparring, excitement coursing through my body. Then here would come Robert with a long face, telling me, "You didn't look good today. You are getting hit a lot in sparring. What are you doing? Your style is changing."

My style was changing because I was learning new things. Finally.

Robert was in denial and he was bringing me down with him. The last thing a fighter needs in camp, especially when he's feeling good about himself, is to have his trainer tear down those feelings.

"Look," I told Robert, "he's teaching me. He's probably teaching you. I know you don't want to accept it, but this is the way it's going to be."

For the first time Robert could see he wasn't going to poison my mind about The Professor. It was either get with the program or get out.

Robert got with the program.

Seeing the bright lights of my first blockbuster fight on the horizon, a match against Ruelas, Robert wasn't about to step back into the shadows.

I was stepping onto a world stage for the first time since Barcelona. It was overwhelming in the beginning, but I would eventually come to feel as comfortable and confident on that stage as I did in my own gym.

While Rafael and I took radically different routes from Southern California to the outdoor ring at Las Vegas's Caesars Palace for our monumental 1995 showdown, we both arrived with credentials impressive enough to excite the boxing world.

There had been no gold medal for Rafael on his journey, only bags of candy. He and his brother, Gabriel, were going door-to-door as teens, selling sweets to help support their family, when they knocked on the entrance to the rudimentary Ten Goose Gym in North Hollywood, built on an old Wiffle-ball field.

Fascinated by what they saw inside, the Ruelas brothers put down their candy, picked up boxing gloves, and, under the tutelage of trainer Joe Goossen, launched careers that would result in world championships for each of them.

The hype for our fight was unbelievable. There were huge spreads in the newspapers, large chunks of airtime on television, banners and posters everywhere I turned, a media mob everywhere I went, and huge crowds straining to get to me.

I was certainly no stranger to the spotlight, but the glare from this fight was blinding. Being in the center of it all, I didn't know how to act. People were telling me what to say when the cameras were on, which seemed to be all the time. They were telling me how to dress: "Be professional." And how to look: "Mean, but always with a smile." There was so much going on that the whole week was a blur to me.

The fight was staged outdoors in what was normally the Caesars parking lot. I wore a hood in those days when I came out of my dressing room. When I pulled back the hood as I marched into the neon night, I froze. In front of me was the ring, above me were cameras beaming down from the metal structures surrounding me, on all sides was a crowd that seemed to go all the way to the Vegas strip in the distance, and beyond that were the glaring lights of a city I felt like I owned that night.

Wow, I said to myself, *this is big.*

The little kid flying down the streets of East L.A. on his skateboard had made it to the biggest playground of all.

Rafael was 43–1 with thirty-four knockouts and had the IBF lightweight title when we faced each other.

We had also fought in our amateur days, leaving me impressed with his power, aggressiveness, toughness, and determination. Rafael's strong point was his left hook, his weakness his balance. My plan was to stay on my toes, keep moving, avoid that left, and move in occasionally to bump him. That would throw Rafael off balance, which usually caused him to drop his hands.

That's exactly what happened. It doesn't always work that way. Sometimes you study a fighter, devise a plan based on his tendencies, and he fools you, doing none of the things you expected. Rafael came on just as advertised. In the second round, I moved in close, pushed him off, and sure enough, he dropped his hands. I threw an uppercut that missed by inches, then came back with a left hand that didn't miss anything. It smashed into Rafael's face and flattened him.

Somehow, someway, he dragged himself to his feet, tough to the end, but I came on with a barrage of punches that caused referee Richard Steele to end the fight in that second round.

For me, it was almost an out-of-body experience. I was in such great shape and the strategy had worked so perfectly that I felt as if I was just floating around the ring, my feet not even touching the canvas. And the next thing I knew, Ruelas was lying on that canvas and that huge crowd was lifting me to the heavens.

My next match was against another L.A.-area fighter, Genaro Hernandez. In order to face me, Hernandez was giving up the 130-pound title he had successfully defended seven times.

As the Golden Boy, I guess I was finally an attractive opponent. Back when I was a teenager and Genaro was already a pro, I had to chase him around just to get him to spar with me. One time he told me he would meet me on a Saturday morning at the Resurrection Gym. Robert and I waited and waited, but Genaro never showed up. We went over to his gym, where we found him already sparring with someone else. I accused him of running from me, but Genaro denied it.

If anybody was going to run when we met at Las Vegas's Caesars Palace, it should have been me after I suffered spasms in my left

shoulder in the second round that left me unable to throw my trusty jab. In the corner, I told Robert what had happened, but all he did was rub my shoulder harder.

Facing Genaro wasn't easy under the best of circumstances. He's a good technician.

As the rounds went on, my shoulder got worse. I could still throw the left hook, but only with considerable pain. At the start of the sixth round, I decided to go for it before my shoulder gave out completely. I landed a devastating uppercut on Genaro's nose, the blow striking so deeply that I could feel bone in his nose with my knuckles through my glove.

Genaro couldn't go on, the nose broken in over twenty places.

I had become big in L.A. and Vegas, no denying that, but I was shocked to find the same crowds, the same adulation, awaiting me on the other side of the country when I went to New York for a match against Jesse James Leija in December of 1995. I wasn't even sure I'd be recognized when I got there. How wrong I was. I was mobbed on the streets of Manhattan.

Wow, people know me, I thought, *and they're not even Mexican.*

Of course that might have been because I had become a regular on HBO, and my face was plastered across the pages of New York's newspapers and beamed down on the asphalt canyons of the city from gigantic billboards.

During that trip, Bob Arum took me to Barneys, a famous New York clothing store, and bought me a new wardrobe totaling $30,000.

Leija and I, two Mexican-American fighters, sold out Madison Square Garden. I stopped him in the second round.

My conquest of New York was complete. More fame, more fortune, more women, a life of limos and private jets.

Was it hard to adjust after my humble beginnings? For me, it seemed like a natural progression. It wasn't as if I had become an overnight success. I had been getting special treatment since I had won that first fight at the age of six. The quarters and half dollars my uncles had given me had mushroomed into millions. And everything else seemed to follow.

Eventually, it would become overwhelming. But not then. Not at the end of 1995. Besides, there was no time to slow down or reflect. And no reason to get smug. Ahead lay a legend.

★ ★ ★ XIV ★ ★ ★

THE BIGGEST BRA
I EVER SAW

In the old days, many boxing matches took place in small clubs far from the bright lights, the smoke-filled arenas packed with shouting, beer-drinking fans who looked as if they'd gladly peel off their shirts and jump into the ring themselves at the first insult.

It wasn't an environment that appealed to women and few came out.

That has all changed today and I like to think I've had something to do with that. Promoters and television executives tell me I draw more females than any fighter in history. I certainly can't argue with the fact that they pack the sites where I fight, fill up the pay-per-view orders, and mob my press conferences and public appearances.

Think about it. If you can take the old fight crowd and nearly double it, you are going to have unprecedented numbers. I have been lucky enough to be able to do that and I will be forever grateful to my female fans for making it possible.

I first began to realize the phenomenon I was generating at Las Vegas's Caesars Palace in the days leading up to the Ruelas fight. It seemed I had reached a new level of fame that week. It was the first time female fans started coming at me in waves. All ages—from

grandmas to mothers to young girls—gathered wherever I went, cheering me on, fighting to get close enough to touch me or get an autograph. I had a female fan club from Mexico all hold up signs wishing me luck. I couldn't walk through the casino because the crowds were so big.

I didn't mind. Those female fans actually relaxed me. Reading newspaper stories or watching TV sportscasts about one of my upcoming fights makes me nervous. Having females surround me, screaming and hugging me and grabbing me was fun. It brought a smile to my face, relieving the tension generated by the fight. I would come down to the lobby just to draw the crowd around me.

While it has been flattering to get such attention, there was one time when it was almost embarrassing. That was during the nationwide tour I undertook with Julio César Chávez to publicize our 1996 fight.

One of the stops was El Paso, Texas. We pulled up to our hotel in the early afternoon for a press conference after a short limo ride from the airport. As we got close to our destination, I saw that a crowd had gathered. Good, that meant people were aware we were in town and, hopefully, were aware of our fight.

But it quickly became obvious that this mob was not your typical fight crowd. For one thing, it was nearly all female. For another, it looked like they were waiting for a rock star rather than a fighter.

It got so wild that some of the screaming, hysterical girls jumped on the front window of our limo and shattered it.

Apparently, the women in El Paso feel a special attachment to me. When I fought Patrick Charpentier there in 1998, the reaction among the female population was just amazing.

It began the moment I arrived in town, my private jet pulling inside a hangar. When I emerged, there were literally thousands of

female fans being held back only by a metal fence. Some of them were holding up signs saying they loved me or wanted to have my baby. Then the bras and the panties started flying over the fence.

Finally, sailing over the barrier came this large white object, looking like a parachute, floating slowly down. It turned out to be a bra, the biggest I've ever seen in my life.

There was a press conference that week that drew one of the biggest mobs I've ever seen, mostly women. They threatened to overrun my security guys, straining to reach me, some of them squeezing and grabbing as I went by.

It was all pretty cool.

The night before the fight, I was sitting in my suite, watching the local news. They went live to the lobby of my hotel, where a local reporter was interviewing one of my trainers, Gil Clancy. When he was asked how I was enjoying the hysteria among local female fans, I saw Gil get that little twinkle in his eyes as he said, "You know what's really odd? Oscar is really into heavy women."

Next thing I knew, the attendant at the front desk called to tell me there was a herd of women in the lobby wanting my room number, all of them slightly overweight.

It wasn't like that just on the road. One night back home, I went out to a nightclub with my usual entourage of about thirty people. That's back when I turned twenty-one. I would have bodyguards, someone to make sure we had the VIP area all to ourselves, and another person to make sure there were girls waiting for us to dance and drink with.

This particular night, it was really crazy, a huge crowd, everyone trying to get to me. A fire inspector showed up because the club was filled way beyond capacity.

We decided to leave, but in order to do so, we had to get from

the VIP section to the front door, which was no more than a few yards.

Not so simple.

Four of my bodyguards had to pick me up and hold me over their heads as they walked to the front door. People tore my shirt off. My shoes were pulled from my feet.

We made it out of there, but it was certainly an interesting experience.

Nobody was smiling, though, when I ran into a different kind of fan, a stalker.

I learned about her in a really weird way when I went up to Big Bear to train for a fight.

When I got to my place, I noticed a box at the front door on the other side of the locked gate. It had no name on it, no return address. Inside was a teddy bear, a little figurine of a boxer, and a pair of my underwear, all items from inside the cabin.

Plus, there was a letter. It read, *Oscar, I want to apologize to you. I am sorry. I came to your house and, it so happened, the door was open.*

Not true.

The letter went on to say, *Now I am returning these items to you because, after I took them, I felt guilty. Once here, I decided to stay a couple of days in your cabin, hoping you would stop by. I was just waiting for you.*

I later learned it was a woman who had broken into my house, stayed there two days, and probably slept in my bed. That was creepy.

We reported it to the police, but they never did catch the person. I was freaking out.

It wasn't only females who could cross the line from supportive to obsessive. Two nights before my fight against Ruelas, I had finished my training and decided to take a stroll down to the Forum

shops with my entourage and several bodyguards, all moonlighters from their LAPD jobs.

Along with the usual well-wishers, and the occasional Ruelas fan who yelled out that I was going to get my ass kicked, I spotted, on the outer edge of the crowd, this weird-looking guy, wearing a heavy jacket even though it was May in the desert, sweating heavily, his face shiny, his eyes furtively looking to his left and his right as if he was about to do something unsavory.

I alerted one of my security guards to keep an eye on this guy. As I signed autographs and took pictures, I saw the guy was edging closer and closer.

All of a sudden he was right in front of me, sticking out his hand to shake mine. What was I going to do? I responded by sticking my hand out. With both his hands, he grabbed my outstretched arm, getting me in an iron grip, his face grimacing from the effort. I tried to pull back, but he wouldn't let go, squeezing ever tighter.

Finally, the security guys interceded, tackling him and wrenching me free. As they led him away, the guy yelled back over his shoulder, "You're going to lose! You suck!"

It was strange. Maybe he wanted to break my hand before the fight. Fortunately, I never found out.

CHÁVEZ: THE MYTH
AND THE MAN

The first time I saw Julio César Chávez in action, I was in awe. Just a kid, I gained access to the inner sanctum of a bar thanks to my father, who snuck me in. That alone left me in awe.

The occasion was a closed-circuit telecast of a Chávez fight. There he was, on the screen, the man whose name was spoken in hushed tones in our house and the homes of so many of my uncles and aunts. Mexico's greatest fighter, Chávez was a throwback to the days when the number of matches a fighter had might reach three digits and the number of years he was in the ring might exceed two decades. Chávez qualified on both counts. He fought for twenty-three years and finished with 107 wins and two draws in his 115 fights, including an astounding eighty-six knockouts.

Chávez looked untouchable to me up there on the screen that day, like he wasn't a real person. It was as if you could only see him on TV, a mythical hero rather than flesh and blood.

He became flesh and blood for me one incredible night when I was seventeen. Training at the Resurrection Gym, I hadn't even noticed the stranger wander in until I heard my name.

"Oscar De La Hoya," he yelled out. "I'm looking for an Oscar De La Hoya."

He was also looking for Shane Mosley and Pepe Reilly.

We couldn't believe it when we heard that this guy worked for Chávez. What could he possibly want with us?

Scheduled to fight Meldrick Taylor in Las Vegas, Chávez, who was in L.A., was looking for sparring partners. He wanted a few promising young amateurs who had speed and could throw a lot of punches. His people were given our names.

Our attitude was, "Hell yeah, let's do it."

With my trainer, Robert Alcazar, I went to an address that turned out to be a restaurant where a ring had been installed upstairs. The place was crowded and noisy with mariachis roaming the downstairs restaurant area.

Pepe, Shane, and I waited in a back room to be summoned. You might think a teenager would be intimidated about getting into the ring with a legend, but I was excited.

Pepe was called up first. When he came back down, Shane and I bubbled over with questions. What was it like? How did he treat you? What did his punches feel like?

All Pepe said was that it was fun.

Shane went next, and finally, my turn came.

Pepe and Shane had both worn twelve-ounce gloves. As I prepared to go up, one of Chávez's assistant trainers stopped me. "Nope," he said, "hold on. First, you have to put these on."

They were eighteen-ounce gloves, so big they were like pillows, so much padding they could do no harm.

"We heard stuff about you," the trainer told me.

I put the gloves on, went upstairs, got in the ring, and when the

bell rang, I didn't hold back. I threw hard punches, fast combinations, and was landing many of them. It was getting serious, at least from my point of view.

I could hear a murmur from the people in the room. I had wanted to make an impression, and apparently, I was doing so.

I had certainly gotten Chávez's attention. All of a sudden he loaded up on a right hand, connected, and I went down to one knee.

I bounced right up, ready for more. After sparring for two rounds, we were told that was it.

As Robert and I started to leave, the assistant trainer came over and told me, "Julio wants you to come to this address tonight. He wants to talk to you. You alone, not the other two sparring partners."

That was awesome. Julio César Chávez wanted to see me. Only me.

Still, I didn't tell a lot of people what had happened because I was embarrassed he had dropped me. I know it was Julio César Chávez, but it was still embarrassing.

Robert and I went to the address, I formally met Chávez, we shook hands, and he said, "You hit me with some good punches. You're a great fighter."

To hear that from him ... whoa, that was a real confidence booster.

Yet, six years later, when we were ready to face each other for real, I still had trouble picturing myself in the ring with this larger-than-life figure. When we posed for pictures, face-to-face, after our double tune-up at Caesars Palace in February of 1996, it was almost like I was merely getting the opportunity to take a picture with my hero, a photo I could show my friends.

It was a scary photo. Julio's face looked like a battleground, the front line for his fights.

And those were just the documented battles in the ring. A heavy drinker and pursuer of the good life, Chávez, a brawler at war with the world, enjoyed folk-hero status among his countrymen. They loved the warrior image. They reveled in his macho style. This wasn't a man who expended a lot of energy studying opponents or discussing strategy. He would simply come forward at the opening bell, absorb the best shots his opponents could deliver, and then proceed to dismantle that opponent's body and will, landing his trademark shots to the ribs and kidneys, shots that could cause legs to shake and resolve to wilt.

For many Mexican and Mexican-American fight fans, this was what the sport was all about.

I wanted to fight him because it was my job and, I felt, my destiny. But there was a part of me that wondered how I could possibly fight my hero, a part of me that questioned whether I was worthy. After all, this was a fighter every Mexican national and Mexican-American looked up to.

My doubts were nothing compared to the doubts and derision I received from Hispanic fans in the period leading up to the fight.

"Chávez is the real champion," they would tell me. "He looks like a fighter. Look at you. You've never been cut up. Look at your nose. It doesn't have any bumps in it. Look at your smile and those perfect teeth. You're the Golden Boy."

They just weren't impressed with my finesse, with my boxing skills, with my fast hands and quick feet, with my ability to inflict damage while avoiding the inevitable counterpunches. They didn't appreciate the fact that, for me, the sweet science was indeed a science.

They didn't even care about my unbeaten record.

They wanted blood and guts. They wanted a hero who looked as if he had been in a fight. Maybe even lost a few.

They wanted Chávez.

So when we signed to fight, Chávez, while certainly not the choice of the Las Vegas oddsmakers, became the sentimental favorite.

Never mind the fact that, at thirty-three, Chávez was living off his reputation, the hard living and brawling having taken a large measure of vitality out of his body. He looked as if he'd been through almost a hundred previous matches.

I, on the other hand, was twenty-three, had perfected my trade, and was entering my prime, undefeated in twenty-one professional fights.

It didn't help my image to be stuck with the nickname Chicken De La Hoya. It had been given to me by a New York writer, Michael Katz, because Bob Arum had matched me up early in my career with unranked fighters.

The nickname I was branded with was unfair. Ever hear of Tunney Hunsaker, Herb Siler, Tony Sperti, or Jimmy Robinson? Probably not unless you are a Muhammad Ali trivia fanatic. Those were Ali's first four professional opponents, fighters designed to ease him into the professional ranks.

No matter how much glory or gold amateurs collect before receiving their first check as a prizefighter, no matter how much time they spend in the gym or how many rounds they spar, they need on-the-job training as professionals.

So it had been with Ali. And so it was with me.

By the time I fought Chávez, I was ready, but his fans refused to deal with the harsh reality. They envisioned a memorable upset, the old veteran drawing on reserves from his storied past to hold off

boxing's emerging attraction, striking down this New Age upstart who dared to challenge a legend.

In order to hype this crossroads event, a nationwide tour was launched, twenty-three cities in twelve days.

It began in disappointing fashion for me at the Olympic Auditorium. The fans, the majority of them Mexican-American, booed me and cheered Chávez.

Chávez grinned and said he'd never be booed in his hometown.

I could only grit my teeth, confident that as the fight progressed, the boos would fade along with Chávez.

At one stop on the tour, Chávez faded away completely, disappearing in a limo after a press conference while the rest of us headed for the airport and our private jets, bound for the next city.

We couldn't depart without him, so we waited on the nearly deserted tarmac until, finally, in the distance, we noticed a cloud of dust kicking up and, blasting through it, a limo moving toward us at high speed.

As the car pulled up, Chávez emerged from the backseat, surrounded by local young ladies he had picked up along the way.

Throughout the tour, he would appear in his fur coat surrounded by a band of followers who acted like servants in Emperor Julio's kingdom. He had one guy whose job, it seemed, was to comb his hair, another to tie his shoelaces.

It was disillusioning for me to see who Chávez really was and how he acted.

From a boxing standpoint, however, it was illuminating. What I saw was an emperor ripe to be overthrown. Any doubts about that should have been dispelled after a telling scene in San Antonio during the tour.

It was dawn, the first rays of light hitting the placid water along

the Riverwalk. I was already up and heading out of my hotel to do roadwork, sweatsuit on, shadowboxing as I made my way out of the lobby and onto the street.

It was then that I came face-to-face with a figure stepping unsteadily out of a limousine.

It was Julio César Chávez returning from a night on the road.

I smiled.

Even in that dim light, I could see the outcome ahead.

So could a lot of Chávez fans and they didn't like what they saw. So some of them tried to influence the outcome. Back in Southern California at my Big Bear training site, I began to get threats. Through the mail, on the phone, Chávez supporters would warn me of the consequences of defeating the pride of Mexico.

"You cannot beat our champion," they would say. "And if you do, you will regret it."

Faced with these warnings, more sinister and voluminous in number than any I had previously received, I hired three additional bodyguards. I felt that a threat by Mexican officials to sue me if I tried to wear their flag on my trunks was just another part of a concerted effort to distract me, to make sure I would not be completely focused when I entered the ring.

Why do I say that? Because after that fight, the Mexican government never again disputed my right to display its flag. It was only for that fight. Strange, isn't it?

While Chávez publicly dismissed me as some inconsequential pretender to his throne, I concentrated on studying the man behind the myth. I didn't think I could knock him out. He had the head of a bulldog, grounded by the boulder that served as his jaw. But I did think I could outbox him by using the advantages of youth and speed.

I saw an immediate improvement in my skill level under The Professor, but I think he was at his best in preparing me to fight Chávez. My opponent was a man who knew only one style: come forward, be aggressive, and have no fear. He thrived in harm's way.

How was I going to slow him down and neutralize his power? The Professor taught me how to do just that.

It was in the training camp preparing for that match when everything clicked. One day, I was throwing my combinations, always moving, staying on my toes, sailing around the ring. I felt like a matador and my sparring partners, in comparison, seemed like slow, plodding bulls. I was the master of my domain.

That's when everybody in camp accepted Rivero as the real deal. Look at what he has done for you, everybody would tell me. They didn't have to tell me. I could see. I was a believer. Whatever he said, I did. He was truly The Professor.

By the week of the fight, I had put aside visions of Chávez as a legend and prepared to fight the man. That remained my mind-set for all but one fleeting instant when I first stepped into the ring. As I looked across to the other corner and saw him, I was ten years old again, thinking, *That's the great Julio César Chávez. He can't be real.*

But I caught myself, refocused, and when the opening bell rang, I was ready.

I boxed well in the opening rounds, blunting every charge of the old bull as if I was wearing the red cape. I didn't feel the bitter sting of those trademark body shots. Instead, he felt the sting of my jab. I used it to open a cut over his left eye in the first round. By the fourth, with Chávez's face covered in blood, the fight was stopped.

Pride would be the last thing to go with this warrior. He later claimed he already had the cut when he entered the ring, that it had

been caused by his young son bouncing on his knee and then jerking his head backward, smashing into Chávez's eyebrow.

I've heard a lot of excuses by a lot of fighters over the years, but that had to be the lamest.

As an added bonus, I won Chávez's WBC 140-pound title, giving me championships in three weight classes.

While there were blue skies ahead for me, there was nothing but a cloud of gloom hanging over the Mexican boxing community. They took it out on me. Hadn't I proven my worth to them? Forget it.

When I came home, my peers were on the bandwagon, but the older generation had a hard time accepting Chávez's defeat.

"Who are you to beat our champion?" they said. "That wasn't the real Chávez. And it wasn't even you who beat him. It was his kid."

They really believed that.

I had believed Mexican fans would finally accept me, but I was fooling myself. It was worse after the fight.

Several months later, I was grand marshal of the annual holiday parade in East L.A. Riding in a car with my father, I was booed. People threw fruit at me and yelled that I hadn't really beaten their champion. Police had to surround my car. My father yelled back, telling my detractors to shut up.

I couldn't understand why they were acting that way. *I'm one of you,* is what I wanted to say.

I found myself having argument after argument with older people around the neighborhood, always forced to defend myself.

"Where were your kids born?" I would say.

"Here in East L.A.," they would admit.

"So what's the problem?" I would ask. "I was born here, too. My parents are Mexican just like you."

"Don't tell me you're a Mexican," they would say. "You're a *pocho*. You're a gringo."

"I'm an American," I would say, my voice rising. "What's wrong with that? I'm the same as your kids."

"That's different," they would insist.

It was a pointless argument, but one I couldn't seem to escape. I don't think my father ever really understood the problem. He was born in Mexico, plain and simple. But me, what was I? Was I an American? Was I a Mexican?

I was mad, I'll tell you that. Mad enough to want to beat their hero once again, to show I had Mexican blood in me as well.

My chance came two years later when Chávez and I had a rematch. Forget the boxing and the moving, the fancy footwork and the quick fists, I told myself as I prepared for the second fight. This time, I was going to stand in front of Chávez, toe-to-toe, and show those Mexican fans I could fight his fight. I could be just as macho as Chávez.

That's what happened. I stood in front of him in a test of wills. I have to admit, he took some blows that would have put anybody else down. I remember landing my 45 punch four or five times flush on his jaw. The old guy still had granite in his chin and a heavy, solid punch emanating from his fists. He caught me with a right hand that caused me to see stars. I was dizzy, but fortunately, he wasn't able to follow up. Finally, Chávez blinked first. He's the one who didn't come out for the ninth round.

He hadn't acknowledged my victory in the first fight. He was too busy looking for an excuse, which he found in his son. And in the press conferences prior to the second fight, Chávez acted as if the first fight hadn't even happened. But after the rematch, he told me, "You beat me. You are a great fighter."

The torch had finally been passed.

STRADDLING THE BORDER

The anger and bitterness that descended upon me in the wake of the first Julio César Chávez fight should not have come as a surprise. For many years, I struggled with an identity crisis. I wasn't accepted as an American by some and I didn't feel I was accepted as a Mexican by others. I felt like I didn't belong.

Maybe it's because, as a high-profile athlete, I tried to satisfy everyone. It was very important to me to show I was proud of being born in this country, but also proud to have Mexican roots.

It started at the Olympics when I carried both the Mexican and American flags into the ring for my gold-medal match. That created an image of me people still remember. At that moment, when I came into the public eye on a world stage for the first time, it was as a guy straddling two cultures.

But it's difficult to maintain that image with pride when you are always getting criticized for it. For example, after Barcelona, I received a lot of complaints from Mexicans who were saying, "Who does this guy think he is? He was born in the U.S.A."

When I fought Chávez the first time, I planned to wear these funky shorts that had the Mexican and American flags intertwined.

Mexican government officials, in the letter threatening a lawsuit, said I couldn't wear the trunks because I wasn't born in Mexico. It was mind-boggling to me. Everybody else can wear trunks like that, but when I do it, there's a threat of a lawsuit. I didn't understand it.

The issue came up again when I fought Fernando Vargas in 2002. This is a guy who feeds off a gangster image and claimed his tough-guy persona made him more of a true Mexican than I, even though he, too, was born in this country. That made me angry. Who is this guy to tell me how Mexican I am? I thought his image tended to portray hardworking, taxpaying Hispanics in a very negative manner.

In my 2006 fight against Ricardo Mayorga, I wore a patch on my trunks in reference to a proposition in an upcoming election. My position, which was sympathetic to undocumented workers, resulted in phone calls and e-mails blasting me. "What in the hell are you doing?" they asked. "You should die. I thought you were an American. You were born in this country."

I don't let such attacks bother me anymore. All those conflicted feelings about my heritage are behind me. I was persistent, believing that one day, people would accept me.

Now people tell me, "Thank you for representing us. Thank you for always believing in us. Thank you for never forgetting us. Thank you for being proud."

Such acceptance, however, doesn't remove me from my responsibilities as a man caught in the middle of one of the hottest issues in the country: immigration. People in Mexico, even some family members who still live there, implore me to lobby U.S. officials to use their power to relax immigration laws. Over here, I have people telling me just the opposite.

It would be a lot easier if I didn't get involved at all. I could just go about my business. Between boxing and promoting and my various other financial investments, I have more than enough on my plate, but I can't turn my back on a problem that affects so many people whose roots run parallel to mine. I have my beliefs about possible solutions to this difficult problem and I will continue to air them and contribute to the public debate.

Let's limit that debate to positive suggestions. We don't need any more finger-pointing. Both sides, if they are honest, must accept some of the blame. This much I think we can all agree on: The current system is not working. There's chaos on the border.

I'm certainly not for opening up the gates and allowing anyone who wants to come here to simply march in. But I'm also not suggesting a permanent lock for those gates. Many of the people trying to cross the border just want to work, want to make a better life for themselves and their families.

Sure, you have some rotten apples who are giving a bad name to all their fellow immigrants and they should be dealt with harshly. Send them back. That's only fair.

For the others, let's implement a more diplomatic approach. Mexicans view the border patrol as the enemy and the border itself as a hurdle they are determined to leap over, tunnel under, or smash through. We have to find a way of making it friendlier, a way to educate those on the other side about the process they must follow to come across. We must instill in them an awareness of the benefits of following the process.

If they want to come here and work, we should give them proper documentation to do so for six months. After six months, they can earn another six. After a year, if they have acted as good citizens, paid their taxes, and contributed to the economy, then they can

begin a process leading to citizenship if they want to stay longer. Everybody would be accounted for through this process.

Let me stress, it should be a comprehensive, extended process. Nobody gets citizenship overnight. It is not a gift to be bestowed without strings attached. Congratulations, you snuck across the border, we'll make you a citizen. No, nothing like that. Nothing is easy in life.

I'm not absolving the Mexican government of responsibility in this matter, either. Mexican officials have to step up and play a big role in enforcement. It's not going to work if the effort is only made on this side of the border.

As for the illegal immigrants already here, don't just send them back home. I'm not saying we should stamp their passports and overlook their past. But again, we should find a way to make them legal, give them the opportunity to work within the system to gain citizenship so that they can continue to live the American dream, but do so without having to hide in the shadows. Why not? There are people who have been here undercover for ten years, fifteen years, maybe even longer, working hard, raising families, and obeying the laws of this great country.

There should be an orderly line for going through the requirements of citizenship based on how long an immigrant has been in America. Those first applying to come across would have to start at the bottom of the list and work their way up. Wait your turn.

Bringing immigrants out of hiding would be a worthwhile accomplishment for all Americans. It would be much safer for both those who are here illegally and the rest of the country if immigrants have records of who they are, have certificates or green cards or,

eventually, passports. I think the people who come here would benefit, I think our economy would benefit, and I think agencies dealing with everything from law enforcement to health care to education would benefit.

Something must be done because, with the situation the way it is now, illegal immigration is never going to stop. It just isn't. That's reality.

I also believe strongly that those who immigrate to this country, regardless of where they came from, should learn English. This is America. The first language is English. You go to Japan, you speak Japanese. You go to Colombia, you speak Spanish.

I don't understand how people can complain that this country isn't doing enough for them. They should be grateful. As an immigrant, you are coming to a country that is giving you a chance to live a better life. Respect it. That's what I do, what my family has done, what my ancestors did.

I will never forget my roots, never forget where I come from, but I am in debt to the United States of America. This is the country I was born in, this is the country that gave me a chance to go to the Olympics, and this is the country that has allowed me to prosper in the years since.

We, as Latinos, need to stand up and recognize the wonders we have experienced in this country. We are Americans.

I have tried to do my part to give back to this great land of ours through the Oscar De La Hoya Foundation. I consider it a privilege to do so.

My efforts began after I won my first world championship. I loved the feel of the belt around my waist, but I also felt the weight of responsibility on my shoulders. I saw all the young kids looking

up to me, and I remembered when I was a young kid, looking for role models as I was shuttled from gym to gym.

Why not give these kids a gym they can call home? So I acquired the old Resurrection Gym, refurbished it, and staffed it with trainers to give the next generation of fighters a place to chase their dreams.

This was the start of my foundation. With all the championships I have won over the years, what I am most proud of is the positive impact I have been able to have on other people, largely through this foundation.

Over the past dozen years, it has grown in reach and influence. Thousands of kids have come off the streets to spend their otherwise idle time in my gym and learning center.

One of those kids, José Navarro, even followed my path to the Olympics. He competed in the 2000 Games.

My desire to use my good fortune for the benefit of others has not been limited to the ring. After my mother died of breast cancer, I wanted to establish a cancer institute in her honor. In 2000, I achieved that goal with the opening of a state-of-the-art facility in my old neighborhood in East Los Angeles. The Cecilia Gonzalez De La Hoya Cancer Center at White Memorial Medical Center offers diagnostic and treatment options for patients with all types of cancer. Thousands have taken advantage of its facilities to fight this deadly illness.

In 2003, I was also able to establish a neonatal intensive-care unit, and a labor-and-delivery center at White Memorial.

I was honored to be able to do this for my community, and I hope that my charitable reach will eventually stretch nationwide.

In a way, I came full circle in 2004 when, in conjuction with Green Dot Public Schools, I opened the Oscar De La Hoya Amino

Charter High School, the first new public high school in East Los Angeles in over seventy years.

Overcrowded classrooms are a problem everywhere in the country. To be able to relieve some of that pressure and give students a chance for a better education is very satisfying to me.

I am sure my mother would be proud.

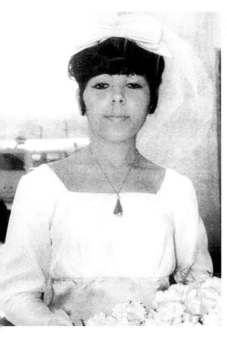

Mother Cecilia, age seventeen, as a
bridesmaid in a friend's wedding.
(Photo courtesy of the author)

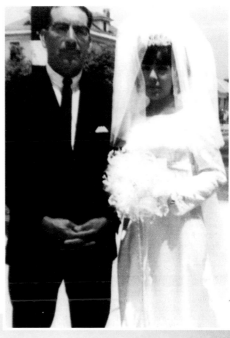

The 1968 wedding of Oscar's parents,
Joel and Cecilia. Mother Cecilia poses here
with Miguel Salas, one of Joel's uncles.
(Photo courtesy of the author)

At home with the family. From right to left: Oscar, Uncle, Joel, Cecilia,
and baby sister Ceci. *(Photo courtesy of the author)*

Oscar's mother Cecilia and brother Joel Jr. *(Photo courtesy of the author)*

Oscar the gym rat, on the right
(Photo courtesy of the author

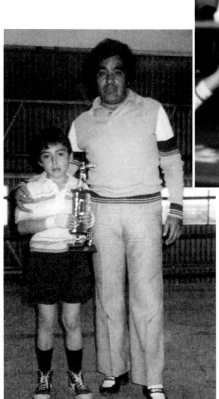

Oscar and his father after a win at a local tournament. *(Photo courtesy of the author)*

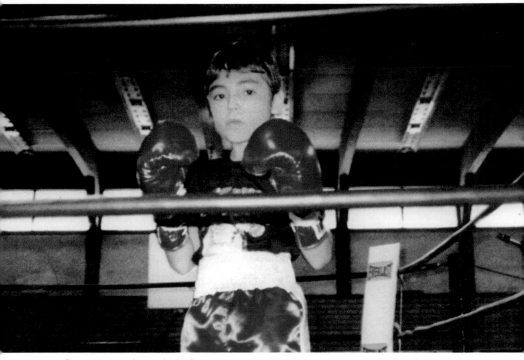

Oscar, age eight, right before a tournament. *(Photo courtesy of the author)*

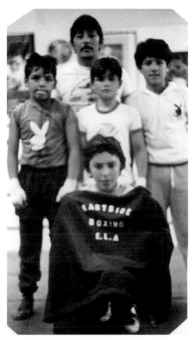

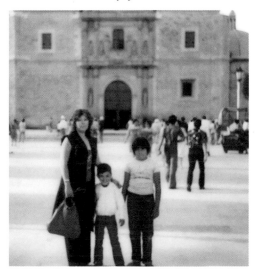

Cecilia, Oscar, and cousin Irma in Durango, Mexico. *(Photo courtesy of the author)*

Oscar and his young stable mates at the East Side Boxing Gym. *(Photo courtesy of the author)*

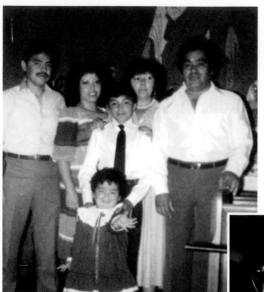

Oscar's first holy communion. From right to left: Joel, Cecilia, and godparents Hermila and Franciso Gonzalez. Oscar is in the middle with baby sister Ceci in front. *(Photo courtesy of the author)*

Oscar, right, throwing his famous left hook at the Azteca Gym. *(Photo courtesy of the author)*

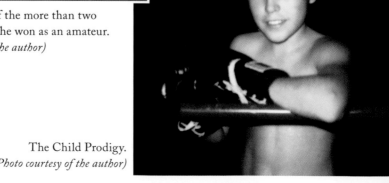

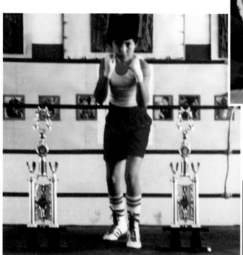

Oscar with two of the more than two hundred trophies he won as an amateur. *(Photo courtesy of the author)*

The Child Prodigy. *(Photo courtesy of the author)*

Oscar gives his mom bunny ears on a family trip to Disneyland. *(Photo courtesy of the author)*

Oscar's parents in a happy moment on Christmas Eve at a relative's house. *(Photo courtesy of the author)*

Oscar's mom Cecilia and little sister Ceci. They were in Washington to watch Oscar in the 1990 Goodwill Games. It was one of the last times his mother saw him fight. She passed away several months later. *(Photo courtesy of the author)*

Three generations of De La Hoya fighters: Oscar stands with his grandfather Vicente and father Joel. *(Photo courtesy of the author)*

Oscar poses after training at the Resurrection Gym in East Los Angeles. He would later purchase the gym and turn it into the Oscar De La Hoya Youth Center. *(Photo courtesy of the author)*

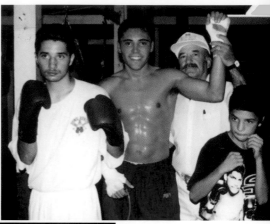

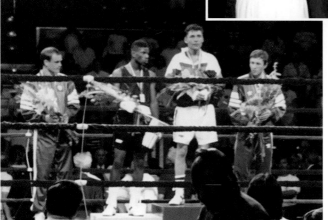

Oscar, center, is honored as the winner of his division at the Olympic Trials. *(Photo courtesy of the author)*

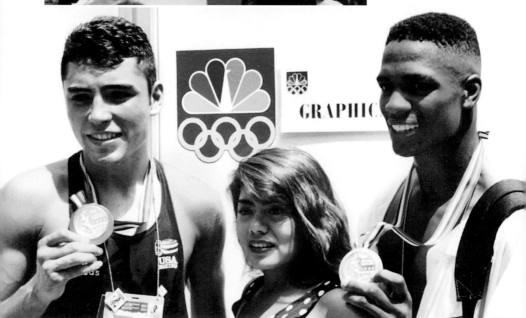

A golden moment: Oscar poses with his gold medal at the 1992 Olympics in Barcelona. *(Photo courtesy of the author)*

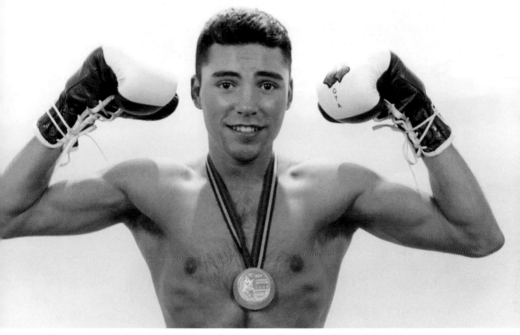

One picture of Oscar's first photo shoot as an Olympic gold medal winner. *(Photo courtesy of the author)*

Oscar poses with one of the uncles who saw him grow into a gold medal winner, Vicente De La Hoya. *(Photo courtesy of the author)*

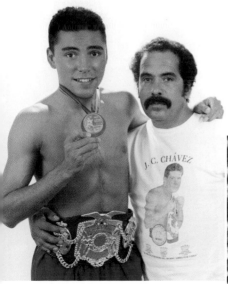

Oscar poses with two Joel De La Hoyas, Sr. and Jr. *(Photo courtesy of the author)*

May 27, 1994: Champion Oscar De La Hoya puts the finishing touches on challenger Giorgio Campanella. *(Credit: Holly Stein/Allsport)*

May 6, 1995: Oscar De La Hoya, left, delivers the decisive left to Rafael Ruelas, knocking him down for the second time in the second round. *(Photo by Getty Images)*

Las Vegas: Oscar De La Hoya, left, lands a left against WBC Super Lightweight Champion Julio César Chávez, right, in the third round. De La Hoya defeated Chávez to claim the title with a fourth-round TKO. *(John Gurzinski/AFP/Getty Images)*

WBC Welterweight Champion Oscar De La Hoya celebrates his win after a unanimous twelve-round decision over Hector Camacho on September 13, 1997, at the Thomas and Mack Arena in Las Vegas. *(John Gurzinski/AFP/Getty Images)*

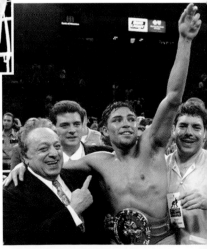

De La Hoya celebrates his win over Wilfredo Rivera of Puerto Rico. *(Tom Mihalek/AFP/Getty Images)*

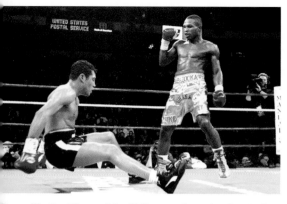

Oscar De La Hoya of the U.S. goes down in the sixth round during his fight against challenger Ike Quartey from Ghana, right, in Las Vegas. De La Hoya won a split decision victory over his challenger, keeping his World Boxing Council welterweight crown. *(Hector Mata/AFP/Getty Images)*

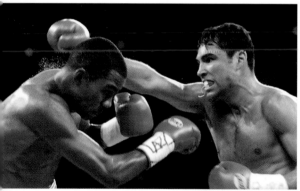

De La Hoya, right, and Félix Trinidad battle it out at the Mandalay Hotel, September 18, 1999, for the WBC/IBF Welterweight Championship. Trinidad won the twelve-round fight on points. *(Photo by Gary M. Williams/Liaison)*

Sugar Shane Mosley lands an uppercut to De La Hoya during the World Welterweight Fight at Staples Center on June 17, 2000. Mosley won by decision in the twelfth round. *(Photo by Al Bello/ Getty Images)*

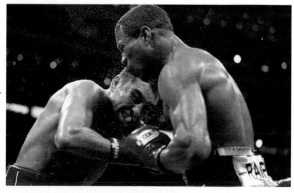

De La Hoya displays his new CD titled *Oscar De La Hoya,* October 14, 2000, during an album signing event at Tower Records in West Hollywood. *(Photo by Frederick M. Brown/ Newsmakers)*

Oscar entertains two of his young fans at a signing event for his CD. *(Photo courtesy of the author)*

De La Hoya smiles in front of a GQ logo backdrop at the Fifth Annual GQ Magazine Men of the Year Awards, held at the Beacon Theatre, New York City. *(Photo by Scott Harrison/Hulton Archive/Getty Images)*

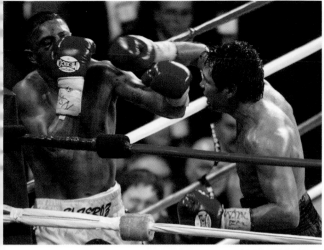

De La Hoya, right, lands a flurry of punches against compatriot Fernando Vargas during the eleventh round at Mandalay Bay in Las Vegas, September 14, 2002. De La Hoya retained his World Boxing Council 154-pound title with an eleventh-round TKO. *(Mike Nelson/AFP/Getty Images)*

De La Hoya lands a punch to the chin of Sugar Shane Mosley on September 13, 2003, at the MGM Grand in Las Vegas. Mosley defeated De La Hoya by unanimous decision. *(Photo by Al Bello/Getty Images)*

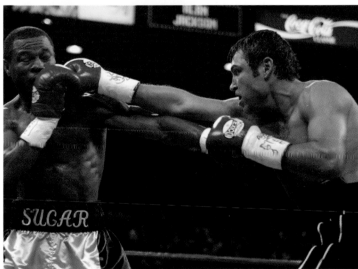

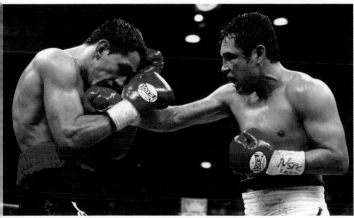

De La Hoya, right, hits Felix Sturm of Germany during their WBO World Middleweight Championship at the MGM Grand on June 5, 2004, in Las Vegas. *(Photo by Jed Jacobsohn/ Getty Images)*

De La Hoya lies on the mat after a knockout punch to the liver from Bernard Hopkins at the MGM Grand on September 18, 2004, in Las Vegas. Hopkins won the world middleweight title in the ninth round. *(Photo by Doug Benc/Getty Images)*

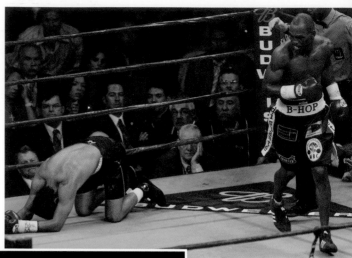

Millie talks with Oscar after he was knocked out by Bernard Hopkins for the world middleweight title at the MGM Grand on September 18, 2004, in Las Vegas. *(Photo by Jed Jacobsohn/Getty Images)*

De La Hoya, left, fights Ricardo Mayorga, right, during the WBC super welterweight title fight at the MGM Grand May 6, 2006, in Las Vegas. Oscar defeated Ricardo Mayorga by technical knockout in the sixth round. *(Photo by Donald Miralle/Getty Images)*

De La Hoya weighs in at 154 pounds at the MGM Grand in Las Vegas before his fight against Mayweather. *(Photo by Al Bello/Getty Images)*

De La Hoya connects with a right to the face of Mayweather during their WBC super welterweight championship fight May 5, 2007. Mayweather defeated De La Hoya by split decision. *(Photo by Al Bello/Getty Images)*

Oscar the humanitarian speaks at his foundation dinner.
(Photo courtesy of the author)

Golden Boy CEO Richard Schaefer, Oscar, and Raul Jaimes, vice president of Golden Boy Promotions, at a foundation dinner
(Photo courtesy of the author)

Oscar, the singer, signs his CD
(Photo courtesy of the author)

Oscar prepares to go onstage at his foundation dinner.
(Photo courtesy of the author)

Sister Ceci and brother Joel Jr. pose with the groom at Oscar and Millie's 2001 wedding. *(Photo courtesy of the author)*

De La Hoya and Millie attend his "Evening of Champions" Award Gala at the Regent Beverly Wilshire Hotel on October 3, 2002, in Beverly Hills, California. *(Photo by Robert Mora/Getty Images)*

Oscar, sister Ceci, and brother Joel at the grand opening of the Cecilia Gonzalez De La Hoya Cancer Center in 2000. *(Photo courtesy of the author)*

Oscar and Millie at the 2003 Latin Billboard Awards at Miami Arena in Miami, Florida. *(Photo by Tom Grizzle/Wireimage)*

Oscar and Millie attend People En Español's 25 Most Beautiful Celebrity Gala at the Roseland Ballroom on May 14, 2003, in New York City. *(Photo by Myrna Suarez/Getty Images)*

ANGUISH TO RAGE

Brave hearts and doubting souls.

Warriors and wannabes.

Those willing to die in the ring and those who die a thousand deaths before they even step into the ring.

In his nearly four decades in boxing, trainer Emanuel Steward has seen them all. But he told me he had never seen a fighter quite like me.

It was a compliment.

My unmarked face, quick smile, soft voice, and gentle nature speak of a life far removed from the cutthroat world of boxing. And indeed, as a singer and amateur artist, I feel very comfortable in the entertainment world.

I think it is using my hands to draw and paint that most appeals to me.

Once asked at the last minute if I could supply a piece of artwork for a charity auction using the rawest of materials—crayons and sketch paper—I produced a drawing of a multitiered golf-course green in two hours.

Whatever talent and creativity I have as an artist, I inherited from my mother.

But there is also my father's side. He was a boxer in his youth and that, too, I inherited.

"I've never seen a fighter go through such a transformation when he gets into the ring," Steward once told me.

My preparation begins long before I see the ring. In the locker room, I like to isolate myself to better focus on the task at hand. I don't really feel sociable anyway. I am anxious, my nerves are on edge, I sweat a lot, and I can't control the flutter in my stomach. You've heard of butterflies? I feel like I have dozens of them down in the pit of my stomach, flapping their wings and darting back and forth. I shake, shivers running through a body that feels stone cold.

Maybe the worst case of the shakes I ever had was before my fight against Fernando Vargas in 2002. It wasn't that I was scared. I was confident of victory. It was just nerves.

The first thing I always do when I step between the ropes is to scan the crowd in search of my father.

Our eyes meet and our heads nod.

People tell me my lips tighten and my eyes narrow as I zero in on my opponent. They say, for an instant, I look like I'm going to cry. And then that anguish turns to rage.

The artist has left the building.

Early in my career, when I was facing guys I could blow away, that rage gave me a huge advantage. I could just go into the ring without thinking and let my power take over. If I got hit, no problem. I was so much faster and stronger than those guys that I knew, inevitably, I was going to knock them out. There was such a difference in skill level.

When I started to face fighters who could really fight, I needed

to worry about what they could do to me, not just what I could do to them. That's when The Professor became invaluable.

The key to his defensive style was the position of the hands. I had always known how to bounce up and down, stay on my toes, and keep the proper distance from my opponent. But by keeping my hands too high, I was losing half a second, or even a second, in trying to block punches. That's a huge amount of time when a punch is coming at you from such a short distance. When you're facing a quick fighter who can put together combinations, being slow on blocking the first punch can prove deadly.

What The Professor taught me was to keep my hands a little out in front and coordinate them with my footwork. If my feet moved backward or forward, my hands had to move in unison.

The Professor used to say, "You are the car and your hands are the steering wheel. If you turn one way or the other, your hands have to lead."

I got very comfortable with that style. I felt invincible.

Robert never got comfortable with this style or with The Professor. Even after I beat Chávez in a dominating performance, he couldn't bring himself to compliment The Professor or admit his doubts about him had been unfounded, based more on his own shrinking role than on what was best for me. Each time I won under The Professor's guidance, Robert seemed to grow more insecure.

He would tell my father, "I love you guys. And I know Oscar's mother would really want me to be here."

Robert was right about one thing. There was a downside to The Professor. It just didn't have anything to do with boxing. It was his plan to educate me, which had turned into a nonstop tirade against religion. He preached atheism.

Kind of ironic that a man named Jesús would be an atheist.

It was when Rivero started preaching that my brother gave him the nickname of The Professor. That's because my brother is also an atheist, so they got along well.

We would spend two or three hours a day in the gym, and much of the rest of the time, we all had to sit around, everybody in camp, and listen to him tell us that there is no God.

"There is nothing beyond man. It doesn't matter what you believe in. You can believe in that book," he would say, pointing to an object resting on the table.

The Professor was a very stubborn man, refusing to listen to anyone else's opinion. He was an educated man—we all respected that—but when he started in on his theories about religion, it was dreadful.

We'd come in from a workout, get something to eat, sit down, and sure enough, he'd start in. We'd think, *Oh no, here we go again. He's our elder, so let's at least listen.*

What was our alternative? We were in training camp. We couldn't leave. It was ideal for him. He had a captive audience.

The Professor was a powerful speaker, so powerful that he made us at least think about what he was saying. I was raised as a Catholic and wasn't going to give up my beliefs, but he certainly made you consider the alternative, at least while you were under his spell. This is a man who could point to a piece of string and convince you it could stand up and slither across the room.

Another of his theories was that I would be a better fighter if I drank a glass of wine every day, even on fight days.

"It's good for the blood," he would say. "It makes you strong. You'll feel a little dizzy, but that's okay. You won't feel the punches."

He was different, weird.

But I couldn't dismiss him entirely because what he was teaching me was working. So while on the one hand, I felt the guy was full of bull and he was talking my ear off all day, on the other hand, I listened to the guy religiously and followed his instructions when it came to boxing.

Following my first victory over Chávez, I was matched against Miguel Ángel Gonzalez, who was 41–0 with thirty-one knockouts. I didn't expect less. I had just beaten the king of the kings and it wasn't going to get any easier. I went into that fight handicapped by a sprained right thumb and weakened by the flu, but fortunately, my jab was working well and I could hit Gonzalez almost at will.

I won a unanimous decision, the only negative being a big bruise under my left eye courtesy of my opponent's right hand. That caused people to whisper that I was a sucker for the right. Until I lost, people were always going to look for supposed flaws.

Next on my dance card was Pernell Whitaker, a master of defense. He was small at five-six, over four inches shorter than me, and had a way of making himself even smaller by curling into a ball. That left me swinging downward at an awkward angle, hitting the back of his head a lot. Whitaker was slippery, tricky, hard to fight. It didn't help that I went down in the ninth round, not from a punch, but because my legs got tangled. That was counted, unfairly I thought, as a knockdown. Still, I won a close but unanimous decision and Whitaker's WBC 147-pound title, giving me a belt in a fourth weight division.

Had I finally found the trainer who could complete my growth as a fighter?

Not exactly, according to Arum and Trampler. Things went well for a few fights, only to find the Top Rank brain trust again whispering in my ear that a change was needed. What didn't they like

about The Professor? Trampler told me that while The Professor's heavy emphasis on defense had been a huge plus for me, there was also a big negative. I was so concerned with avoiding incoming punches that I was no longer throwing my own punches with the same authority. My new style had robbed me of some power, Trampler figured.

Ultimately, though, it was I who made the decision to let The Professor go. The primary reason I did so was not because of his approach to boxing, but because of his religious rants. They were too disruptive to our camp. They added to the friction between Robert and The Professor. There was a lack of unity. We weren't a team and I got fed up with that.

I felt I had absorbed what The Professor had to offer. It was time to move on to the next guy and learn even more from him. I got the process going with my business adviser, Mike Hernández, telling him my concerns. I knew he would tell Arum, who would discuss it with Trampler, and I would soon have a new trainer to work with Robert.

The Professor's last fight was my 1997 match against Pernell Whitaker.

When we told The Professor he was out, he showed defiance rather than disappointment. "You guys don't know what you are doing," he said, telling me I needed him more than he needed me.

Who did I need in my corner? For my next trainer alongside Robert, the idea was to go in an opposite direction. Rather than a renowned defensive specialist, a retired old master with only a few fighters on his résumé, we wanted an active, experienced, big-name trainer with an appreciation for an aggressive approach. They don't get any bigger than Emanuel Steward, a legendary figure who has trained fighters ranging from Thomas Hearns to Lennox Lewis.

The two things Manny gave me were confidence and an active right hand. He made me feel good about myself. He told me, "You should walk right through these guys."

My first fight under Manny was against David Kamau in 1997. If I had still been under The Professor's guidance, the plan would have been to stay outside, use my jab, counterpunch, and maybe win by decision or a knockout in the later rounds.

When that was presented to Manny, he emphatically said, "No, you've got to just go at him, attack him, and knock him out. You can do it." That was certainly a huge change from The Professor, who was always lecturing me on the danger of absorbing punishment. Manny's attitude was, as good as I was, I didn't have to worry about absorbing too much punishment.

Manny wasn't satisfied with just bringing out the aggressor in me. He was determined to make me a two-handed aggressor. For far too long, I had relied primarily on my left hand. I had a strong left hook and an effective jab, but could I double my effectiveness if I used my right hand with greater frequency? Manny was determined to find out. As he pointed out, the mere possibility of an effective right hand would alter the defense of an opponent, leaving more openings for my left hand to crash through and do its work.

It was tough to change a message that had been drilled into my head. In the first round against Kamau, I stuck to the conservative game plan I had grown accustomed to under The Professor, and Kamau was still around when the bell rang three minutes later.

When he came through the ropes to confront me as I sat down on my stool, Manny was fuming.

"What are you doing?" he asked. "Go in there and knock him out."

I came out in the second round with a new, ferocious mind-set, threw my combinations, and, just as Manny had predicted, knocked Kamau out. When I hit him, his legs were so wobbly, he looked like he was doing the lambada in the ring.

It wouldn't have surprised me to see my next opponent, Hectór "Macho" Camacho, do the lambada in the ring. A former champion, Camacho was a bit wacko, the kind of guy who would take his shirt off at the podium during press conferences and start flexing his muscles.

I had fun with him. We made a bet that if he won, he would get an extra $200,000. If I won, I could cut off that trademark curl of hair he had hanging down on his forehead. And I could do it right in the ring in front of the world.

After beating Camacho by unanimous decision, I went over to my corner, grabbed a scissors, confronted him, and said, "Hey, a bet is a bet."

"Come on, man, please," he said, begging me to let him keep his precious curl. "This is who I am. I'm like Samson. If you cut that off, I'll lose my strength."

Camacho didn't sound too macho at that moment. I took pity on him and let him keep his locks.

That was my last fight with Manny.

The problem wasn't what he did during my two fights with him in my corner, but what he didn't do in preparation for those fights. Manny did wonders for my jump shot. It seemed all we did was play basketball. If it wasn't basketball, it would be Ping-Pong.

I like Manny. He has a good heart, but that wasn't enough to please my father, who couldn't deal with his laid-back approach. Not just the hours playing basketball, but the fact that he trained me only four days a week. I had Wednesdays, Saturdays, and Sun-

days off. That was a radically different approach from the one I was familiar with. With other trainers, it was six days a week with a light routine on Sunday, consisting of watching film and taking long walks. But we were always active.

With Manny, if I was tired, he told me to take a day off. Rest is better for you anyway, he would say. That was his theory with sparring rounds as well. Fewer can be beneficial to the body. It didn't feel like a real training camp with Manny.

None of this felt right to my father, who was old school. He wanted to see me spar and run and sweat. Lots of sweat. Dead time? Run some more.

Even the way Manny worked the mitts bothered both my father and me. He would hold them very high and kind of flap them at you. It didn't work for me.

But I will always hold Manny in high regard for bringing back the aggression that had slipped away under The Professor and for reintroducing me to my right hand.

After beating Wilfredo Rivera and Patrick Charpentier rather easily and winning my rematch against Chavez, both in 1998, I had a classic battle against Ike Quartey of Ghana in February of 1999. I wasn't that concerned about him, even though he was unbeaten at 34–0 with a draw and had twenty-nine knockouts. Not concerned, that is, until I was on the receiving end of his punches. It felt like he had bricks in his gloves. Every blow stung. In the sixth round, Quartey knocked me down with a left hook.

I knew then that I couldn't worry about the damage he was capable of doing. I couldn't worry about getting my nose broken or having my features marred. I had to go get this guy. I got up and put Quartey down in the same round.

It was still a close fight heading into the twelfth and final round.

I shook off exhaustion and dug deep down inside for a final burst. It has been called one of the best rounds of my life. It was certainly one of the most satisfying. With the crowd roaring and my rhythm flowing, I felt a rush. It was as if everything was happening in slow motion. I could see each punch land, the sweat fly off the top of Quartey's head, and his face become contorted.

It seemed like the round took ten minutes. I kept waiting for someone to stop it. Quartey finally went down, but got back up and finished on his feet. I won by split decision.

I got more than a victory that night. I also gained the confidence, for the first time in my career, that I could be as effective in the last round as I was in the first, that I had the stamina to fight for a full thirty-six minutes, if necessary.

I needed all the confidence I could muster because I was going through a tumultuous time in my life. I would soon face Félix Trinidad, considered by many the best pound-for-pound fighter in the world, in the richest nonheavyweight match in history. I was also facing the fact that despite all my success in the ring, I was still lacking the two things I had desired from the beginning, a family and financial security.

It was time to grow up.

SEARCHING FOR LOVE

I had traded in my skateboard for a private jet, my neighborhood friends for an entourage, my meager-paying jobs for pots of gold, my few steady girlfriends for endless packs of groupies, my pitiful clothes for a wardrobe worthy of a *GQ* layout.

What was there not to like? I was like a kid in a candy store. But I suddenly felt as if I was locked in that candy store, having gorged on the goodies until I was sick with excess.

It all hit me one night in Vegas, an emotional uppercut that jarred me to my senses.

The evening had not started out well. It should have been a relaxing trip to Vegas. After all, I hadn't come for a fight, just to kick back and enjoy. I was staying in a huge, two-story suite at the top of the Rio Hotel, a ballroom-size area with a gorgeous view of the strip in both directions. This was going to be party central.

But first, I wanted to spend some time in the casino, and as it turned out, some money on the tables. Playing craps, I lost $350,000.

I didn't have much time to think about it, however. By the time I got back to the suite, the party was in full swing, about a hundred

people—many of whom I didn't even know—drinking, laughing, and dancing to the blaring music. It was bigger and wilder than any of the clubs downstairs.

It was wasted on me. I felt like a zombie as I wandered through a room full of strangers.

I walked over to a huge window and stared out at a thousand twinkling lights in this place known as Sin City.

As I looked around, everybody seemed to be moving in slow motion, like they were on a movie screen and I was in the audience as an uninvolved spectator.

Wham! Something just shook me. Tears began to run down my cheeks. I felt like I didn't belong there. Who the hell am I? What am I doing? They're all having fun, but I'm not happy. What kind of a life am I living? What have I become? This is not what I want. This is not for me. This is not what my parents taught me. I'm the kid who grew up with a solid foundation, the kid who had nothing as a child in East L.A. and I was happier then than I am now. I had become a different person because of the fame and the money and the women.

I just lost $350,000 and I was standing there crying while the party went on around me.

Nobody seemed to pay attention to my anguish. Nobody except Raul, who is always there for me.

He took one look at my face and immediately started emptying the room. The partygoers wanted to know what was up, but I didn't owe anybody an explanation.

Shutting everything down didn't help. I cried myself to sleep. The next morning, Raul and I checked out and headed home, even though we had been scheduled to stay for a few more days.

Sometimes I just didn't want to be the Golden Boy. No one is

going to feel sorry for me. I know that. No one is going to shed a tear for a celebrity whose life consists of partying, womanizing, and high-stakes gambling.

Run that by the average person and they'll have only one question: Where do I sign up?

After a while, though, you realize there's no substance to your life, no family values. There are too many people around you who care only about what you have, not who you really are.

In the midst of all those people, I was lonely. So lonely I would sometimes go to strip clubs more to talk to the women than anything else. Sex was always available to me, communication was not.

I was reaching the peak of my career, fighting big-name opponents, getting great pay-per-view numbers, making big money, and enjoying a constantly expanding fan base. But all that wasn't enough to satisfy my soul.

After my high school girlfriend, Veronica Ramirez, broke up with me, another Veronica came into my life, Veronica Peralta. We went together for about four years until she caught me with another woman. The two came to blows before I separated them. I was single again.

It's not that I lacked for women after that. Far from it. I was fooling around and having a good time.

I think it took that night in Vegas to motivate me to seek something closer to a normal home life. I wanted to know what it was like to settle down and have kids. I was anxious to find the right woman to make that possible.

Part of my motivation stemmed from my desire to prove that I could be different with my kid than my parents had been with me. I was hungry for that. I wanted to show my father I could do it, that I could be that lovable, expressive person that he never was

with me. I wanted a baby—didn't matter if it was a boy or a girl—to love, and to tell that baby I loved him or her.

I had had a girlfriend at the time named Toni Alvarado. We had been dating for a couple of years and had a wonderful relationship during that period. After a while, though, we had called it off because it wasn't working out.

She was an unwed mother with a two-year-old, a wonderful mother, very responsible, always there for the baby, always putting it first.

When we started talking again, I started thinking. Why not make an arrangement with Toni? I told her I wanted her to have my child and I would, of course, provide the financial support, but there would be no strings attached. I told her, "I don't want to have a relationship, I want to have a kid." And that's what we agreed to do.

We had a boy she named Jacob. She had agreed to have a child with me, so it was only fair that she got to name him.

When Jacob was born in 1998, I went into shock. I was ecstatic, but also uncertain. I knew I had come to a crossroads in my life. Seeing that precious infant hammered the point home. I had to choose which lifestyle I wanted, Oscar the high-living celebrity or Oscar the family man.

I started to think that, perhaps, we could live together as a family, and down the road, who knows? Maybe there would be marriage. Or maybe I would continue to live in my place and she would live in her house, but I would still take care of my little boy.

We wound up living separately, but I was over there all the time, telling Jacob I loved him, something I never heard when I was young, and even changing diapers.

I felt so good. It was a big load off my shoulders. I had done it. I had had a child and had formed a loving relationship with him right

from the start. When I was in town, I would see Jacob almost every day. And when I was up in Big Bear training, Toni sometimes brought him up to see me.

I bought a house for Toni and the kids in Glendale and provided financial support, and she was fine with that.

There was a period of about nine months when I didn't see Jacob. I went back to dating other women, reverting back to my old lifestyle, which I found I had missed. I have to admit, my absence was irresponsible.

I really missed Jacob, but I kept telling myself he'd be all right. He had a great mother and he knew I was his father. Toni was very supportive, never speaking badly of me to him. Whenever I fought, she made sure Jacob saw me on TV. He understood who I was and liked being the cool kid on the block whose father was a famous fighter.

Other than that one regrettable period of absence, we have had a great relationship to this day. I feel very close to Jacob. And very proud. He's a straight-A student, and plays soccer and baseball.

He asked his mother one time if he could be a fighter like his father. She took him to the gym, but once he got hit, he didn't like that, so he turned to baseball.

If any of my kids wanted to box, I would obviously support them, but it would kill me inside. If they're going to want to do it, they're going to do it, so I would come out to watch them even though I wouldn't enjoy it.

After Toni, I met Shanna Moakler. She was an actress and a former Miss USA, strikingly beautiful, with blond hair and green eyes.

We started dating and wound up having a child together.

Our relationship eventually went sour, but that had nothing to

do with the unborn baby. Even though the pregnancy had not been as elaborately planned as Jacob's had been, I wanted to make this work for the baby's sake. Marriage wasn't out of the question.

The baby was born in 1999, a girl we named Atiana. I was in the hospital, but not in the delivery room, for the birth. While Shanna's family was friendly to me, I always felt like the outsider.

I made a real effort once they came home from the hospital. I moved Shanna and Atiana from Shanna's condominium to a luxurious penthouse on Wilshire Boulevard. I wanted the good life for my daughter. There were many occasions when I slept over in that place in order to spend time with her. I tried to make it work for several months, but there was too much tension, too much friction.

The relationship deteriorated so badly that Shanna and I just stopped talking to each other.

By then, Shanna and the baby were living in my house in Bel Air.

"This is my house," she said. "I'm not moving out. My daughter deserves the best."

It was going take a lawyer, or the police, to get them out.

We had never settled on a figure for financial support, so Shanna came up with her own figure. She slapped me with a $62.5 million paternity suit.

I stayed away from the house while she was there. It took about a month to resolve the issue and bring the moving vans. We settled on a figure for support based on what I was earning.

She didn't need my house anymore. She got more than enough money to buy a very nice house of her own.

Through all the turmoil, I have been able to maintain a good relationship with Atiana, which was my main concern. The first few years of her life, I saw her a lot. I was there for her all the time.

Then there was a period when I didn't see her often, which was very unpleasant for me.

I don't think Shanna exposed Atiana to our problems. The times we were all together, Shanna was very good at masking her feelings. Nor was there any evidence that she bad-mouthed me to Atiana. Whenever I see my daughter to this day, she runs over, gives me a hug, and tells me she loves me. Shanna and I have joint custody and there's never any problem when I want to see my daughter. Shanna and I went through an ugly period when we were young, but we learned from it.

I eventually had a third child, Devon, out of wedlock as well.

While I'm so proud of those kids, I'm not proud of having three children with three different women, none of them my wife. But I was always a responsible father, taking care of the children's financial needs, seeing them as often as I could.

There were other women who claimed I had fathered their children. I acted responsibly in those cases as well, consenting to blood tests that revealed no biological link.

But I did have the three kids and still not the family life I wanted. What kind of existence was that? I had dug myself into an even deeper hole, for which I can only blame myself. Yes, I wanted to have children I could love, children who would love me, children I could forge a bond with, but it had not happened the way I had envisioned it. My life was still out of control.

People expect you to be this perfect person, and nobody's perfect. I certainly wasn't. I made a lot of mistakes as I dealt with the pressure of trying to balance my two worlds, the world I had known in East L.A. with my family and the world I found myself in as I gained worldwide exposure.

It was a double-edged sword. Sometimes, I wanted to be left alone to be with my family and live a normal life. But if I did that for too long, I missed the attention, missed signing autographs and being in the spotlight. You have to learn how to juggle the two worlds, a task it took me years to master.

I had been running around with a bad crowd. I hadn't been listening to my father or my brother or my oldest, closest friends from childhood. I had been listening to guys who only wanted to go clubbing and drinking, guys who kept reminding me I was Oscar De La Hoya and the world was mine. Often, I would go out with fifteen to twenty friends gambling or to a strip club. We were just young and stupid.

I knew it was time to get smart. I came to realize I couldn't simply go out looking for that certain special person to spend the rest of my life with. I understood you can't force the issue. I knew it didn't work that way. I was confident that if I waited, the right person would come into my life. I had to slow down my frenetic lifestyle once and for all and let it happen.

And, sure enough, like the answer to a prayer, there was Millie.

★ ★ ★ XIX ★ ★ ★

TITO

Unless you lived in Puerto Rico, it is difficult to understand how big Félix Trinidad was in his native land during his prime.

One of his schoolteachers, Carmen Carattini, who had lost her son Hugo in a motorcycle accident, said of Trinidad, "God gave him to me. I have lost a son, but I have the son of Puerto Rico."

Two cultures, Mexican and Puerto Rican, two undefeated fighters, the two top promoters in the game, Bob Arum and Don King, all coming together in Vegas, the boxing capital of the world, for a nonheavyweight showdown that brought back memories of Ray Leonard and Thomas Hearns, or Leonard and Roberto Duran, or Leonard and Marvin Hagler.

I couldn't wait.

Before I could think of the man in the other corner, I had to think about my own corner. Manny and The Professor were long gone. I needed a new trainer to partner with Robert.

Bob Arum suggested another big name, one who wouldn't vary from the more orthodox methods of training, Gil Clancy.

Gil, a Hall of Famer himself, had trained Hall of Fame fighters like Emile Griffith, had worked with everybody from Muhammad

Ali to Joe Frazier to George Foreman, and had also been a fight manager, a matchmaker, and a television analyst.

Hiring Gil was great for Robert because Gil, seventy-five years old and retired for twenty years with the exception of one fight, made it clear he had no interest in becoming my head trainer. He wasn't about to relocate from his home on the East Coast, nor did he want the heavy workload at that point in his life. He would assess my status in training camp either by phone or on an occasional visit and be in my corner for the fights. It was the only time Robert didn't feel threatened by another trainer, which made for a looser atmosphere in camp. Robert still got to be the boss.

In my first fight with Clancy, four months before my September 1999 match against Trinidad, I faced Oba Carr, and reinjured my left hand throwing a jab, the very first punch of the fight, but hung on to win by TKO in the eleventh round.

My hand healed in time for the big match, leaving me beaming with confidence. I knew Félix Trinidad was a dangerous puncher, a strong fighter, but I figured he couldn't be any tougher than Quartey. The guy who did bother me in that fight was Don King. He was the rival promoter for the match, the first in which I had been involved with him, and I have to concede, he intimidated me. He made me nervous.

Trinidad didn't bother me. He and his father, Don Félix, talked nasty in the press conferences. Bad stuff. The way I responded was to refuse to look Trinidad in the eyes. Never. That ate him up alive. It was my way of saying I didn't respect him without saying anything at all. He would yell, "Look in my eyes." I wouldn't do it.

I thought of Trinidad as coming out of the same mold as Rafael Ruelas, a strong puncher with poor balance. The trick was to take away Trinidad's best weapon, the left hook, by moving side to side.

That would neutralize him. If I could do it, I figured it would be an easy fight.

I honestly believe if Gil Clancy hadn't been in my corner that night, I would have knocked Trinidad out.

I trained for that fight for three months and all I ever heard from Gil was, "Box, box, box." If I tried to stay toe-to-toe with my sparring partners and exchange punches, Gil would stop everything and yell at me, "Damn it, you've got to box this guy. You've got to stay on your toes."

I never really understood why I couldn't vary from that strategy if an opening presented itself. Yeah, I was fighting Félix Trinidad. So what?

Robert didn't buy into the fight plan at first. "No, let's take this guy on," he would say. "Come on, we can do it."

"No, damn it," Gil would insist. "Oscar's got to box."

With Gil's words ringing in my head, that's what I did the night of the fight, stay on my toes and box.

It felt so easy. I was expecting a lot more from Trinidad. And I wanted to do a lot more, like move in and finish him off. But the few times I tried to mix it up and throw combinations, what would I hear when I went back to my corner? Gil and Robert would both ask, "What are you doing?"

After the ninth round, as I sat down on my stool, Gil was going through his boxing mantra, and Robert was agreeing with him.

"You want this fight? Just box," they both said. "Do not stay in front of him. Don't get hit. You have the fight won."

Even though there were three rounds left, a long time to be dancing around, I went out there like a robot and followed the strategy that had been pounded into my head for three months. I had been programmed to box and nothing else. It wasn't as if I was hurt

or had run out of gas and couldn't physically do anything else. I was in tremendous shape.

Nor was it necessarily the smartest strategy to just keep boxing. The more I stayed in front of Trinidad, straying from the directives I was getting from the corner, the better it was for me, because I could handle him. I could keep him at bay and throw my combinations, which were proving quite effective.

It was when I started backtracking, as I had been ordered to do, that Trinidad got the momentum he had been looking for the entire fight.

Those last three rounds went so fast it was all a blur to me. While those rounds were unfolding, I didn't feel as if I was fighting differently than I had earlier in the match. But I have to admit, when I saw the tape, I realized I wasn't being as aggressive, wasn't throwing as many punches. But Trinidad didn't do all that much, either. All he was doing was going forward. He certainly wasn't inflicting any damage.

When the final bell rang, the first thing I thought was that I should have knocked him out. I was mad at myself. But I had no doubt I had won the fight. I was happy as could be. At the very worst, I had won seven rounds to five. If I had not listened to my corner, used my old style instead, it would have been a walk in the park. But even so, what were they going to give Trinidad? Four rounds? Five?

Trinidad knew. He came up to me while we were awaiting the judges' decision and said, "Great fight. You won."

When the scorecards were read, announcing Trinidad had won by majority decision—judges Jerry Roth (115–113) and Bob Logist (115–114) gave it to Trinidad, while judge Glen Hamada (114–114) had it a draw—I was stunned, devastated. It was my first professional loss. I couldn't believe it. I was in shock.

When I got to my dressing room, I went crazy, punching the

lockers. Gil was also devastated. I remember him in my dressing room afterward, head in his hands, tears in his eyes.

Still, I have to admit, it wasn't as bad as losing to Marco Rudolph eight years earlier at the world championships. This time I didn't lock myself in my room for two weeks.

The difference was, I had honestly lost to Rudolph and that hurt. This time I didn't think I had been defeated fair and square. This time I thought Don King had something to do with those judges. Now that I've become a promoter myself, I realize how hard it would be to affect the judging.

I'm not absolving myself of blame in the Trinidad fight. I made it closer than it should have been. I should have knocked him out. I failed myself and my corner failed me that night. My failure was in listening to them, in convincing myself they were right and I was wrong. It's difficult to fight both your opponent and your corner.

There was one bright moment after the fight, a moment I had been waiting for all my life.

When the outrage had calmed, my father pulled me aside and said, "I'm proud of you. I'm proud of what you have accomplished."

That was the first time I had ever heard him say that and it came after my first defeat as a professional.

Nothing would take the sting out of that loss, but those words certainly were a balm on my emotional wounds.

There was also the consolation of knowing the fight was a tremendous financial success. It attracted 1.4 million pay-per-view buys, the largest total for a nonheavyweight bout in boxing history.

The idea of losing a fight somewhere, somehow, had entered my mind long before I fought Trinidad. *Prepare yourself. You're not going to quit when it happens,* I had told myself. *Everybody loses. The question is, how are you going to come back?*

I assumed I could come back against Trinidad in a rematch, but it just didn't materialize. Back then, I didn't have anything to do with the negotiations for my fights. For the proposed rematch, it was all Bob Arum, Don King, and Don Félix. I was out of the loop. After a fight, I would go party and figure my promoter would cut me a good deal.

If someone had come up to me and said, this is the money for a Trinidad rematch, this is the weight, what do you think, I would have said, "Let's fight."

Even after the negotiations collapsed, I always assumed we would fight again at some point until Trinidad moved up in weight.

When Bernard Hopkins fought him in 2001, I hoped, at first, Trinidad would knock Bernard out. That would enhance my performance since Trinidad didn't touch me.

But when Bernard exposed Trinidad's weakness and defeated him, I realized Bernard saw my fight and learned from it. That made me proud.

I haven't lost any sleep over not fighting Trinidad again. I'm convinced I beat him and I'm content with that.

SHOOTING FOR THE MOON

They appeared out of the shadows on the day I put that gold medal around my neck and they would not leave.

Along with the leeches I have already described posing as promoters, managers, and trainers, there were the financial parasites. They also wanted a piece of Oscar De La Hoya.

While my fans merely wanted to look, or perhaps touch, the precious gold I had won at the Olympics, the parasites wanted to own the Golden Boy himself.

They promised me and my family riches that would make the gold hanging down from my neck look dull in comparison. Just as was the case with the boxing people who wanted to steer my career in the ring, there were lawyers, agents, accountants, and snake-oil salesmen who wanted to steer me to the top of the business world. They, too, waved wads of money, offered contracts, cars, and guarantees if only I would sign with them.

The vultures had been circling long before I went to Barcelona, but I, with the help of my family, had been able to wave them off, telling them, and myself as well, that there would be plenty of time to cash in after I was triumphant at the Olympics.

But now that time was at hand, the time to turn professional, the time to invest my faith and potential fortune in someone who could guide me through boxing's treacherous terrain and deal with the sharks and the phonies, someone who was motivated by more than just greed, someone who genuinely had my best interests in mind.

Many suitors called me, and a few even showed up on my doorstep. The standard line was, "You don't have an agent? Well, I'm the guy. Let me tell you what I can do for you."

One guy came to the door wanting to sell T-shirts with my face on them.

It was all so confusing for a struggling family from East Los Angeles. Who do we go with? Who do we trust?

I knew all the horror stories. I had read about Joe Louis, one of boxing's all-time greats, winding up as a greeter at Caesars Palace. I knew that most fighters squandered their money, saddling themselves with investments in the wrong deals, listening to the wrong advisers, hanging out with the wrong people, or marrying the wrong women.

I was determined to be different.

I was different all right. I picked Mike Hernández, owner of a car dealership, to be my business adviser.

That caused a lot of people to raise their eyebrows. Unfortunately, that didn't raise any concerns in my mind. At nineteen, I was too naive, too oblivious to the realities of finance, to even listen to those who questioned my odd choice.

I met Hernández soon after I had won Olympic gold and the offers were flowing in from all directions. Somebody relayed one such offer that immediately got my attention: Chevrolet wanted to give me a purple Corvette.

Great, where do I sign up?

The name I was given was Mike Hernández.

I went down to his dealership, Camino Real Chevrolet in Monterey Park, and he gave me the car. But he also gave me a spiel about what he could do for me, the bright financial picture I had, and how he could make that picture bigger and brighter than could anybody else.

Hernández was smart. Once he'd sunk his hooks into me, his next move was to find a way to hang on to those hooks, no matter who else tried to lure me away.

Who is close to Oscar? Oh yeah, the father.

Sound familiar? That was the same strategy employed by my old managers, Mittleman and Nelson.

Hernández introduced himself to my father and they became friends. Hernández was determined to keep my father close to him, figuring he'd keep me close as well.

I can't blame my father for that. Hernández and I were friends, too, and we had a good relationship for a long time.

After I began making money, he told me, "Look, you have to start taking care of your money. You have to invest your money. Let me set up a corporation for you."

To show you how little I knew about finances, I thought, *Wow, this is my savior. Look at the big store he has. He's selling cars. Amazing. This is my golden ticket. He's going to take care of me and I'm going to live happily ever after.*

It went on like that for years.

So what did he do with my money? Kept it in the bank earning 4 percent interest. I might as well have been keeping everything in cash under my pillow.

I can't say Hernández broke any promises to me about expanding my income because no specific promises had ever been made.

I wasn't concerned. I was having a great time, doing my thing,

living the good life. I was happy to just train and fight, relying on Hernández to take care of me.

I didn't even ask how much money I had. Nor did I ever worry about where it went and neither did the people around me, other than Hernández and my promoter, Bob Arum.

When people would ask me where my money was, I would point to my house, dangle my jewelry, rev up the engine in my purple Corvette convertible, or mention my country-club membership in Whittier.

Shortsighted? Definitely.

Pretty common among fighters? Absolutely.

When a fight was over and a commission official handed me a check, Hernández would take it.

I didn't even know what bank he put it in.

What happened when I wanted cash? Say I wanted to go to Cabo San Lucas for a weekend and say I wanted to take $10,000 with me. I'd tell Hernández and he would have the money waiting, usually in cash, at the car dealership. I'd go down there and they would open their cash box, take out $10,000, and hand it to me, sometimes in an envelope, sometimes without an envelope.

If I wanted to go again the following week, it was the same deal. Go down to Camino Real Chevrolet and punch my ticket.

When I told Hernández I wanted to buy a Bentley, it turned out to be one of the most expensive Bentleys ever built. He told me he bought it through his company, but I wound up paying more than I would have if I had simply bought it off a showroom floor.

That's when I first started sensing something was wrong.

Another example. I purchased a condominium in Cabo San Lucas from a good friend of Hernández. When I decided to sell the place, it turned out to be worth a lot less than I had paid for it.

There was the one investment Hernández got for me: his car dealership. He told me, "The parts department makes a lot of money. You should invest two-point-two million. You are going to make a fortune."

When I signed a check for that amount, he told me, with a big smile on his face, "Great investment. Great investment."

Something else that struck me wrong was a comment Hernández made after one of my fights. He said, "Now you're worth what I'm worth."

I had just made several million, I was filling up stadiums, selling pay-per-views, and I was worth the same as a car dealer? What's wrong with this picture?

Then there was my office at Hernández's dealership, an office I was being charged rent to maintain. I later found out I was being charged thousands of dollars more than I charge for an office in the high-rise I now own in downtown L.A. at a prime location.

When he tried to generate outside income for me, Hernández seemed out of his element. I had had a Budweiser patch on my trunks from the time I first stepped into the ring as a pro. By the time Budweiser wanted to renew, they were offering me $250,000 a year to make a few public appearances and keep that patch right where it had always been. As part of the deal, Budweiser would continue to feature me in Super Bowl ads, the best exposure possible for an athlete.

The deal fell through because of Hernández's insistence that the patch alone was worth $1 million and would not be available for less.

All these incidents kept piling up, but I guess I was a slow learner.

I also found I didn't trust Hernández to adequately represent me in my career any more than I did in terms of my finances. He was my manager, but he wasn't a boxing guy. Arum would go to

him and say, "Look, this is what I'm going to pay Oscar." Hernández, not having the experience or the knowledge to counter that offer, could only say, "Yeah, take it."

A perfect example was my fight against Tito Trinidad in 1999. I left tons of money on the table because, in my opinion, I wasn't properly represented. That fight was purchased in 1.4 million homes. Even though I was no expert on the pay-per-view business, I started doing the math. I know Arum says he took the risk and got rewarded, but there's never a risk with a fight like that.

Arum and Hernández were so close. They never seemed to have issues with each other, while I always felt out of the loop. Hernández had control of my father and they both thought my father had control of me.

The only thing Arum would ever say to me about Hernández was, "Oh, Mike Hernández is a great guy. You have a wonderful guy behind you."

I'm not implying Arum stole from me. I'm just saying he didn't have a knowledgeable boxing guy pushing him to cut me a better deal.

I didn't talk to my dad or my brother about the situation. Nobody knew my business. Everything was always kept quiet.

Besides, why would my father complain? He was a happy camper. He was getting 10 percent of my purse. He was handed his check and he could do anything he wanted with it. He had his own people to manage his money.

What did Hernández get out of representing me? He would tell me he only wanted to take a dollar a year. That's it.

Again, I didn't question him. I believed he was a genuinely nice guy and a powerful businessman in the community. That's how I perceived him because he had this big lot with all those cars.

But finally it all added up: the incident with the Bentley, the condo, the outrageous rent. Finally, some maturity and wisdom kicked in. I woke up one day and realized this was not the direction I wanted my life to go.

It hit me that knocking people out was not going to assure me of long-term financial security. Why wasn't my net worth growing at the same rate as my prizefighting purses? I know I'm a kid from East L.A. with hardly any education, but that doesn't mean I'm going to let people take advantage of me forever.

I needed someone who could honestly answer questions about my financial future and I felt Hernández was no longer that person.

Sitting in my apartment in Whittier, I made a decision from which I would not be swayed. I called Raul Jaimes, one of my oldest and most trusted friends, my right-hand man, and told him to come over. It was time for action.

When he got there, he could see the determination on my face.

I said, "Raul, I've had enough. Enough. Let's go down to Camino Real Chevrolet and get rid of Mike Hernández and everybody else. I can't reach my potential with a car dealer. I'm making all this money and he doesn't know what to do with it. There's no way I can grow like this."

Raul was nervous and scared.

"What are you doing?" he said. "You can't do this."

I wasn't budging.

"No," I said, "I am going to do it. This is what's meant to be."

Before I told Mike I was cutting the umbilical cord, I wanted to inform those closest to me. So a meeting was set up that night at a restaurant owned at that time by my trainer Robert Alcazar. Robert, of course, was there, as was my father, my brother, and Raul.

When we arrived, we had a few drinks to soften up my father.

Then I told him, "I'm getting rid of Mike Hernández."

"What?" my father said, his eyes getting wide. "You can't do that. Your life is going to be ruined. Look at what this guy is doing for you. Look at what he is doing for us. He's a good man. He's the smartest man ever."

The mellow feeling induced by the beer had definitely dissipated.

I looked over at my brother, who had worry written all over his face.

"Who are you going to get?" my brother asked. "What's going to go on?"

"I'll figure that out," I said, bolstered by a rush of newly discovered confidence. "I'm just going to get rid of him. I'm not happy with him. I can do a lot better."

My brother and Robert started crying.

After a while, everybody realized, yeah, Oscar really is going to do this. They were petrified. Especially my father

"Look," I told them, "I'm going to shoot for the moon. You are all going to hang on or you are going to let go and watch me fly away."

Nobody spoke.

We broke up the meeting agreeing that we were all going together to see Hernández the next day.

As Raul and I drove over to the dealership in the morning, Raul called my father, my brother, and Robert. Nobody picked up their phone. We were on our own.

When we got to the dealership, we went up to Hernández's office on the second floor.

Hernández looked at Raul and said, "Get out. I don't want you in my office. I need to talk to Oscar alone."

I nodded and told Raul, "Go downstairs, I'll be okay."

I did away with the niceties and told Hernández, "I'm going to go my own way."

I don't think he really got it at first.

He just said, "Okay, that's fine. We'll talk."

"No," I said, "I'm serious. This is it. It's over."

Then it sank in. He tried for an hour to talk me out of it.

"We have big plans," he told me. "You are making a huge mistake. You have your whole career ahead of you. Bob Arum is going to try to screw you over. I'm the one who is taking care of you."

He couldn't get to me. I just wanted him out of my life.

Don't get me wrong. When I left Hernández in 1999, I had money, but it was a lot less than I'd thought it would be.

Mike wound up suing me and I countersued. We wound up together again in the same room to give depositions, along with Raul, Hernández's girlfriend, and the lawyers.

After a long morning session, there was a break around lunchtime. I went over to a wet bar in the corner to get some coffee. Raul remained at the table, where Hernández confronted him.

"What the hell are you doing with Oscar's life?" Hernández asked him.

I looked over and saw Raul was scared. He had always felt threatened by Hernández.

Hernández hadn't realized I'd overheard the conversation until I got in his face.

"What are you talking about?" I asked him. "My life is perfect."

"Oscar, are you really happy? Look at the big mess you're in, the way your career is going," he said, referring to my controversial loss to Félix Trinidad. "All this is happening because you're making the wrong decisions."

"I'm happy," I told him. "Leaving you was probably the best move I ever made."

I could see the frustration in Hernández's face, which was turning red. Getting nowhere with me, he turned his fury on Raul.

I stepped between them and told Hernández to back off.

It felt good after all those years of mindlessly nodding at everything he proposed to finally fight back.

Hernández immediately backed down, unable to even look me in the eyes. He wasn't used to seeing me act this way. In his heart, he might have thought he'd be able to get me back at this hearing. I think, right then, he knew he had really lost me.

"Don't do this," he said in a soft voice. "We don't have to do this."

"I'm standing up for myself," I replied. "I'm not the kid anymore."

And that was that. We ended up settling and Mike Hernández was, finally, totally out of my life.

ENTER RICHARD SCHAEFER

When Raul and I left the hearing, I was feeling pretty good about myself. As we got into my Bentley and headed home down Sunset Boulevard, I felt like a great weight had been lifted from my shoulders, like I was sailing along with my tires not even touching the ground.

How wrong I was.

Suddenly we heard a bang, felt a lurch, and my car began to shake. I pulled over to the side of the road, right across the street from UCLA. I had a flat tire.

"Do you want me to call a tow truck?" Raul asked.

"No," I replied, "let's do it ourselves."

It seemed so fitting. On the day I shed myself of the man who had run my career, I was rolling up my sleeves to take control of this minor mishap on the road. It was a first step in taking control of my life.

With Hernández in my rearview mirror, what lay on the road ahead for me?

Raul, knowing where I wanted to go, came up with a shortcut. I had figured I would hire some good lawyers and do the kind of

research on finances that I should have done years before. Raul suggested I first talk to the husband of his aunt Lilia, a banker named Richard Schaefer.

The name was not completely foreign to me. We had met two or three years earlier. When Raul brought Schaefer's name up, the first thing I did was break into a big smile.

This was a guy who had taken me over the edge and left me soaked for all I was worth. Not exactly a performance that leaves you with a lot of faith in the man.

Except, I'm talking literally. He hadn't steered me into the wrong investment, just into a shallow lake.

I had gone with Raul and some other friends to Palm Desert to play golf. Richard, who had a home in the area, was a big boxing fan, so Raul teamed us up. We even shared a golf cart. Bad idea.

It was a friendly game. We talked boxing, not business. Raul hadn't told me what Richard did for a living or who he worked for.

With Richard driving the cart, we found ourselves with a small mound to ascend in order to reach the green on our next hole. Coming down the other side, Richard was speeding on grass that was still moist and slick from the morning dew. From one side, my brother and Raul suddenly came into view, also speeding down on a collision course.

Richard made a sharp turn to avoid them, throwing us into a spin that ended with us splashing into a lake. Our clubs were drenched and we found ourselves ankle-deep in water, trying to push the cart back onto the grass.

It was hilarious.

So yes, in my first meeting with Richard, he definitely left an impression.

Richard and I talked occasionally after that about investments. I thought he had a brilliant mind for finance, so I asked him if he would educate Mike Hernández, who was still my business adviser at the time, about some of the programs Richard's bank offered. I thought maybe Richard and I could do some business together. Richard had the same idea when we met. He was in the private banking business and what better client could he find than a young millionaire with a growing income?

Richard went to the car dealership, but when he sat down in Hernández's office, he knew right away that Hernández was not going to be receptive to an outsider.

"What do you want?" Hernández asked him.

"I would like to explain to you what our bank does," Richard said, "some of the services we offer."

"Can you guarantee him ten percent return?" Hernández asked.

"No," said Richard. "If you want a guarantee, put your money in CDs and right now the CD rates are five percent. If you want more, it depends on what kind of risk you are willing to take. If you are in bonds, you can make this much; if you are in equities, you can make that much. You have to tell me the risk profile he has, his overall asset allocation, and how Oscar invests his money. He's a high-income taxpayer. We could look at municipal bonds, maybe some stocks, some international stocks. We could put together an investment portfolio to make sure he's nicely diversified."

"Let me stop you right there," Hernández said. "If you can't guarantee him ten percent, you are wasting your time."

"Why?" asked Richard.

"Because I can guarantee him ten percent," Hernández said.

"How can you do that?" Richard asked.

"Because he's investing in my dealership," Hernández said.

"Oh, wow; well, good luck," said Richard, who immediately got up, took his briefcase, and left.

He told me there was no use in talking to Hernández because he didn't make much sense.

It was three years before I dealt with Richard again.

When I said good-bye to Hernández, Raul again mentioned Richard as the ideal guy to help me set up a team of business advisers and lawyers.

We didn't go to Richard with the idea of asking him to take over my financial affairs. I wasn't looking for that. I had just been burned by depending on one guy for all my monetary advice and I wasn't anxious to fall into a similar trap. I wanted a team around me.

"Richard will help you," Raul said. "He's a nice guy and he'll give you some direction." I needed a few days to think about it.

The more I considered the idea, the more I liked it. After I retained the services of Bert Fields, perhaps the most respected attorney in L.A., Raul and I went to see Richard in his Swiss Bank Corporation office on the sixty-fourth floor of the Library Tower.

Very impressive. Even more impressive than a car lot.

We reminisced about our adventure in the lake, talked a little boxing, and then got around to finances. It was a pleasant conversation, leaving me with a good feeling about Richard.

I told him, "I don't know what I'm doing as far as my money is concerned. I need help. I just terminated my relationship with Mike Hernández. I want to have more control over my business dealings. And I hope you could help me."

Richard agreed.

"I'll help you out," he said. "I'm a boxing fan, I like you, you're a friend of Raul, and he is part of the family."

Leaning heavily on Richard for advice, Raul and I began an extensive search for the right people to form my financial team. We were at it from 7 A.M. to 7 P.M., interviewing money managers, agents, and lawyers, all the top-notch people in their respective fields.

I already had two reliable agents, Bruce Binkow and Leonard Armato of Management Plus, who had been with me since 1998.

I talked to Jerry Perenchio, the majority owner of Univision and the man who had promoted the first Muhammad Ali–Joe Frazier fight. He had become a good friend and I valued his advice. I signed up with a top-notch accounting firm. But most of all, Raul and I met with Richard again and again.

I kept asking Raul, "How much am I going to have to pay this guy? What's the deal here?"

Raul told me not to worry about it.

My concern was understandable. Everybody also told me I had nothing to worry about when I was with Mike Hernández.

That one visit to Richard turned into hours, days, and then weeks. He spent a great deal of time organizing my finances and discovering how much I had and where it was.

I told him, "I want to get out of anything I was involved in with Mike Hernández."

Richard kept at it, but he never asked me for any compensation. More importantly, I could tell he was honest and that meant a lot. It's funny. As a fighter, you feel invulnerable in the ring, but very vulnerable outside of it, especially when it comes to money.

I remember Richard drawing a pie split into four pieces. He said I should invest this much in one piece and this much in another. The days of banking on the best interest rate for the savings account were over.

It was safe to assume Richard Schaefer didn't keep his money

under his pillow. I realized this was the guy I had been looking for since I first put that gold medal around my neck.

I also had problems, serious problems, outside the ring. I was being sued by a woman who falsely claimed I had raped her, had a paternity suit pending against me, and I would soon be involved in lawsuits with Hernández.

The Golden Boy was tarnished.

Schaefer came from a banking family back in his native Switzerland. After graduating from a business school in Bern, he worked for the esteemed Swiss Volksbank and then spent a dozen years in the U.S. offices of Swiss Bank Corporation. During that time Swiss Bank merged with UBS, another Swiss banking company, and Richard was put in charge of their entire U.S. operation west of the Mississippi. By the time I came to him for financial help, Schaefer had twenty of the forty wealthiest people in the western half of the country as clients and was deputy CEO for the company's private banking operation for the whole country. He had been so successful, the bank's West Coast branch, which had begun in 1987, was bigger than the East Coast operation, which had started in the 1930s.

I reached a point where I wanted to be his only client.

"This is all too much for me," I told Richard. "I can't handle both my boxing career and the business side. I need a CEO for my financial interests, a quarterback to run the show."

Replied Richard, "Why don't you go talk to other people as well and then we'll talk again. I will help you to identify that person."

That was not necessary.

"I don't want to talk to anybody else," I said. "I have already identified the person. It's you. I don't know how to ask you this and I figure you are probably going to say no, but I want to hire you. Would you leave the bank to come work with me?"

Richard's first reaction was, "Wow!"

Having worked with him for months to construct a game plan for my future business dealings, I found a kinship with a man who, on the surface, didn't have much in common with me. He was nearly fifteen years older, came from Switzerland, grew up in a family where finance was the focus, had attended prestigious schools, and had made his mark in plush financial institutions. Yet he was every bit the fighter I was, just as driven, as competitive, as determined to win the gold. The only difference was, his gold was stored in vaults.

Once he caught his breath, Richard told me he was "surprised, but honored at the offer. I know there are an awful lot of people who would love to have this kind of opportunity. And that's what I view this as, an opportunity."

Richard went home and talked to his family and we soon had an agreement.

He found himself making a career leap he couldn't have imagined before stepping onto the golf course that day so long ago.

Richard's father, a Swiss banker himself, still couldn't imagine it. When the younger Schaefer called home to say he had decided to resign from the bank to become the business adviser of a boxer, his father was stunned.

"It's time to come back to Switzerland," his father told him. "You've been in America too long. You are going from banking to boxing? At least come home first and talk."

The younger Schaefer wasn't going anywhere. At thirty-eight, he had made a life-changing decision. He would lend a golden touch to the Golden Boy.

I had no doubt he would succeed. I couldn't have given Richard a better glimpse at the cutthroat world he was entering than my 1999 fight against Félix Trinidad. I had given him tickets to the

blockbuster event. What he saw was a horrible decision, in the eyes of almost every boxing writer sitting ringside, followed by a bitter post-fight press conference. Don King, who promoted Trinidad, announced to the media with his trademark cackle, "The lights are going out in Arumville." He went on and on, as only King can do, prompting my publicist, Debbie Caplan, to reach behind the lectern and pull the plug on King's microphone. That further enraged him.

Seated in the audience, Richard had to be thinking just how bizarre this whole boxing universe was, especially in comparison to the boardrooms in which he conducted business.

But when the chance arose to become part of that universe, he never blinked. As I soon learned, he could be just as tough a fighter in his business suit as I was in my trunks.

When Richard told his superiors he was leaving, and why he was leaving, they were just as mystified as his father.

And even more determined to stop him.

If it was sports Richard was interested in, they would give him a sports-and-entertainment group to run. If it was travel that intrigued him, they would make him head of the company's Monte Carlo bank in Monaco.

None of these opportunities gave Richard second thoughts any more than had his father's concerns. He was going to come to work for me.

But for how much? I may not have been a financial whiz, but I knew bank executives didn't come cheap. Especially one like Richard, who was the highest-paid private banker in his company worldwide.

Again, I was very impressed with him. He pulled out a sheet of paper and wrote down some figures. It was very professional. He told me the banking industry had provided him with a very lucrative income and he wasn't willing to sacrifice it. But he also didn't

feel comfortable taking more than a business manager should, so he would work to generate enough income to satisfy both of us.

Who could argue with that?

"I know you've been talking about retirement," Richard told me (remember, this was back in the year 2000). "It would be awfully foolish of me to leave behind the amazing job I have to go to work with a guy who is contemplating retirement. So why am I doing this? Not to be a part of your boxing career as much as being involved in your fantastic opportunity, as a true Mexican-American icon, to capture the growing Hispanic market in this country in a way no one else can."

Married to the former Lilia Jaimes, a native Mexican who had emigrated to this country as a child, Richard understood the Hispanic culture. He saw the potential of the growing Hispanic buying power in the United States and felt I, as a Mexican-American, had crossover appeal to both Anglo and Hispanic consumers. I could not only straddle two cultures, he said, but also appeal to both males and females, sports fans and pop-culture fans.

Richard wanted to know what my goals were in the business world. I told him they weren't modest. I wanted to make more outside the ring than I made inside it. I wanted to build a business empire. Since boxing was what I knew best, it seemed logical to start there, as a promoter, and then expand into other businesses.

With both of us on the same page, Richard and I drew up a blueprint for success, a blueprint based on my future in business, not my past in the ring.

Next, Richard turned to the lawsuits.

"Take the bricks off your shoulders, the gum off your fingers, and breathe again," he said. "Be free. These lawsuits have encircled you. You keep pushing them forward as if they are suddenly

going to go away. They won't. You need to take care of them, get them dismissed. Face them head-on just like you face your opponents in the ring. We need to move on. Why do you want these people lingering in your life, hanging on? It's not worth it. This has to be your first order of business so that, when you go to training camp, you can focus on your fights. You will have a financial base when you are done. And whatever that base ends up being, you will start building again. Build from that foundation. Build your business."

From Richard, I finally learned to face my problems and deal with them. It was uncomfortable, but when I was done, when the last lawsuit was dealt with, I had a great feeling of relief.

Finally, there was the matter of my father and brother. They had both been receiving a percentage of my earnings under Hernández, and I had no intention of cutting them off now.

"How much do you want to pay them?" Richard asked. "It's up to you."

I came up with a figure and everybody was happy.

It was all so new with Richard. I had my first credit card. Can you imagine that? Here I was, a professional fighter, a very successful professional fighter, for eight years, and I had never had a credit card. The days of getting cash in an envelope at the car dealership, like I was engaged in some drug deal, were over.

The difference between Richard and Mike Hernández is best illustrated by the way they regarded me, the man who was supplying the revenue. Richard sees me as an equal, someone who is involved every step of the way in every business transaction.

Hernández's attitude was demonstrated in a conversation he once had with my agents Binkow and Armato. "The best way to

keep Oscar out of trouble," Hernández told them, "is to buy him his own strip club."

I did as Richard advised on many issues—he never advised me to buy a strip club—and off we went, the financial world opening up under his guidance.

I was almost on empty when that journey began. After all the lawsuits were settled, I had only a few million dollars left.

"Now we have to reload," said Richard, undaunted by the numbers.

He had two targets for us, operating businesses in which we would be actively involved in running the day-to-day operations as majority shareholders, and businesses in which we would only invest.

Richard believes in a well-diversified allocation of liquid assets, putting the funds into fixed-income investments, such as municipal bonds, along with traded equity, private equity, commodities, and alternative assets.

That, Richard said, would be my safety net, my guarantee that I would always have enough money to support me in a comfortable lifestyle.

We could then take some risk by investing additional money in real estate and corporate assets. With Richard, it's not that much of a risk because his years in the financial arena have enabled him to identify money-savvy people to become our partners in various business ventures.

Richard believes that with investments, you make your money on the way in, not on the way out. When nobody wants an asset, you buy. When everybody wants it, you sell.

We have focused on five areas to invest in, with a special emphasis on the growing Hispanic market:

Real Estate

We have formed Golden Boy Partners for development projects and Golden Boy Real Estate for existing structures.

So many Hispanic neighborhoods in L.A. and frankly, all over America, have been neglected. They are crying out for the kind of redevelopment Magic Johnson has done in the African-American community. While Richard is my guru, Magic is my role model.

We have hooked up with John Long, a very successful developer, through his company, Highridge Partners. We combined forces to form Golden Boy Partners. Gabriel Brener, a wealthy businessman from Mexico, has also joined us in this venture, as he has done in many others.

We currently have eight projects in various stages of development. These projects will be lifestyle centers where people can live, work, and play. We want these places to be a destination for people. They will contain stores, movie theaters, affordable housing, restaurants, and fun zones. Something for everyone's taste. It's a chance for me to give back to the community

Along with Gabriel, we acquired a high-rise on Madison Avenue in downtown Manhattan. We bought the office/condominium structure in 2003 and sold it in 2006 at the height of the market, one of the highest per-foot sales ever recorded in New York.

In 2005, we bought a high-rise on Wilshire Boulevard in downtown L.A., which now houses our offices, and renamed it the Golden Boy Building. Through another associate of Richard's, Chris Rising, we had been tipped off that the fourteen-story building was for sale well below replacement level because it was only 40 percent occupied and was missing an elevator.

At the meeting to close the deal, Richard informed the seller it would be that seller's obligation to replace the elevator, which would cost half a million dollars.

The seller balked.

"Then forget it," Richard said. "I'm not going to buy a building with one of the elevators missing. That's not right. That's like buying a car without wheels. Give me a break."

The sellers thought Richard was nuts, threatening to walk away from a deal like that because of an elevator. Richard was just bluffing, but the bluff worked. The seller paid for the elevator.

Because of the conversion of many downtown L.A. structures into residential buildings with lofts, and all the other construction going on in the area, available office space has been diminishing since we made our purchase. As a result, today, our building is 100 percent leased, every office filled, generating an annual profit in the millions.

A couple of years later, Richard refinanced the building and used the extra money generated to buy *The Ring* magazine, boxing's most prestigious publication, and several other magazines as well. So really, that purchase didn't cost us anything. Today, the building is worth several times what we paid for it.

For now, we are holding on to it. Eventually we will sell because, as Richard always says, "Never fall in love with your assets. You only fall in love with your wife and your kids. Everything else is for sale."

Sports and Entertainment

This includes Golden Boy Promotions; Golden Boy Mixed Martial Arts; the Houston Dynamo, the two-time defending Major League

Soccer champions; Frontera Productions, a movie company geared to making films for Spanish-language audiences; as well as a small stake in Univision, the leading Spanish-language television network.

Media

We have gotten into the Hispanic newspaper business as investors in ImpreMedia, the dominant source of information for Hispanics in this country. ImpreMedia owns *El Diario La Prensa* in New York. Around since 1913, it is the oldest Hispanic newspaper in the United States. ImpreMedia's publishing empire also include *Hoy Nueva* in New York, *La Opinión* in Los Angeles, *La Raza* in Chicago, *El Mensajero* in San Francisco, *La Prensa* serving Orlando and Tampa, and the chain of Rumbo papers in Texas. Included in this category are *The Ring* magazine and the other publications related to contact sports.

Food and Beverage

We have equity ownership in Equal, the sugar substitute, a growing industry not only in the United States, but elsewhere in the world under the brand name Candarel. We are also investing in a distinct brand of tequila and a premium water product.

Hotel and Leisure

We will have partial ownership in a planned chain of Fontainebleau hotels and will create the Golden Boy Sports Lounge. The first of several is planned for Las Vegas.

There are also plans for a bank and insurance products geared to

Hispanics. Perhaps the greatest compliment we could receive is that AEG, the fabulously successful company run by multibillionaire Philip Anschutz, is acquiring an equity interest in Golden Boy. AEG normally acquires companies, not minority interests, but Anschutz thinks enough of us to make an exception.

Most of these investments focus on the Hispanic market. It is my way of giving back to my community while also educating and empowering Hispanics.

So Richard's father need not have worried. His son is doing just fine.

I always had big dreams. I just took them to another level when I hired Richard. Without him, I could not have gotten to where I am today.

He has also become one of my best friends, the best man at my wedding, and a godfather to my son, Oscar Gabriel. It's gotten to the point where we don't even need to sit down and talk at length about a business proposal because he knows what I think, I know what he thinks, and usually, it's the same. What I bring to the table, Richard doesn't have, and what Richard brings to the table, I don't have. That's why we make a perfect team.

I trust him completely. Well, almost completely. I still wouldn't trust him to drive me around in a golf cart.

LOSING THE GOLD

Going from Mike Hernández to Richard Schaefer, I felt like a blind man who miraculously gains the gift of sight. My future suddenly looked so bright, the financial landscape so appealing, my path to success beyond boxing so clearly marked.

I had struck a blow for my financial independence, but I began to wonder if I should be throwing a second knockout punch. Should I also get rid of my promoter, Bob Arum? After all, he and Hernández had been joined at the hip. They would disappear into a room, huddle together, and when they emerged, I would be presented with a contract for my next fight. How could I separate the two? If Hernández had been bad for my economic well-being, was Arum any better?

I knew that he and his matchmaker, Bruce Trampler, had done an excellent job in bringing me along through the early part of my career, picking just the right opponents to season me without threatening me. As my skill level rose, so did the quality of opposition. When I peaked, the blockbuster fights awaited.

People said I was the masterpiece of a man who had made promoting an art form. But at what price?

That question echoed loud in my mind after my fight against Trinidad.

When he began to take over my affairs, Richard wasn't shy about admitting what he didn't know. Give him a financial portfolio, an investment plan, or an innovative business idea and stand back. The wheels start turning, numbers are crunched in his head with the speed of a calculator, and within minutes, he can present you with options. But when it came to boxing, the numbers were foreign to him. He was like the average fan. He read about the purses the fighters earned in the ring and was impressed.

When it came time to take a hands-on approach as my representative, that quickly changed. Richard passionately devoured information. He had a hundred questions off the top of his head. He wanted to know about every revenue stream in boxing from the live gate to the pay-per-view telecast to the closed-circuit broadcast to the international rights. He wanted to know how everybody involved in a fight gets paid and how that is determined.

Richard's involvement began after the Trinidad fight. We had set a record for a nonheavyweight match with 1.4 million pay-per-view buys. My share of the revenue had been a $23 million guarantee up front.

"How do you know if this is a good amount?" Richard asked me.

"It's a good purse," I said.

"Related to what?" Richard said. "You sold one-point-four million pay-per-view buys at fifty-five dollars a household. That's seventy-seven million right there. The live gate was something like fourteen million. Now we are up to ninety-one million. If a sports bar buys the fight and charges admission to the public, do they have to pay extra for that?"

I didn't have all the answers for Richard and neither did my father. The questions triggered another question in my mind.

Trinidad had made $10.5 million in the fight. Bob? Probably the same or more. It was Trinidad and I who had put in the long hours on the road promoting the fight, Trinidad and I who had worked and sweated and starved our way through the agony of training camp, Trinidad and I who had attracted the record crowd, and Trinidad and I who had taken the blows and sustained the bruises in the ring. So why was the promoter making more than one fighter and more than half of the purse of the other fighter? The more I thought about it, the less logical it seemed.

After learning what Bob had made, I recalled a conversation I had had before the fight with my agents, Bruce Binkow and Leonard Armato. They had advised me to take the risk rather than the guarantee. Go for zero guarantee, they said, and take a percentage of the revenue because this fight is going to be big.

I remember hearing that Bob had been pounding his fist on a table at the Mike Hernández car dealership, saying, "No way this fight does more than eight hundred thousand buys."

Binkow and Armato disagreed. Their plan was to bring in new sponsors who would, in turn, bring more media exposure and more hype for the fight. That's what they did and Bob wound up the beneficiary when the pay-per-view total exceeded his own estimate by 600,000.

I had left money on the table, but I would make no changes in my relationship with Bob, however, until Richard could give me an educated opinion. He went to Bob, who was very cooperative and schooled Richard on boxing finances.

Looking at the cold, hard numbers may have been instructive, but seeing the flesh-and-blood movers and shakers with all their sound

and fury was even more illuminating. Richard got that opportunity in a brief, explosive meeting at the HBO offices in New York.

The purpose of the gathering was to see if I could get a rematch with Trinidad. He would be there along with Don King, his promoter; Don Félix, his father/manager; and, of course Bob and the HBO executives. I asked Richard, who was still working for the bank and was in New York on business, to represent me.

The meeting began, Richard told me, with a discussion of a catch weight for the fight, since Trinidad's people said he could no longer make 147 pounds, as he had in our first match. Trinidad talked about going to 154. Bob held firm at 147. Trinidad came down a few pounds and Bob went up a few until they dug their heels in just 2 pounds apart. And there they held firm.

The whole discussion lasted all of five minutes, ending when Bob said, "Forget it, then. There will be no rematch."

And just like that, everybody stood up to leave. Richard was flabbergasted.

"Excuse me," he said. "I'm new to all this. Most of you came from far away, from Puerto Rico, from Vegas, and you guys are breaking up the meeting after just five minutes, a meeting for a rematch, which I understand could potentially be one of the richest fights in the history of the sport, because of two pounds?"

"Who is this guy?" asked King, as everybody walked out the door.

They would soon find out.

With the rematch talks dead by the spring of 2000, negotiations were under way for me to fight Shane Mosley at Staples Center.

First, however, I had to decide what I was going to do about Bob. My lawyers had determined that I could legally break my contract with him, so that was not a hurdle.

Richard, however, lobbied to keep Bob. He had determined that the promoter had never ripped me off.

"Arum negotiated very smart deals for himself and Top Rank," Richard said. "There is nothing illegal about that. If a promoter gets away with a deal where he ends up making millions, good for him. Bad for you. That certainly doesn't make him a crook. The problem was, you didn't have anybody on your side doing a better job of negotiating.

"Having changed business advisers, maybe you should maintain stability by keeping the same promoter. It seems to me Arum has done a pretty good job of guiding your career. I think you should continue to work with him, but only after redefining the relationship. Don't just dump him."

That sounded fair as long as I had Richard looking over my shoulder. I felt he knew enough by then to represent me in my dealings with Bob.

After seeing Bob's proposal for the Mosley fight, Richard suggested a way to reconfigure my deal with the promoter. Richard gave me the same advice I had received before the Trinidad fight from Binkow and Armato: take less of a guarantee and more of a percentage of the revenue. I had always felt more secure taking the guarantee, money I knew was mine regardless of how well the fight sold, content to let Bob take a percentage of the profits. I figured it was Bob who was taking the risk.

"It seems to me the risk Arum takes is relatively minimal," Richard told me. "You agree to a big guarantee, but it turns out to be not such a big guarantee if the fight does as well as projected. It's the percentage that turns out to be a big figure and that goes to Arum. You really should get the lion's share. You are the big-name star who is bringing in the money."

I told Richard to go back to Bob and present the new terms. Bob agreed and Richard brought me back a tentative deal. I looked at it, picked up a pen, and wrote on the offer sheet, *Plus one Ferrari.*

"What's that?" Richard asked.

"I want him to buy me the car," I said.

Richard wasn't so sure about that. "I negotiated hard," he said, "and I really squeezed the guy. It's a much better deal. Now I have to go back and ask him for a Ferrari?"

I wouldn't back down.

Richard called Bob, told him we had a deal, but I wanted a Ferrari thrown in.

"What?" Bob screamed.

"And, Bob," Richard added, "it has to be a Maranello."

"A what?" Bob said.

"A Maranello," repeated Richard. "It's a certain model of Ferrari."

"How much?" asked Bob.

"About two hundred and twenty thousand dollars."

"That's crazy, just crazy," Bob said.

When he, nonetheless, reluctantly agreed, I went down to a Ferrari dealership to get my car. Because the trunk space in that model is so small, there is specially made luggage to fit in there, luggage that runs $18,000 to $20,000. So I ordered that, too.

When Bob received the bill, he called Richard, screaming, "What's with this luggage? Eighteen thousand dollars for luggage? I didn't agree to pay for any luggage."

And he didn't, but he did write the check for my Ferrari.

After my loss to Mosley in 2000, I decided it was finally time to cut Bob loose.

As he drove to the office, Richard called Bob from his car to give the promoter the unpleasant news.

By the time he reached his desk, Richard had a call from Seth Abraham, then the president of HBO Sports. Abraham told him, "Huge mistake. Huge mistake. What are you guys doing? You are going to ruin everything. You can't do this. Bob Arum is very powerful. It's the most stupid thing imaginable."

Richard calmly replied, "Oscar is determined to do it. He feels, after all these years, he has the right to be free and see what else is out there. We have already filed the lawsuit."

Once more, Abraham repeated, "Huge mistake," and hung up.

I had made a huge mistake, but it wasn't cutting my ties to Bob. It was supposedly strengthening them four years earlier with a grand gesture I made at his sixty-fifth birthday party. I presented him with my gold medal, the precious prize that has remained the strongest tangible link to my mother.

When I split from Bob, I assumed he would give me the medal back, but for years, he refused.

After the euphoria of winning the gold at Barcelona had settled down, I wondered what to do with the symbol of the greatest accomplishment of my career. Soon after, while house-hunting in Montebello, I was walking up to the second floor in one place when I halted on the stairs. There in front of me was a tiny alcove that looked as if it was designed for a small statue.

I had a better idea. This would be the spot for my gold medal, a place to display it and stir my memory of my most triumphant moment every time I walked by.

I needed to look no further. I bought that house, put a picture of my mother in that alcove, hung the gold medal from the frame, and further adorned the little exhibit with an Olympic belt.

I suppose I should have been concerned that someone might break in and take the medal once my ownership of the house became

known. It wasn't too difficult to learn where I lived, since I had the name De La Hoya welded onto the front gate.

That medal would have fetched a fortune from some shady memorabilia collector. I guess I was just too naive to think that could happen. Because everybody was always taking care of me in those days, I couldn't imagine anyone plotting evil against me.

I couldn't imagine ever giving that medal away, either, until Mike Hernández put the idea in my head. He was talking to Bob at the time about a three-fight deal that would earn me over $20 million.

"Jump on it," said Hernández. "Don't even negotiate. Just say yes."

To show our appreciation, Hernández felt we should give Bob something nice for his upcoming birthday.

"What do you give the man who has everything?" Hernández said. "Give him your medal."

"I can't do that," I said.

"He will really appreciate it," Hernández said, "and it will do us a lot of good in the future."

He talked me into it. The look on Bob's face when I brought the medal into the room in Reno where his party was being held was priceless, which was gratifying to me.

But after a few days, I regretted my generosity. What was I thinking? Why did I listen to Hernández?

I wasn't going to ask Bob to return my gift, but I assumed he would someday. I certainly expected him to do so after our acrimonious parting. Instead, he announced he would hold on to the medal until I retired.

How could he do that? Why would you refuse to turn over someone else's gold medal, especially when you have a feud going with that person? How can you keep something that is so precious to the other person? I couldn't understand it.

Finally, in 2007, after eleven years, Bob agreed to give back the medal. He returned it in a public ceremony at the White Memorial Medical Center in East L.A., where it would temporarily go on display at the Cecilia Gonzalez De La Hoya Cancer Center, named for my mother.

It turned out to be a very emotional moment for me. Seeing that medal for the first time in years, everything came flooding back, the struggle I went through to win the gold, the presentation of the medal, and my trip to the cemetery to show it to my mother. I broke down crying as it all unfolded in my mind.

I had regained my precious link with my mother.

BURNED

He was known as Sugar Shane Mosley. A more apt description would be Speedy Shane Mosley.

His style had been built on speed as far back as I can remember. And there was plenty to remember. We moved in the same circles from the time we were kids, fighting in the same tournaments, two hot prospects from Southern California, me from East L.A. and Shane from Pomona.

He was known for his great discipline and dedication in the gym and for being one of the nicest guys in the sport, an opponent you just couldn't find a reason to hate.

Shane was always one or two weight classes above me and a couple of years older. We sparred in Colorado Springs when I was about seventeen. It was a great session, so great that I recall thinking if I ever met him in the pros, it would be tough because he was so fast.

We did meet in 2000, but my first opponent that year was Derrell Coley at Madison Square Garden in New York. I couldn't see myself losing to Coley, but it could have happened because, for several days that week, I could barely see at all.

My problem started innocently enough on a Wednesday. It was

February, freezing in New York, not my kind of weather. Being a Southern California guy, I love the sun, love to get a tan.

I bought a small tanning machine and had it sent to my room. You get protective covers for your eyes, but, stupidly, I didn't use them. You are supposed to expose yourself to the rays of the machine for no more than ten minutes. Again, I was dumb. I exposed myself for twenty minutes and leaned in closer than I should have for maximum effect. Got to look good for the girls.

When I woke up Thursday morning, I realized the folly of what I had done. My eyes were swollen shut. I was forced to wear sunglasses to the press conference that day, then had to cancel my training session because, even when I finally pried my eyes open, all I saw was a blur. I stayed in bed much of Friday, coming out only for the weigh-in, and finally, thanks to rest and a lot of ice, my vision cleared Saturday in time for the fight.

I went in there like a bull and stopped Coley with a body shot in the seventh round.

Shane and I were to meet at Staples Center in June. I was worried as heck. This was the first guy who could match my speed.

I had struggled to make weight at 147 pounds, so when I did, I felt like celebrating. I went out with my team to a seafood restaurant in East L.A. and ordered two dozen oysters. Not the best idea the night before a fight.

I went back to my room at the Beverly Hills Hotel and turned in about 9 P.M. only to wake up about ninety minutes later with excruciating pain in my stomach. I was cold and shaking, my stomach problems getting worse. I had eaten a bad oyster.

I wasn't any better in the morning. How could I fight like this, I asked myself, especially against Shane Mosley?

I always gain something after eating following the weigh-in.

At welterweight, I might go up as high as 153 pounds. This time I lost. When I weighed myself in the morning, I was down to 145 and feeling weak.

In my dressing room at Staples Center, some friends of mine came in to say they had bet heavily on me. The look of joy on their faces was quickly replaced by dread when I told them I was feeling so bad, I might cancel the fight. Just touching my stomach, I felt pain. What would happen if Shane hit that stomach?

I didn't cancel. I couldn't. This was a major opponent in a block-buster fight in my hometown in my Staples Center debut.

It was a brutal fight. But even though I was physically drained, it was a great match that went down to the last round.

He won on a split decision. Unlike the Trinidad fight, I thought it was the right decision.

But adding this defeat to the Trinidad decision less than a year earlier, I experienced a wave of self-pity as I prepared to enter the postfight press conference. I felt people were out to get me, wanted me to lose. I was blaming the world, wanting to quit, get out of boxing altogether.

With my emotions running wild in the heat of the defeat, I told myself I had been stifled by promoters, managers, and trainers. If I was really going to quit, it was time for the world to finally hear from the real Oscar De La Hoya. What the media heard in a bitter press conference was me rambling on about perceived injustices against me.

"I'm going to rethink my career," I said, "including retirement. I'm going to rethink my whole game plan of life. I'm still a very hungry fighter, but boxing turns me off right now. With what goes on in boxing, I don't feel I can continue on like this."

What did that mean? I had grown suspicious of Bob Arum after the

Trinidad fight, thinking that perhaps he wasn't giving me my fair share of the revenue. That's one of the reasons Richard Schaefer was taking over my affairs. I thought maybe Bob had sensed what was coming, had figured out that I was planning on leaving him. Maybe that had motivated him to talk to the judges and cause me to lose. Maybe he did it to set up a rematch, which would mean more money for him.

All kinds of crazy thoughts were going through my head.

Looking back now, I don't feel that way anymore about Bob. Since becoming a promoter myself, I have come to the realization that there's no way any promoter can tell a judge how to mark his scorecard. It just doesn't happen.

When I calmed down afterward, I realized it was just me overreacting to the loss. I was angry, hurt.

When those feelings faded, what remained was my resolve to shake up my operation after two losses in my previous three fights. I was done with Bob and with Robert Alcazar. As long as I was going to clean my plate, I might as well do it all at the same time.

I had lost my last bit of faith in Robert after he sided with Clancy in the Trinidad fight.

That's when I told myself, *Robert's got to go. Now it's not my father or Bob Arum or Bruce Trampler or Mike Hernández saying it. Now it's me. No more excuses. No more camps with Robert as the figurehead. No more trainers surreptitiously calling the shots under him. It's time for somebody else. Period.*

I couldn't fool myself anymore by saying I was still undefeated under Robert. Reality check: I had lost. This is what can happen with a trainer who is limited.

When it came to actually showing Robert the door, however, I delayed and delayed. Before I knew it, I had signed to fight Shane another match that figured to be tough. It didn't seem like the right

time to make a drastic move like cutting adrift a trainer who had been with me for so long and knew me so well.

So I gave Robert one more fight,

Afterward, with my father present, I sat down with Robert and informed him he was no longer my trainer. It was not a pleasant conversation. Robert was like family.

"It's time for a change," I said, struggling to get the words out.

"Oh no," Robert responded. "I can change my style. I can learn new methods."

"I'm sorry, Robert," I said, "but we are going to take another route. We can still be friends."

Robert wished me luck, but in a way that indicated he didn't really mean it. I think he kind of hoped I would lose again. Not that he would wish anything bad upon me, but I think he wanted me to struggle enough to realize I really needed him in my corner, that maybe he was a good trainer after all. I understood his feelings.

I felt bad for Robert when I let him go, but I knew it was the best thing for me.

I haven't seen him since that day. My father has called him a few times, and my brother keeps in touch, but Robert and I haven't had any direct contact.

It's a shame because we had a good relationship. We helped each other. He had my back for a long time and I had his.

I had been through trainers who stressed offense, and those who stressed defense. I had trainers who had worked me hard and those who hardly worked me at all. I had a trainer who had been with me since my amateur days and trainers who never really knew me.

So what did I want after releasing Robert Alcazar? The best of what I had before. I wanted a taskmaster who would splash water in my face at five thirty in the morning if I was still in bed, and order

me to get out and run. I wanted someone who knew both sides of the fight game, offense and defense. I wanted someone who had been in ring wars himself and could understand the physical and emotional demands on someone going into battle.

Ultimately, I realized I wanted Floyd Mayweather Sr. Floyd had a sixteeen-year career in the ring, taught an intriguing defensive style, and was a spirited disciplinarian.

He came with a heavy load of baggage as well. He served five years in prison for drug dealing and had an ongoing, ugly feud with his son, Floyd Mayweather Jr., whom he once trained.

Once I hired Floyd Sr. in October of 2000, all the negatives faded into the background. Right away Floyd imposed his will on me in camp. There would be no basketball, no Ping-Pong. If I tried to take a day off, good luck. Wasn't going to happen. I was literally scared to ask him for a break. Even if I didn't feel good, I would train because I knew, if I said I didn't want to, he would be angry. He used to say, "If you don't let me do my job, see ya."

Not only did Floyd have me run, but I had to do so with weighted boots. Not only did I pound opponents in sparring sessions, but I was also required to chop wood.

Sparring sessions were more like actual fights. Floyd wanted me to take my sparring partner's head off. If the other guy got in a good blow against me, Floyd would start yelling at me, "Hey, man, you got this piece of bleep fighter hitting you. At my age, I could still kick your ass."

An outsider might look at all the hard work I was doing and think I must be miserable. Not at all. Training was fun again. This was what I had been missing. He got me in great shape. That is what I loved about Floyd.

One thing Floyd loved about me was the spotlight. Once he saw

the bright lights surrounding my fights, he took center stage. A Muhammad Ali wannabe, Floyd would spout poetry and infuriate opponents. He was always working on his next poem. In camp, we would hear the various versions of the one he was trying out for an upcoming press conference thirty times a day.

When I was fighting Fernando Vargas, who had previously been convicted on assault charges, Floyd told him at a prefight press conference, "You came here on vacation, but you're going home to probation." He had an angle for everybody.

While Floyd could be entertaining and charmed the media, I could have done without the whole sideshow, but because I appreciated all I was learning from him, I bit the bullet and let him do all his attention-grabbing histrionics. I have to admit, though, just being around him gave me a million laughs a day. Floyd was a character, a real piece of work.

He bragged that he was going to pass on all the tricks he had learned in his own career and make me the first "blaxican" boxer, a combination of the traditional styles employed by black and Mexican fighters.

Defensively, Floyd taught me to roll my shoulders to avoid punches rather than employing all the techniques involving footwork I had learned under The Professor. With Floyd's approach, I could stand in front of an opponent, not get hit, and be in great position to launch a counterattack of my own.

I finally faced Shane again in 2003 after beating Yory Boy Campas earlier that year on a seventh-round TKO.

The Campas fight featured the mysterious magic potion produced by Bob Arum that was supposed to give Campas a chance against me. It was a marketing gimmick Arum came up with to supply a little juice to a fight that didn't figure to be competitive.

But you never know about those things. Every opponent I faced elevated themselves to another level, because, if they could beat me, they were King Kong.

I was looking forward to the rematch against Shane because this time I would have Mayweather in my corner.

When I saw Shane at the weigh-in, he looked different. He is always well cut, well defined. This time, though, he seemed bigger, his muscles different. I know he's a good athlete and I heard he had been doing some heavy lifting with weights, so I figured that's what it was. He'd bulked up.

I later heard his name had been linked to the BALCO steroid scandal though I know he said he never took anything and has never been charged with anything.

I couldn't believe it when the BALCO story broke because it was Shane. The Shane that I know, the Shane that I grew up with, is honest, the nicest person in boxing. To this day, I maintain he didn't take anything. He's not a cheater.

Shane did seem stronger in the fight. I tried to box a little more than I did the first time we met and time his punches to nullify the speed.

I felt it was a close fight, but I didn't think I lost. Who knows, maybe I did, but I think I did just enough to win. Not an obvious win like the Trinidad fight, but a win nonetheless. I was frustrated once again. I felt like the judges in Vegas had something against me and I was getting weary of it. My recent fights had been so close, why couldn't some of them have gone my way?

Shane and I have never talked about the BALCO allegations, but I'm sure we will someday.

★ ★ ★ XXIV ★ ★ ★

GOLDEN BOY TAKES ON
THE BIG BOYS

I was like a wild horse bolting from the barn. Ahead lay a new frontier, lush with possibilities and boundless room to roam. But behind lay that familiar stable, confining but reassuring, secure from the menacing elements outside, stocked with all my material needs.

While Bob Arum was no longer guiding my career, I wasn't quite ready to gallop off on my own. I still needed someone to handle the reins, looser than before, to be sure, but still pointing me in the right direction. I needed a knowledgeable promoter.

Eventually, that would be Richard, but, when I first broke with Bob, Richard was just getting acclimated to the always tricky labyrinth that stands between a fighter and his purse.

Dan Goossen came to see us. The founder of the Ten Goose Gym, he proposed becoming my promoter under a company that would be called Golden Goose Promotions. Not quite what we were looking for.

I had an endorsement deal at the time with Univision and its majority owner, Jerry Perenchio. We felt if we could convince Perenchio to become my promoter, thus joining forces with Univision, the largest Spanish-language network in the United States, it would make a great partnership.

But this was about more than just entertainment. It wasn't exactly like we were picking a TV executive, clueless about boxing, to run my career. Perenchio had promoted one of the most successful fights of the twentieth century, the first Ali–Frazier battle at Madison Square Garden. I was very much in awe of this billionaire and felt this was a man who could make really big fights happen.

He was very passionate about boxing when we met with him, so passionate that he agreed to become my promoter.

Perenchio had a different way of doing business from Arum, a different way from almost all boxing promoters. He was immersed in the entertainment business and saw no reason why that approach couldn't be effective in my sport as well.

My first fight under the Perenchio banner was a match against Arturo Gatti at Las Vegas's MGM Grand Garden Arena, nine months after the first Mosley fight. Howard Rose, one of the most successful music promoters in the business and Perenchio's point man for boxing, designed posters for the fight with only my likeness on them. No sign of Gatti.

Rose, who was used to promoting musical acts, thought he could do the same with a fighter. It was like I was putting on a concert at the MGM Grand.

Was I the new Wayne Newton or Elton John? Rose referred to me as "an artist," and said those who were criticizing the promotion were "jealous."

I don't know that Rose fully grasped the idea that boxing's appeal comes from the tension between the two fighters. It was not a virtuoso performance by Oscar De La Hoya that was being sold. It was the possibility that I could lose, no matter how much of an underdog I was facing.

Some people like to wager on the underdog at the sports books, watch in anticipation of an upset, or simply like to see a champion fall. Most of all, the fans want to see a competitive match.

It they want a virtuoso performance, they'll go see Jennifer Lopez or Marc Anthony.

My performance, as it turned out, wasn't bad. I made a triumphant return to the ring with a five-round TKO victory over Gatti in March of 2001. I knew Gatti was going to stand in front of me and attack from the opening bell. I had no doubt I could overpower him and that's what I did. With a sold-out arena and an impressive performance, I was reassured that night that I hadn't lost anything during my hiatus.

In June, I was scheduled to fight Javier Castillejo in Vegas. Playing off the traditional time of the year for proms, one poster had both Castillejo and me in tuxedos with the words PROM NIGHT IT AIN'T. It seemed a bit strange to me.

That's the way it seemed to Richard as well when he saw the poster along with a few others displayed in a conference room. Along with several Univision executives, he was there to choose the best one.

"I'm sorry, but with all these concepts here, I really don't like this one," said Richard, pointing to the prom-night poster, "because it really has nothing to do with boxing."

They all agreed.

In walked Perenchio, who took one look at the choices and said, "Oh, I like this one, 'Prom Night It Ain't.'"

Richard said it was the one he didn't like. Perenchio looked around the room, pointed to the prom-night poster, and said, "Okay, let's take a vote. Everybody who thinks this is the one, raise your hand."

All the executives, the very same executives who had agreed it was unsuitable a moment before, raised their hands.

Prom night it was for that fight.

While I wasn't crazy about the poster, I was pleased with the training camp. I was trying to win a championship in a fifth weight division, 154 pounds, so it was a big fight for me. I knew that it could be a dangerous match because getting in the ring with added bulk the first time can be tough; I decided to come to Vegas two weeks before the event, a week earlier than normal.

I rented a house near the MGM Grand Hotel where the fight was to be held. It was June, a time when it's hot and dry in the desert. It must have been 115 degrees minimum every day. We had this nice pool in the back of our place, so, in the afternoon before sparring, I would lie out for like an hour. I did that for eight straight days, thinking, *Oh, I'm going to get a nice tan.*

As the fight grew closer, I noticed I was starting to feel weak, but I didn't make the connection to my pool time, so I continued to work on that tan.

When I weighed in Friday afternoon, with the fight on Saturday, everything still seemed fine. I felt good.

After the weigh-in, I went out to the pool as usual. Only instead of staying out there an hour, I made it an hour and a half.

When I woke up Saturday morning, I felt really hot. No wonder. I had the worst sunburn of my life. When somebody touched me, it stung. My legs were so weak I literally couldn't walk.

I somehow made it to the arena about three hours before the event and sat down on a couch in the dressing room, but when I tried to stand up, I had trouble doing so.

I wasn't going to tell anybody what I was feeling. I had trained hard for this fight and I still felt I could do it.

By seven thirty, seven forty, as it came time to go out to the ring, I seriously thought for the first time about not fighting because of the continuing weakness in my legs.

Then I started hearing the fans out in the arena cheering for me, yelling, "Oscar! Oscar!" That pepped me up and I think the adrenaline took over.

I still hadn't told anybody what was going on. I starting loosening up by throwing punches into the mitts held by my trainer, Floyd Mayweather Sr.

By the time I walked down the aisle, my legs were actually shaking. When I took that first step up into the ring, I thought I was going to fall before I made it through the ropes. That's how weak my legs were.

I was cursing myself for having sat out in the sun for so long. I made it into the ring on another rush of adrenaline, but there was still a fight to be fought. In the first rounds, my legs were not steady. I had to fight through the stinging and the soreness as much as I had to fight Castillejo.

Ultimately, all the conditioning and training I had done, and the fact that I was the superior fighter, carried me to a win by decision.

It was a fight I had made much more difficult than it should have been.

After it was over, my doctor examined me and determined I was suffering from heatstroke.

It was Perenchio who ended our professional relationship when the CEO of Univision left, forcing Perenchio to assume those duties as well as his own.

He called Richard and told him he was going to have to bow out of the promotion business because of his increased workload.

"I really can't play promoter anymore," Perenchio said. "I worked

with you for this past year and I am confident Oscar is in great hands. You guys will do just fine."

He drove to my house that night to tell me personally, and that meant a lot to me. It was Perenchio who gave us the wings that have enabled us to soar so high in the promotion business. We learned from him to be less dependent on the HBO marketing machine, how to come up with creative marketing concepts of our own, and how to find better ways to reach particular markets we are targeting and the Spanish-language audience in general.

With Perenchio's exit and a year of hands-on involvement by Richard, it was time to take off on our own. So we formed Golden Boy Promotions.

If I was going to get into the promotion business, I felt it was better to do so while I was active as a fighter. The limelight is still on me and that gives me clout with HBO and other networks, with the media in general and with other fighters. If media members want to talk to me about my upcoming fights, they know the best opportunities for access are at Golden Boy press conferences, other fights, or media events that I always attend. Signing fighters for Golden Boy is easier while I'm active because they know they'll have a chance for exposure on the undercards of my fights. All these factors helped me to quickly become a major player in the promotional business.

I look at Ray Leonard, who has attempted to become a promoter after retiring, and that seems a tougher way to go.

Not that it wasn't tough for Richard and me in the beginning. While Richard had learned the big picture, had sat in on HBO meetings and negotiated with Bob, neither of us knew the inner workings of the business, the behind-the-scenes grunt work that determines whether a boxing show will be successful. From printing

tickets to hiring concessionaires to installing a ring, there are dozens of crucial jobs that must come together.

And let's face it, we needed to find these people because we weren't going to start at the top, putting on a pay-per-view blockbuster at the MGM Grand or Madison Square Garden. I may have had a big name in the sport, but that was as a fighter, not a promoter. I had to prove myself all over again, just as I had when I came out of Barcelona.

First, we bought Roy Englebrecht's promotional company in Orange County. His regularly scheduled fights at the Irvine Marriott have become one of the longest-running boxing shows in the country as they stretch into a third decade.

That's because Roy isn't just a flashy promoter who twirls his cigar and counts the money in the back room. He's involved in everything on-site from how the chairs are arranged to who the cut men will be. He showed us everything, from printing the tickets to selling the tickets to handling the sponsors to dealing with the athletic commission.

Roy has a school for prospective promoters. After attending classes, they receive a degree certifying they are qualified to apply for a promoter's license. Since we had the luxury of being a little wealthier, we just bought the whole university, professor and all.

Of course you can have the greatest arena, the cheapest tickets, the tastiest beer, and the most comfortable seats, but if you don't have good fights, those seats will be empty.

The quality of the fights is determined by the matchmaker, someone who not only knows who the best fighters are, both the current stars and the hot prospects, but also understands styles, envisioning which fighters will clash in an entertaining manner.

Our search for good matchmakers led us to Don and Lorraine

Chargin, Hall of Famers whose expertise has been demonstrated over half a century. Nobody has anything bad to say about them. That's pretty remarkable in this sport.

We also moved Eric Gomez, my boyhood friend who was working for my foundation, into the matchmaking operation. A lifelong boxing fan, he learned quickly under the Chargins' tutelage and is now a first-rate matchmaker on his own.

We experimented with a management company, signing Olympian José Navarro. Richard and I were his managers and Lou DiBella was his promoter, but we quickly realized the management side was not where we wanted to be. It was a pain in the neck. So Navarro was our first and last fighter. We focused all our energy on the promotional side, where we can have the biggest impact on the sport.

We started slow, with nontelevised shows for about a year. Then it was time to bring in the cameras and take it to the next level. So who did we call? Jerry Perenchio, of course.

He had Friday-night fights on Telefutura, an ideal spot for our young company. Even though Perenchio had been our promoter and was still a good friend, he was also a businessman. He cautioned us that despite our previous ties, despite the Golden Boy name, we were going to have to prove ourselves by staging fights that drew good ratings and pleased the sponsors.

Perenchio started us out with four shows. Determined to make an impact, I put myself out there, hoping to draw on my fame. I was at the press conferences and at the fights, happy to go before the cameras. Most of the questions from the media were about my future fights, but that was okay. The mere presence of the media drew attention to the fights in our Golden Boy shows. With a good publicity kick and competitive matches, we got good ratings, good enough to impress Perenchio.

He gave us more shows the next year and more the year after that. Now we are up to eighteen a year.

Having rung up the numbers on Telefutura, we decided to go for the big boy, HBO, the ultimate prize for a promoter. If you are on HBO, you are a serious player.

They had the ultimate vehicle for us to get in the door, the HBO Latino channel. How perfect was that for Golden Boy Promotions? HBO is always looking for live programming, so why not a boxing series called *Oscar De La Hoya Presents Boxeo de Oro*, a monthly show.

HBO bought it and ran it for three years, producing several fighters who wound up graduating to matches on the main HBO channel, fighters like Israel Vázquez, Daniel Ponce de León, Librado Andrade, and Abner Mares.

It was a great arrangement for everybody. We got a strong selling point for signing fighters, offering them the chance to appear on an HBO channel, and a venue to allow them to develop. HBO got programming for its Latino channel and a breeding ground for its future main-event performers.

We went back to Bob Arum for my next fight, against Fernando Vargas. Why? Because it was a big match, the kind Bob was great at promoting.

"We are still not ready to do a mega-event like this," Richard said, "a Super Bowl of boxing. Let's continue to learn. When I tell you I am ready, I will be ready. There's a lot of money at stake. Just trust me on this one."

We would work with Bob on a fight-by-fight basis, which was fine with me. I wasn't about to get sucked back in by way of a long-term contract.

Bob promoted my fights against Vargas in 2002, and Yory Boy

Campas and Mosley in 2003. During that period, we introduced our Golden Boy logo and found other ways to put our name out there in preparation for flying solo.

Bob also did my fights against Felix Sturm and Bernard Hopkins in 2004. It was during the buildup for the Sturm fight at the MGM Grand that I knew Richard was finally ready to assume command. The match was part of a doubleheader. I was coming up to 160 pounds for the first time and Hopkins was defending his middleweight title against Robert Allen. If Bernard and I both won, we would face each other in September.

"I would do this differently," Richard told me when he saw how the show was being presented to the public. "I'm not attacking Arum or belittling the promotion, but look at what we have. Hopkins is defending his title for a record eighteenth time. You are attempting to become the first fighter in the history of the sport to become a champion in six weight classes. These fights are being promoted as must-win matches for two legends headed for a showdown. This is the semifinals, but somehow, the semifinals never quite get the ratings that the finals get in any sport. I would promote this as a historic night that stands on its own. You have two legends trying to pull off legendary feats in one show, a legendary night in and of itself."

Richard no longer needed to depend on Bob, the old master, to sell a fight. The young lion had a vision of his own, a pretty good vision.

Richard was right in his assessment of the semifinal approach. The doubleheader pulled in about 350,000 pay-per-view buys while my match against Hopkins three months later attracted about 950,000 buys.

It would soon be time to take the training wheels off Golden

Boy Promotions. We had the knowledge, the foundation, the structure, the matchmakers, the television dates, and the young talent. Only one thing left. The hot talent, the big names, the fighters who would allow us to catapult from Friday-night lights to Saturday-night prime time.

What would be the springboard to get us there? An old Hollywood idea with a unique fistic twist. In 1919, D. W. Griffith, Charlie Chaplin, Mary Pickford, and Douglas Fairbanks, all big movie figures of the time, broke away from the studios, which controlled the industry, and formed their own company, United Artists.

We did the same thing with Golden Boy, signing fighters like Hopkins, Mosley, and Marco Antonio Barrera as equity partners. We provide the infrastructure and financial backing, they bring their assets, and together we are a force able to compete with the old powerhouses of the sport like Arum and King. It's a model that has been working since 1919.

The long-awaited event—Golden Boy Promotions promotes the Golden Boy—finally occurred Cinco de Mayo weekend of 2006 when I faced Ricardo Mayorga.

That fight attracted 925,000 buys, nearly as many as I got against Hopkins, one of the all-time great middleweight champs, nearly two years earlier. De La Hoya–Mayorga was a coming-out party for Golden Boy Promotions. We showed the world we could successfully stage a blockbuster event.

And then we blew well past that number with my 2007 match against Floyd Mayweather Jr. It got 2.4 million buys, the largest pay-per-view total in boxing history.

We had predicted that we were going to set a pay-per-view record with that fight and people laughed. The old mark had been 1.9 million buys for both Mike Tyson's fight against Evander Holyfield

and Tyson–Lennox Lewis. Both of those had been for the heavy-weight championship of the world, once the most prized possession in boxing, not to mention, arguably, in all of sports. How could my fight against Mayweather—whose previous pay-per-view high had been 400,000 for his fight against Carlos Baldomir—even equal, much less exceed, those two Tyson bouts?

We were up to the challenge. We named our fight *The World Awaits* and that, indeed, turned out to be the case. When the opening bell rang, fans in 187 countries were sitting in front of their screens.

We also set records for the live gate, the closed-circuit telecast, the foreign buys, and the level of sponsorship. My purse was also a record breaker.

After more than four decades of domination by King and Arum, Golden Boy Promotions had climbed over both of them to reach new heights in a sport critics had pronounced dead only months before.

THE LOVE OF MY LIFE

While many of my business ventures have been the result of solid forecasting, careful planning, and an accurate assessment of the marketplace, I can take no such credit for the launching of my singing career in 2000. I was practically an innocent bystander at its inception.

I was at a restaurant in the Caribbean with a group of people celebrating an endorsement deal I'd made with Univision. When some mariachis came by, I started singing with them. At our table was Cristina Saralegui, the Oprah of Univision. I was scheduled to be on her show the next day, and when she heard me sing that night, she insisted I sing on her show as well.

I did, and the reaction was beyond what I could have imagined. Offers come rolling in from recording companies large and small. I finally settled on EMI.

Singing has always been important to me because it was my link to my mother. She had loved to sing, I loved to listen to her, and occasionally, we engaged in impromptu duets.

If I boxed because of my father, why not sing because of my mother?

Still, my singing career just sort of happened after that appearance on Univision.

I was confident I could do it even though my only experience was singing karaoke with a few beers in me.

Nevertheless, just like I needed a trainer to box, I realized I needed a voice coach to sing. I went to one who had worked with both Millie and with Michael Jackson.

Nothing, however, could have prepared me for the task of actually recording an album. It may have been the most difficult thing I have ever done. You have to sing the same song over and over to make every word perfect. There were sessions that lasted most of the night.

But I never lost my enthusiasm for the project because I had such great material to work with. Diane Warren, who writes songs for people like Celine Dion, Elton John, and Faith Hill, wrote a song especially for me entitled "With These Hands."

I thought it was a good album and those feelings were validated when I got nominated for a Latin Grammy Award.

One way to look at my overnight success in the studio was to see it as a substitute for boxing, a way to continue to make a great living without getting hit. I looked at it as just the opposite. I felt my singing career was getting too big, it was too much work, and it was taking me away from what I loved to do most: box. I missed the ring. That's my thing. Record sales were great, there were plans for another album, but I just couldn't walk away from boxing.

Besides, I had already gotten the greatest gift of all from music. I had gotten Millie.

My unlikely path to the love of my life began one night in the recording studio, working with a producer named Rudy Perez.

Only it wasn't happening for me that night. It just wasn't happening.

The song, "Para Que," was about heartbreak, but, Rudy told me, he didn't hear that in my voice.

"I've never had my heart broken," I told him, "so how can I express those feelings?"

Rudy smiled and said, "I'm going to give you someone who will do it for you."

He put on a video by a Puerto Rican singer named Millie Corretjer.

Rudy was right. That did it.

It wasn't just that she looked beautiful. I've seen many beautiful women in my life. It was something beyond that. I don't know what an angel looks like, but I felt like I was seeing one. I was mesmerized.

After her picture came into view, the song just flowed out of me without effort. As I opened my mouth, the feelings tumbled out, tears rolling down my cheeks.

When I was done, I said, "This is the woman. Somehow, some-way, I have to meet her."

With Shanna in my past, I was sincere in my desire to meet this woman, but I didn't act on it. I thanked Rudy for reaching down into his bag of inspirational tricks. He'd make a heck of a corner man, the kind who always seems to pump up your heart before the most crucial rounds.

I might have never seen Millie in the flesh had I not been flown down to San Antonio by José Behar, then the president of EMI Latin Records, my label, to meet a group of executives from the biggest chain stores, places like Wal-Mart, Kmart, and Target.

"By the way," José told me when we arrived, "you know who else is in town? Millie Corretjer. She's here to do a concert."

I tried to stay cool, but inside, I felt like a kid who spots his first crush across the lunch court.

When I finally saw Millie, it was at a San Antonio restaurant the night of her concert. I had gone there with José and several other EMI executives. As I ate, I noticed José's attention shift from our table to one across the room. He excused himself, only to return about five minutes later accompanied by a female. It was Millie.

When he introduced her, it was obvious she didn't know who I was, nor did she look particularly interested.

José motioned for her to sit down next to me, explaining I was a boxer. Finally, a look of recognition appeared on Millie's face. She knew my name because I had fought Félix Trinidad the year before.

Everybody in Puerto Rico, even someone like Millie, who didn't follow sports, knew of Trinidad. She recalled being in a restaurant with her cousin Jaime Durand, the night of my fight against Trinidad. At first Durand, a radio pressed to his ear, misunderstood what he heard. He thought Trinidad had lost. Mille saw a cloud of gloom spread across the restaurant after Durand shouted the bad information. Then came the clarification from Durand. It was I who had lost. The restaurant exploded in elation, Millie among the celebrants.

Now she was sitting next to the man whose defeat had brought her joy.

Millie didn't know how many fights I'd had, or that I now had a music CD coming out. She really didn't know anything about me. And I wasn't able to fill in the blanks because I couldn't speak. Literally. Normally a pretty sociable guy, I was so nervous I couldn't get any words out of my mouth.

When José told her about my CD, Millie seemed less than impressed. An established recording star back in Puerto Rico with a huge fan base, she wasn't about to get excited about some boxer who

thought he could sing. I could almost read her mind: *Who the heck does this guy think he is?*

Millie was polite, but it was obvious she didn't want to be there. My first encounter with my dream girl was turning out to be a nightmare.

Gorgeous and extremely talented, she had been hit on by all sorts of big-name performers, from Ricky Martin to Marc Anthony, so she certainly wasn't starstruck. I was just another guy.

Millie didn't stay long because she had to get ready for her concert. It was to be in an outdoor amphitheater on the closing night of a weeklong musical celebration.

After she left, José said, "Hey, champ, why don't we go see her concert?"

My reaction? "Of course."

There was anticipation in the air among the several thousand in attendance as we arrived at the concert. I shared that feeling. I was anxious to hear her sing in person.

But unexpectedly, I went from spectator to participant.

"Champ," said José, "why don't you introduce her? She would like that."

That wasn't true, but José was trying to get on my good side and he knew that I liked Millie because Rudy Perez had told him what had happened in the studio.

I was thrilled. Sure I'd introduce her.

I got on the stage, was handed a microphone, and gave Millie a big buildup. As she walked out, she gave me a quizzical look, like, *Why is this guy introducing me?*

As the concert started, I joined José and the rest of our group in a VIP tent, where we had refreshments and a great view of the stage. Millie was tremendous and the audience let her know it.

She and the band came into the tent afterward, buoyed by the enthusiasm of the crowd. She had a glow to her face, which made her more beautiful than ever.

I found myself standing next to Millie and José. With cameras everywhere, José, ever anxious to push Millie and me together, suggested a photo of the three of us.

Then José made a slick move in order to slip out of the camera's eye and signaled for another picture.

That second picture, with just Millie and me, conveniently found its way into Spanish-language publications with a suggestion from José that there might be some sparks flying there.

The only sparks were from Millie, who didn't appreciate being shoved into my company.

That became glaringly apparent when it was time to leave. We were all staying at the same hotel on the Riverwalk, limos waiting to take us there. After I had gotten into one car, the door remained open for additional passengers. Glancing out, I saw José and Millie several yards away in a discussion, a discussion that seemed to become heated.

José was telling Millie, "Look, you are going to get in the limo with Oscar, you are going to talk to him, and the two of you are going to ride back to the hotel together."

"No, I'm not," insisted Millie. "Why do I have to do this?"

She didn't and she wouldn't. Millie marched over to another limo and got in. José climbed in next to me and rode back silently, not telling me about his confrontation.

Reaching the hotel a few minutes before Millie, I hung around in the lobby until she arrived. When she came in, she was surrounded by her band and her dancers, about ten people in all. Our eyes met, but she kept walking, her group moving in step on all sides, as if she

was a running back and the musicians and dancers were her blockers, running interference for her all the way to the elevators. If she had asked for protection, it could only be because of one person: me.

I got the hint, but I wasn't going to be discouraged. For the first time in my life, I was being humbled by a woman. Here was someone I couldn't have. After being pursued for much of my life, I was the pursuer. Everything had been so easy for me in the past. Here was a real challenge, someone who was difficult, almost impossible, to get. I wasn't going after her just because I had to prove I could overcome the hurdles and win in the end. I had real, strong feelings about her. But the fact that it was such a struggle made me think that this most elusive woman might ultimately result in my most satisfying relationship. This might be the person I wound up with.

I went back to my room, but couldn't sleep. Raul, who was sharing the suite with me, had a copy of my CD. I wanted Millie to hear it, wanted her to give me her professional opinion.

"Raul," I said, "find out Millie's room number and get ahold of her or her manager. Get ahold of someone. I have to talk to her. She's an artist. I want her to listen to this."

It was about one in the morning by then, but I didn't care.

Raul got Millie's room number, made the call, and got her manager, Marisela. Raul told her what I wanted. Marisela, very protective, hung up.

"Call again," I told Raul. "We have to go there. We have to go there."

Marisela relented on the second call and said we could come to her room. We rushed over, but there was no Millie.

A few minutes later, in she walked, still dressed in her concert outfit. She wasn't much warmer to me than she had been earlier in the evening.

Marisela had told her, "He doesn't seem like a bad guy. Make him happy. Listen to his CD."

Millie listened, almost grudgingly it seemed, but when it was finished, she had no reaction. Talk about shooting down a guy's confidence.

But I refused to let go. I knew if I walked out of that room, I'd probably never see her again. So I asked her if she'd go down to the Riverwalk with me for coffee.

"Come on," I said. "You're not doing anything tomorrow and we both have late flights home."

Millie and Marisela excused themselves and went into another room to talk it over and decide how to handle this pushy guy.

"Okay," she said upon her return, "we'll do it. I'm still so pumped up from the concert that I can't sleep. But on one condition. All of my dancers and the band have to come with us."

What choice did I have?

So here I went on my first unofficial date with Millie, accompanied by ten chaperones. I guess the only good news was that the musicians didn't bring their instruments with them.

Millie and I started to talk a little bit, but we couldn't finish a conversation because fans, recognizing me, approached for autographs or to take a picture.

I have always taken that aspect of my career very seriously. I understood from the beginning that it is the fans who have enabled me to become the most popular fighter in the world. So when I am out in public, I am really into it.

Even in a moment as important to me as that night with Millie, I simply couldn't turn my back on the people. I accommodated them on the walk to the restaurant and after we arrived as word

spread that I was in the house. Waiters, the managers, diners, people from the street, they all came over.

Was Millie impressed with my celebrity? Not at all. Instead, she was getting really irritated because I wasn't paying attention to her. I just couldn't.

It seemed like I lost her right there. Whatever goodwill I had built up on the walk over was lost. She was again going through the motions, anxious to get it over with and be done with me.

I tried to talk to her, but every time I made a little progress, somebody asked me to get up and come over here or over there to take a picture. As they lined up their shots, I glanced anxiously over to our table at Millie, who was losing patience by the minute.

We walked back to the hotel, and she was soon on her way back to Puerto Rico, and I went my way back to L.A.

A month went by, but I couldn't get Millie out of my mind. I called Marisela and told her that. I didn't hold back. No false pride for me. I wasn't worried about my remarks getting into the tabloids. I was desperate.

"I feel she is the one," I told Marisela.

"Oh, that's cute," said the manager.

I had won Marisela over to my side. She wanted Millie to be happy and that meant breaking Millie's routine. She hadn't had a boyfriend in years, hadn't even dated much because she had been so focused on her career. Besides, Marisela enjoyed the drama of the whole situation, so she relented and gave me Millie's phone number.

Thus began my long-distance courtship over the phone. We would speak in Spanish. The Puerto Rican dialect is different from the Spanish I grew up with. It seems more like slang to me. But not

232 OSCAR DE LA HOYA

Millie's Spanish. Hers is more precise, has the feel of an educated person's speech.

Our frequent conversations continued as days turned into weeks and months. I was content, no longer pushy. We were getting to know each other, we were forming a relationship, innocent as it was, and that was fine with me. As long as the lines were open, there was hope.

Just to cement our bond, I sent her white roses nearly every day.

I had never worked so hard at getting a woman, but never felt so fulfilled.

At first she tried to brush aside my obvious interest, telling me over and over again that I must have hundreds of women pursuing me and had probably told many of them the same things I was telling her. I insisted it was different with her and asked if I could fly down to Puerto Rico to visit her.

Hesitant, she nonetheless agreed. I stayed at a hotel near her condo in San Juan and hung out at her place, happy to just talk.

I must have been making some points with her because she didn't invite the chaperones over to join us.

We didn't go out, just stayed there and talked.

One aspect of my life she couldn't get her head into was the whole boxing thing. "Why do you guys have to fight?" she asked me. "Can't you just talk about it?"

"That would kind of miss the whole point," I explained.

Both of Millie's parents are alive and she has two brothers and a sister, but she didn't mention any of them at that point. It was just us.

On that first trip, I spent a few days. When I got home, I learned that as part of my promotional tour for my CD, I was scheduled to spend a few weeks in Puerto Rico. That made me a happy camper.

Millie never came to any of my public appearances in San Juan, but she did reserve time to see me, which was all I cared about.

That went on for over a year. Then I took another step by inviting her to come out to L.A. to go to the Grammy Awards at Staples Center.

L.A. wasn't totally foreign to Millie. She had spent time there taking singing lessons from Seth Abrams—ironically, the same voice coach I had studied with.

It took Millie a while to accept my invitation. She kept stalling, unable to make up her mind. Finally, Marisela called to say Millie would come. I put her up at the Peninsula Beverly Hills Hotel and proudly took her to the awards show.

But even afterward, she remained unsure.

"I don't know why I agreed to come," she told me. "I had the same invitation from Ricky Martin, but I'm a grown woman, I made my decision, and let's just take it from there. See what happens."

There was still no romance in our relationship, but we were definitely getting closer. I took her to Disneyland, introduced her to my family, and had her meet Jacob.

Millie was taken aback to learn that I had a child out of wedlock, but when she saw how loving I was with Jacob, she liked that. Kids are reserved a very special place in her heart, and when she meets others who feel the same, she connects with them.

What affected Millie more than seeing Jacob was going to my father's house. Not in a positive way.

"Why did you do that?" she asked me after we left. "We're not a couple. We're just friends."

I, of course, wanted us to be much more.

It took a while, a long while, but after about two years of commuting to San Juan, I decided the time was right. While in

Puerto Rico, I placed a call to my jeweler in L.A. and ordered a ring. I knew what I wanted. It was about six carats. I told the jeweler to make it as quickly as he could and FedEx it to me.

Yeah, I trusted a precious little package like that to be shipped across the country.

It arrived two days later. I took a look at it, felt my nerves erupt, shoved the box in my pocket, and joined Millie for a visit to her parents' home.

Millie's mother and father are the easiest people to be around, unassuming and warm. Her father, Jesús, is an engineer; her mother, also named Millie, a homemaker. They are far removed from the two worlds Millie and I inhabit, sports and entertainment. Church-going, decent people, their priority is family. Their home is always filled with joy and music. All of Millie's siblings either sing or play instruments.

It was a typical visit to the house, everybody's spirits bright. So Millie looked up perplexed when I turned to her parents and said, "Could I talk to you on a serious note?"

As I sat everybody down, my own nervousness came out. I was wearing a white T-shirt, nylon pants, and sandals. I started sweating so heavily that I became soaked. It was as if I had just stepped out of a shower.

"I'd like to ask for your daughter's hand in marriage," I said to her parents.

That got Millie's attention. There was a big pause, a few seconds of silence in the room that seemed like hours to me. Then her father simply said, "Yes."

Her parents saw how I was with their daughter and how much in love I was.

"Hey, wait," said Millie. "What about me?"

I hadn't forgotten her. I took the ring out of my pocket with my sweaty hands, dropped to my knees, and said, "Millie, will you marry me?"

She, too, paused; then she, too, said, "Yes."

As I put the ring on her finger, Millie's eyes got wide. "Where did you get that?" she asked.

"FedEx," I replied with a big grin.

We were married about three weeks later in San Juan. We had tried to keep it low-key so we could enjoy the ceremony with just family and friends, but something like that wasn't going to stay secret. There's always a leak.

Keep in mind, news that I had become a commuter suitor had become well known to the Puerto Rican media over the previous two years. Like bloodhounds on a hot scent, the media was always trying to find out what we were up to and if a wedding was imminent. It was crazy.

We decided to get married on October 5, 2001. Only a select few knew our plans. The other invited guests were just told they were coming to a family dinner. We even secretly flew in the dress Millie was going to wear.

By the wedding day, we were proud of ourselves, figuring we had gotten away with it.

The plan was to go to Millie's grandmother's house to dress and then head over to the wedding site, an old building that had once housed government offices.

While Millie was in the back of the house changing into her gown, I was in the front with her brothers, getting ready. The TV was on in the background, and all of a sudden it caught our attention.

There was the wedding site being shown live for all of San Juan to see, with field reporters staked out at all the entrances as if they were covering a hostage situation.

In a way, they were. Millie and I had become hostages, trapped in our celebrity lives.

We flipped the channels, but we couldn't get away from the wedding scene. It was on every one.

There was my father, microphones in his face as he entered the building. There was my sister. In all, about forty people were invited.

As I continued to get dressed, one of the reporters on-site had a bulletin. "Here comes Oscar De La Hoya himself," said the reporter excitedly. This limo had pulled up and a guy in a tuxedo with the jacket pulled over his head had leaped out and was running into the building, reporters chasing him, asking him how he felt.

It was Eric Gomez being Eric. He loves to pull pranks.

By the time we had finished the ceremony and the celebrating and were leaving, it was 6 A.M. and the sun was out.

And can you believe it? Those reporters were still there.

★ ★ ★ XXVI ★ ★ ★

MY GUARDIAN ANGEL

It's been almost two decades since I last saw my mother, but I still feel her presence.

Never more so than the night I took a spin in my brother's new car. Anxious to see the Mercedes-Benz he had leased, I had him pick me up for a dinner we attended in West L.A.

When we got back to my place in Whittier, it was nearly 1 A.M. I wasn't ready to call it a night, however. Having spent the whole evening meeting and greeting people, I hadn't consumed so much as a mouthful of food. And now my passion at that time—tacquitos at Jack in the Box—was calling out to me.

I borrowed my brother's car for the food run to take a test drive because I was thinking of getting that model for myself.

When I got to the drive-thru, the eyes of the server at the window lit up as he recognized me.

"Oscar De La Hoya?" he said. "What are you doing here so late?"

"Tacquitos," I said with a smile.

Back on the freeway in the fast lane, I had a wide-open drive so late at night, only the occasional car in sight. I gobbled down my

tacquitos, pulled out my cell phone, called my brother, and then called a few girlfriends.

All of a sudden the lights on the dashboard went out. *That's weird,* I thought.

It got a lot weirder very quickly. I could feel the steering wheel locking on me and the car slowed down, from seventy to sixty-five, down to forty, thirty, twenty, ten.

I looked to my left, but there was no escape lane, just the retaining wall. I looked for my cell phone, couldn't find it, then looked in my rearview mirror. Fortunately, I saw nothing but darkness.

Not for long. In the distance, I suddenly saw a pair of headlights getting larger and larger. The object was coming full speed in my lane.

It's the lane I was stuck with since I couldn't steer out of it. And I realized, with my taillights also out, this driver might not see me until it was too late.

That's exactly what happened. As my car totally died, coming to a complete stop, the car was upon me. I hunched over, petrified, awaiting the impact.

I guess the driver spotted me at the last instant because he swerved over, only sideswiping me. I could hear the screeching of tires, the tearing of my bumper, and then I saw his taillights. He didn't stop.

I knew I might not be so lucky the next time. Again, I frantically looked for my cell phone. Where was it? I had just been using it minutes ago.

Looking out the passenger side, I saw a call box across several lanes on the shoulder of the freeway. That was reassuring.

What I saw next was frightening. More lights in my rearview mirror. Many more. Enough to fill up three lanes.

Get out, I told myself. *Just get out.*

I leaped out and starting running across the freeway. Ever try to outrun a car moving with the pedal to the metal? I felt like an out-of-shape heavyweight racing a flyweight. Those cars seemed to be bearing down on me.

Somehow, I made it to the safety of the freeway shoulder just as I smelled tires burning and heard the hellacious sound of metal smashing into metal. Turning around, I saw a huge truck crash into the back of what had been my brother's car, causing it to fold up like a beach chair in a hurricane. That started a chain reaction, the sound of several other cars colliding reverberating across the asphalt.

My hands shaking, I used the call box to summon help and then just stood on the shoulder, afraid to venture into the wreckage for fear I'd find a dead body. A small fire erupted, smoke adding to the chaos of the scene.

Several home owners made their way up the embankment, pointing at the metal pancake that had been the Mercedes, asking aloud what kind of a person would abandon his car in such a spot.

I began to circulate among the victims, admitting that it was my car, explaining how it had inexplicably lost power, offering my sincerest regrets.

I found one man lying on the ground, holding his nose, blood spread across his face. I tried to explain to him what had happened. He looked up at me through bleary eyes, focused, and then an animated look crossed his bruised face.

"It's Oscar De La Hoya," he said loudly. "Now I can tell everybody Oscar De La Hoya broke my nose."

If I hadn't been in shock, I would have laughed at how ridiculous that sounded.

When the cops arrived, they first checked to see if I had been drinking or using drugs. They soon satisfied themselves that there was nothing I could have done to prevent the mayhem.

Fortunately, that broken nose was the worst injury in the whole pileup.

I never did find out what caused the car to stall like that, but I am convinced my mother was looking out for me that night. I say that because there was a reason I couldn't find my phone. It turns out, it had fallen between the seats just before the power went out. If I had known where it was, I would have used it to call 911, been sitting there when that truck came barreling down the road, and might well have been crushed to death.

It's incidents like those that tell me my mother is still protecting me.

I did make a change in my thinking the night of the Fernando Vargas fight.

It had nothing to do with my feelings about Vargas, my performance that night, or even the outcome. It was a subtle change, unnoticed by all but those who knew me best. But to those who did notice, it sent a message that I was taking a meaningful step in my life.

When the referee, Jay Nady, was giving Vargas and me our prefight instructions in the ring, I looked Vargas right in the eye.

So what?

It was the first time since my mother had died that I had done so with an opponent. In every other fight, while the referee gave his instructions, I stared at the ceiling, imagining my mother looking down on me.

The change wasn't because I felt she had abandoned me. I think, to this day, that she is watching over me. It's just that, a few months

shy of my thirtieth birthday, I thought it was time to break away and do things on my own, to look to the future rather than the past.

In my immediate future was Fernando Vargas, a fighter I had grown to detest. He had been chasing me for a long time, trying to lure me into the ring by questioning my ability, my character, and even my heritage. He loved to say he was more Mexican than I was, whatever that means.

Vargas proved you couldn't take anything he said seriously when he claimed he had fallen in the snow while jogging in Big Bear, only to see me coming up the road. In this fairy tale, Vargas said he stuck out his hand for me to help him up, but I ran right by him, giving him only a cold shoulder.

It never happened. I cannot picture myself refusing to help somebody who had fallen. Maybe he made up that story to stir fan and media interest in seeing us settle our differences in the ring, or maybe he just needed a reason to hate me if I was going to be a future opponent.

I had a different reason for disliking him. His claim that he was more Mexican than I because, in his mind, he was more macho, got to me. It ate at me inside, though I wouldn't show it. I thought I had put all that behind me after beating Chávez a second time. I had finally gotten the Mexican fans to accept and respect me, and now along comes Vargas with that same old crap.

It made me want to destroy him, really hurt him. Vargas was the first opponent I had ever felt that way about. If his goal had been to fire me up enough to fight him, he succeeded.

Our mutual dislike became physical at a press conference in L.A.'s Biltmore Hotel. As we stood face-to-face for photos, I made some remark about his weak chin and he shoved me, causing

handlers on both sides to jump in to prevent a riot. Ricardo Jimenez, a publicist for Bob Arum, tried to play peacemaker and wound up with a broken leg.

With both Vargas and me training in Big Bear, it was inevitable that we would cross paths. One night, about ten of us showed up at a restaurant where Vargas was already eating with his team.

A couple of my guys told me not to go in. "No," I said, "I'm hungry."

The tension was thick when we entered. Would the fight be held here, far from the view of paying customers?

Vargas stood up and marched out, his team quickly following.

Another time, as I began my early-morning jog around Big Bear Lake, there was Vargas just finishing up.

"Ha, ha," he yelled out like a child, "I woke up earlier than you."

Looking at the plastic sweatsuit he was wearing, I yelled back, "Keep losing that weight, keep draining yourself."

The fight was weeks away, but the mind games were already under way.

At the weigh-in Vargas whipped off his shirt and started flexing his muscles. I had to admit, I was impressed. This was a guy who had a history of flabbiness, but he looked big and ripped that day. I thought he might be on something because he had been bragging all through training camp that his appearance was going to surprise everyone.

After the fight, a blood test revealed the reason for the surprise. Vargas had taken stanozolol, an anabolic steroid. For testing positive, he was suspended for nine months and fined $100,000 by the Nevada State Athletic Commission.

When the match began, my first impression was that I was going

up again a heavier, stronger fighter, someone in a bigger weight class than 154. More like a light heavyweight.

Vargas didn't hurt me at all. I kept remembering all those things he had been saying about me and that just hardened my resolve that nothing was going to beat me that night.

Vargas slowed down appreciably in the ninth round, my right hand hitting him at will. You could see by the look on his face that he was defeated.

When I got Vargas in trouble on the ropes in the eleventh round, I started firing away. I would have kept on throwing punches if referee Joe Cortez hadn't stepped in to stop me. It felt great hitting Vargas, but I could have seriously hurt him.

When I learned he had used steroids, it made my victory that much sweeter.

After things calmed down, I wanted to patch things up with Vargas, so a meeting was arranged at a Pasadena restaurant.

"You know I beat you," he told me after we sat down, the sunglasses he was wearing when he entered still covering his eyes. "Come on, give me the rematch. You've got to give me the rematch."

I tried to be conciliatory, suggesting we might be able to work together on future boxing ventures.

He wasn't listening. He just kept asking for the rematch over and over.

Finally, I had enough. "Good luck to you," I said, and walked out, invigorated by the thought that I'd never have to listen to him again.

CASHING IN MY CHIPS: A GAMBLER REFORMS

I spent a lot of time in the Vegas casinos, locked in a world of dice and cards. When I was in, I was all in. Gambling became a real problem for me. When I got the bug, it was hard to shake.

A good example was my stay at Bellagio the night a Félix Trinidad fight was on TV. Hotel mogul Steve Wynn came over to watch with me, because he wanted my analysis of the match.

After the fight, five of us decided to go hit the clubs. Walking through the casino, we passed the baccarat room. When I looked over, it was calling to me.

I said I was just going to play for a little while, that's all. It was around ten thirty at night.

I played and played. The rest of the group, with the exception of Raul, left, but I couldn't seem to pull myself away from the table. It was like I was chained there. Especially when I got down $250,000.

I finally did leave at three . . . the next afternoon.

And I didn't leave empty-handed. When I cashed in my chips, I had a total of $1 million, which they gave me in cash. I was walking around the casino with one mil in my pocket.

The next day, I took the money to play baccarat at Caesars Palace and lost it all, the entire million.

I didn't have a favorite spot in Vegas to gamble. I played everywhere from Rio to Bellagio, depending on where I was staying. Sometimes I would be sitting at home, get the itch, call some friends, charter a plane, and we'd be in Vegas just like that.

I was a heavy gambler for about six or seven years, always playing either baccarat or craps. I would usually open up a $100,000 line of credit when I sat down, but on three occasions, I opened up a million-dollar line.

There was never a problem getting credit. I guess they kind of knew who I was.

When I lost, the competitive side of me would come out. I would think I could beat the house if I just stayed at it. But even I had my limits. Usually. If I had a $100,000 line, 90 percent of the time I wouldn't exceed it if I was losing. I would just walk away.

Once in a while, I would go crazy. I remember one time at the baccarat table, I played three hands at once, each for $100,000. Luckily, I won two out of the three, but it was bets like that, seeing all those chips stacked up, that made me ask myself what I was doing.

Raul would tell me I had a gambling problem, but I was very stubborn. I was going to do what I wanted to do. I would tell him, "It's only a hundred thousand. Don't worry about it."

If I had a problem, I know where it started. My father has been a big gambler all his life. With him, it was always the horses. There were times, during my childhood, when he would gamble heavily, with his paycheck, either at the track or with the bookies.

When I was about seven or eight, my father often took me with him on weekends to see those bookies. They had a place on Olympic

Boulevard. We would go down an alley to a gated door, knock several times, and give a secret password. It was all so mysterious and fun for a young kid.

The door would open and we'd be in this big room. There were guys spread out all over the place, smoking, eating, drinking, playing cards, and studying the racing form. There was even a small snack bar.

Next to it was the spot where you placed your bets.

As the only youngster in there, I became a runner. Guys would yell out, "Hey, kid, place this bet for me. Five on so-and-so, and place and show on number three." They would add a few coins as a tip for me.

My father also took my brother and me to the track. We'd be there all day while he played the ponies. We would run around collecting all the tickets people had thrown away, take them home, and count them. They were losing tickets, of course, but what did we know? We were kids.

That's probably where I got my taste for gambling, but strangely enough, I have never bet on the horses. Never had an interest.

When I finally gave up gambling, it was because of Richard Schaefer, the financial genius who heads my business operations. He is such a positive influence on me, kind of like a father figure. I really look up to him.

He would tell me, "You have to stop gambling. You're a businessman now. Look at all the other businessmen you have come to know through all of our transactions. Do you see any of them gambling? No. You have a wife and family to take care of. You have to act responsible."

It took a while, but his message finally sank in. The fact is, I wasn't making money at the tables. Here and there, yes, but overall,

I figure I probably lost a couple of million dollars over the years. For what? I had worked so hard for my money, either by taking punches in the ring or in the business world, and I was just throwing it away. I'd look around the suite I was staying in at my Vegas hotel and think, *It was my money that helped build this.*

It was time to start taking better care of my money. So I quit gambling cold turkey, but I have to admit, I missed it at first. The tables continued to tempt me because I was in Vegas all the time for fights. Whenever I walked by the casino, I could hear those dice calling to me. I would think, *Maybe I'll just play ten thousand. Just to get the feel of it.* But with Raul by my side talking sense into me, along with Richard's words still echoing in my head, I would fight off the urge.

After a while, it became natural to just walk past the casino without so much as a second glance. Now I have no desire to gamble. It's no big deal to me. When I'm staying in a Vegas hotel, I don't even think about there being a casino downstairs.

For me, the roll of the dice and the flip of the cards have lost their allure.

★ ★ ★ XXVIII ★ ★ ★

MORE MEN IN MY CORNER

The scene can be the most dramatic in boxing. Two fighters have left their hearts and guts, and sometimes a good deal of blood, on the canvas for twelve often close, always grueling rounds.

Their handlers and supporters, fans who have given their devotion and gamblers who poured in their cash, all have strong opinions about the outcome. But it's the opinion of only three men in the arena that matters: the judges.

As the scores are tabulated, the fighters, blood and sweat forming bizarre patterns on their battered skin, strut around the ring, waving their fists in elation over a perceived victory. Yes, both fighters. Both corners celebrate.

Then the public-address announcer slowly reads the scores, stretching out the tension until you just want to grab those scorecards and read them yourself.

Finally, after a last, torturous pause, he'll say, "And the new welterweight champion . . ." or "and still the . . ."

One fighter leaps onto the ropes to soak in the elation of the crowd. The other howls in protest, his anguished face searching in all directions for justice.

In reality, it's sometimes an act, the winning fighter trying to bolster a win he knows in his heart he didn't earn, or the loser questioning a decision he knows is just. Fighters don't need the judges to tell them what happened. They know. Win or lose, they can feel it. And they can see it in the face of their opponent. The judges don't always get it right, but the fighters usually do.

For example, when I fought Felix Sturm in my debut as a middleweight in 2004, even though I was given a victory by unanimous decision, I felt like the loser. I was taken aback by the decision.

I had made it unnecessarily difficult for myself because I was so anxious to bulk up for the new weight. I ate everything I could get my hands on. I wanted to feel heavy, but I didn't know how to handle the weight. It was the only time I ever ate out in restaurants during training camp, held at Dodgertown in Vero Beach, Florida, rather than having meals cooked for me by my handlers.

Sturm is a good boxer, but if I hadn't been too heavy, I would have beaten him easily. Instead, I felt sluggish, I felt slow, I didn't stay on my toes, and I didn't hurt him because there was no snap to my punches. I just wasn't into the fight.

When the final bell rang, I went up to Sturm and whispered in his ear, "Good fight. You won."

I had reached my long-sought goal, winning a title in a sixth weight class by capturing Sturm's WBO middleweight championship, but considering the circumstances, I didn't feel much like celebrating.

When I went back to the dressing room, Millie and my team were all cheering for me. I called Millie over, threw my arms around her, and started crying like a baby.

"Why are you crying?" she asked.

"I lost this fight," I said, repeating myself over and over.

She started laughing. The more I cried, the more she laughed. Finally, she got me laughing as well.

"Look at you," she said. "Look at how tight your trunks are around your middle. It wasn't you up there."

She made me feel a little better, but I still walked out of there feeling like a loser.

A lot of people feared I could wind up a loser when I fought Bernard Hopkins, one of the all-time-great middleweights, in 2004. He was clearly bigger than me, but I allowed myself to be talked into the fight by Bob Arum and matchmaker Bruce Trampler, who convinced me I could be successful and make boxing history.

It didn't seem like such a great idea, however, when Bernard and I were face-to-face in the middle of the ring listening to referee Kenny Bayless's prefight instructions. I asked myself, *What in the hell am I doing here?*

I actually felt I was in the fight until the end, which frankly surprised me. In the eighth round, Bernard tried to take my head off, but missed with about eight punches, an effort that seemed to leave him winded. That gave me hope.

But in the ninth, he caught me with a perfect body punch to the liver that froze me. A shot like that tightens you up to the point where you can't breathe. It feels like your insides are shrinking. You curl up into a ball.

I went down, helpless on the canvas for the first time in my career. You feel like you have all this weight on you, preventing you from getting up. I was too focused on trying to breathe to even hear the count.

Two seconds after referee Kenny Bayless counted me out, the pain started to subside. By the time I got up, I was ready to go

again. If you take that one punch away, this was a fight I could have won. But there wasn't anything I could have done. It's a tough punch to recover from. It was so disappointing.

I took 2005 off, enjoyed the birth of my first child with Millie, Oscar Gabriel, and then came back in 2006 to fight Ricardo Mayorga of Nicaragua, another Vargas with a better chin.

He and I did our share of trash talking. He told me I was better-looking than his wife. "I've seen your wife," I said. "You're right. I am better-looking."

The conversation turned ugly, however, when Mayorga got graphic about my wife. Nobody had ever talked about Millie like that. That made the fight personal.

Wednesday of fight week, I was waiting to go into a press conference when I was informed that Mayorga wanted to talk to me.

About what? I asked impatiently

He said he won't fight unless he gets to talk to you, I was told.

That got my attention. Mayorga, this big, tough guy, was crying when he came in.

"My promoter, Don King, is not paying me enough money," he said. "Pay me another four million and I will fight."

He already had a large purse, although I don't know how much of it was King's share. Nor was it any of my business.

Richard threatened to sue if the contract was not honored. We left the room, went into the press conference, and a few minutes later, King and Mayorga took their seats on the podium as if nothing had happened, King waving his American and Nicaraguan flags and chortling as only Don King can.

Mayorga has no concept of defense. You can see every punch coming. I could have taken him out in the first round, but remembering

what he had said about Millie, I punished him for a while before ending it with a sixth-round TKO.

After the fight, Mayorga told me, "I'm sorry what I said about your wife, but it was just part of the promotion."

A part I didn't appreciate.

Finally, there was Floyd Mayweather Jr. in 2007. Everybody considered him the best pound-for-pound fighter in the world and I always want to fight the best.

But to fight the best, I needed the best trainer I could find. For six and a half years, that had been Floyd Mayweather Sr. But this was going to be awkward. A father training someone to beat his own son?

Floyd Sr. kept insisting he wanted to train me for that fight. He kept telling the media, "I taught my son everything he knows, but I didn't teach him everything I know."

That was a great sound bite, but as it turned out, he was even reluctant to tell me everything he knew. I would ask Floyd Sr. how to beat Floyd Jr. and Senior would tease me, saying, "I ain't going to tell you."

He finally did tell me how he thought I could beat Junior at a meeting we had in Vegas after the fight had been set. But then Floyd Sr. added that, for him to implement the strategy as my trainer, it would cost me $2 million. Even though the money wasn't an issue, as far as I was concerned, that was a sign he wanted me to turn him down. It was his out.

Floyd Sr. insisted he wasn't looking for an out, but then he looked at me in obvious anguish and asked, "What is my family going to think of me, all my sisters and brothers and my mom? This is my blood."

254 OSCAR DE LA HOYA

I couldn't use him after that. I didn't want to deal with the friction it would create. How could there not be friction? This was his son. I didn't feel right about it. I think the father-son connection would have constantly been on my mind. And on his.

I turned instead to Freddie Roach, one of the most likable, thorough, disciplined trainers in the business. I am sure Floyd Sr., was relieved. He never tried to contact me while I was in training camp to offer me advice. He stayed out of it.

Floyd Jr.'s people brought Senior into their camp briefly to try to play mind games with me, but it didn't work. Not with Freddie in command of my camp.

Freddie's client list has grown impressively in recent years as word has spread that he is one of the best, if not the best, trainers in the world. This a guy who even got Mike Tyson to listen to him, if only temporarily.

I can't say I learned a lot from Freddie, because, at this point in my career, nobody is going to teach me to drastically alter my style.

I don't want that. But Freddie instantly got my attention and my respect.

Normally, you would be leery of bringing in a new trainer for a huge fight like the Mayweather match. But because Freddie is so perceptive, so ring savvy, he was able to absorb all of the nuances of my style quickly and merely fine-tune me for the fight.

Freddie was quite a change from Floyd in terms of personality. Freddie Roach will never get up at a press conference and read poems. While Floyd had his game face on all the time in training camp, a drill sergeant in sweats, Freddie is easygoing. But I learned not to be fooled by that. Once we are in the gym, he is just as demanding as Floyd, a no-nonsense guy in his own way.

Just doing a press tour with Mayweather Jr. can wear you out, because when you stand there, face-to-face for the photo op, he never shuts up. It gets so old.

"I'm the best," he says over and over. "I have a lot of money."

Mayweather is a very insecure person who needs a large entourage to reassure him he's the best.

No matter where we went on our tour, even his hometown of Grand Rapids, Michigan, nobody was cheering for Mayweather. No wonder he needs such a large entourage.

I knew I had to be aggressive in the fight, but it was going to be difficult to get to him because he fights to survive.

My aggressiveness was working in the early rounds, but I abandoned it in the later rounds. I stopped throwing the jab because of a flare-up in my left shoulder where I had an old injury, a slight tear in the rotator cuff. The pain spread to my elbow, causing it to lock up.

Floyd Sr. had told me, back when he was my trainer, that the jab neutralizes everything when it comes to his son and he was right. Floyd Jr. can't avoid a good jab. He just can't. He's very vulnerable to that flicking, stinging glove in his face. It's the one flaw in his game.

Once I couldn't throw my jab the way I wanted, everything went downhill. My heart, my mind, my body, all ceased to function at the peak level I had trained for. My confidence went out the window. I felt, if I didn't have my jab, I didn't have anything because the jab was the key to that fight.

I was reduced to leaving my head out there as a target, letting Mayweather tee off on me with the hope he would break his hand, that he would do more damage to himself than he could do to me. He has a history of hurting his hands, and maybe it would happen again. I kept the bull's-eye in front of him without fear of getting

hurt because I didn't feel any power when he hit me. I don't know how he knocked out Ricky Hatton. I really don't.

As the rounds went by, however, the constant pounding seemed to have no ill effect on Mayweather's hands.

I lost the fight, but I know I can beat this guy. He wasn't all that great.

My disappointment at losing, however, lasted only as long as it took Millie to climb into the ring. She leaned over and whispered two magic words in my ear: "I'm pregnant."

The anguish in my face turned to a glow. The loss faded in significance. Millie and I were going to have our second child, a girl we would name Nina Lauren Nenitte. I was ecstatic.

As the sting of that loss faded, I also became ecstatic at the thought of continuing my boxing career. I was determined not to end with that defeat. I feel I'm still growing and learning in the ring, and for that, I can thank so many of the men who have been in my corner over the years.

Each of my trainers had his own methods of getting the most out of me. I, in turn, took the best from each of them:

• In the corner, the best was Floyd Sr. He would wake you up, slap you around, or rant and rave at the slightest sign of fatigue, lethargy, or overconfidence. Sometimes, it was worse facing Floyd in the corner than it had been facing my opponent in the middle of the ring. But it wasn't all sound and fury. Once he had your attention, Floyd was very good at analyzing where you were in the fight, what your opponent was doing, and what you needed to do in the round ahead. It wasn't just the clichés about throwing the jab and protecting yourself. Floyd was very specific.

- In training camp, the toughest was The Professor. You had to be in shape for that guy. If you did something wrong, anything, he made you do it over and over and over. We would stop sparring every five seconds. He would say, "Nope, do it again. Again. Again." I don't think we ever finished a full, three-minute round. It was a very military approach.

- In terms of analyzing an upcoming opponent, I think Manny was the best. He was great at breaking down a fighter in terms of strengths, weaknesses, tendencies, and history. He would give you a true blueprint to follow.

- In terms of mental preparation, the best was Robert. He was always in my face, telling me, "You can do this. That guy didn't train. Believe in yourself." He would always remind me, "Do it for your mom." He pumped me up quite a bit.

I feel blessed to have had so many fascinating, knowledgeable, unique individuals in my corner over the years, guiding me, pushing me, soothing me, and inspiring me throughout my career. I couldn't have done what I did without them.

BARING MY SOUL

From the fields of Tecate and Durango to the dazzling towers of Vegas, from the food stamps of my youth to an endless feast of unimaginable richness as an adult, I have traveled an amazing journey in my thirty-five years.

There have been many lessons learned, the most indelible being that America is the only place in the world where I could have accomplished what I have.

My family has shared in all of it. I would like to think that the far-flung Hispanic community has also felt a part of the life of this American son. After all, we are all America's sons and daughters.

There have been highs beyond imagination, but also lows, both in and out of the ring, that have challenged my strength and my character, but ultimately made me stronger.

In my brightest moments, I have tried to share the glow with those near and dear. In my darkest hours, I have tried to shield them.

It hasn't always worked out that way. That's the cost of being a public figure.

There have been strains on my marriage, but, thank goodness,

Millie is such an incredible woman. She and I are determined to make it work. We want to be with each other and have committed ourselves to working past our issues.

Millie and I went to marriage counseling in Puerto Rico for about a year. It wasn't because we were having major problems. There was just a disconnection there, partly because of all the traveling I do and partly because the arrival of little Oscar had naturally become the focus of our lives. The counseling has helped us to also focus on each other once again.

I also went to a therapist on my own to deal with my problems. It was intense, often several hours at a time.

Over time, I believe that I got to the core of my problem.

It started with childhood, with my relationship with my mother and father. They were great parents to my brother and me. They gave us all the basics of life. They instilled in us the moral values we have carried through life. But the one thing they didn't give us was a demonstration of the love I know they had inside, the same love I felt for them. I knew it was there, but they never showed it. Neither my mother nor my father told me that they loved me. I never got a hug. It was a cold environment in which to grow up.

I had a lot of pain inside of me that came out in therapy. I learned I needed love. I learned I needed my parents.

I haven't talked to my father or my brother about this because that's still difficult for me. My experiences in childhood had a powerful impact on me and I'm sure our household had the same effect on my brother.

I know I'm going to have to talk to my father to release all this anger, to explain to him the way I felt and how it has made me act.

That won't be as hard now as it would have been in the past. Things are good between us now, and have been for the last few years. He has opened himself up. Now it is easy for us to give each other hugs. He will call me and say, "How are you doing, my son?" It's a different relationship.

A lot of the credit for the change has to go to my sister, Ceci. She is the peacemaker in the family. At gatherings, she'll get my father and me together and make sure we hug.

Ceci had to grow up quickly after my mother died, being only five at the time, and in a way, she has become my mom. That's the way I see her. She may be the baby of the family, but we all go to her with our problems. I still feel close to my mom through her.

She is never hesitant about scolding me or telling me what she thinks. If I'm feeling bad about something, or if I have a tough situation to deal with, I can talk to Ceci because I know I always get the truth from her. She says, "What would Mom tell us?" and then Ceci tells us.

My sister has all the qualities I admired in my mom. She is strong, fun, outgoing, lovable, and has a big heart. And she has an incredible singing voice, just like my mom.

Ceci takes care of my father now. If he doesn't eat in the morning, it's because my sister wasn't there to cook for him. He relies on her for everything. My father is lost without her.

I don't blame him for not being that close with me in the past. He didn't mean to be remote. It was all he had ever known, the way he had grown up.

Maybe as he has gotten older, he's come to realize it's important to have a bond with his kids.

The reason I'm talking publicly about all this now is that I hope

others can be helped by my experience. A lot of people have pain inside of them and the best way to ease that pain is to acknowledge it, talk about it, and then follow up with the proper treatment.

Therapy gave me a whole new perspective. I have a wonderful woman in Millie, an incredible life.

I sat down with Millie when I returned from therapy and told her everything.

I've grown from my exposure to therapy. I got help, but it's just the beginning. I'm looking at a long process.

At first Millie had her doubts that I could change. She asked me: "Is this new attitude real?"

She soon saw that it was. She admitted, "I've never heard you talk like this. We've never had conversations like this about your life."

She understood that I was emotionally abused as a child, that I was neglected.

I have always seen Millie as a goddess, as the perfect woman, a person with a tremendous heart and unshakable values. She's unbelievable. With all the money we have at our disposal, I have to bend her arm to go buy a pair of shoes. She doesn't need an overflowing wardrobe to fulfill herself. She is happy in a pair of shorts and a T-shirt. She knows what's important in life. That's what I love about her. She can tell me, "Who do you think you are?" or "Okay, Oscar, take out the trash," and I listen.

I put her on a pedestal because I felt she was superior to me as a person. I treated her like a queen.

Now, after therapy and counseling, rather than looking up at her on that pedestal, I feel we are becoming more equal in our relationship. It doesn't mean I no longer treat her special, but I feel I have come closer to her level as a person.

Not equal. Maybe never equal. But closer.

We have a strong foundation now. Everything is in the open. I feel I have a partner. Our marriage is better than ever after seven years together.

The lessons I learned from my upbringing and my therapy are being applied in my household. When I am at home in Puerto Rico with Millie and the children, we always eat with little Oscar, putting his schedule ahead of ours. When he has breakfast, we eat breakfast. It will be the same with my new daughter, Nina, when she gets a little older.

It's a very difficult situation, I admit, because of all the traveling I do, but when I'm home, not one day goes by without me spending some quality time with my kids. I am always there for them. They will never have to complain about a failure to communicate.

My life right now is the way I want it to be forever. It's perfect, from my marriage to my kids to my boxing career to my other businesses.

Millie has even come to accept my boxing career in the way I had hoped she would. The first few fights after we got married, it was like pulling teeth to get her approval. She didn't want me to fight anymore. Now she still gets scared and nervous, but she understands this is what I love doing and she is 100 percent supportive.

People often ask me why I keep fighting. They look at all the money I have made and all the businesses I have become involved in and my wonderful family and they say, "Why? What do you need it for?"

Those people are not boxers. They can never understand the incredible rush I get from stepping into the ring and challenging my mind and my body to the ultimate degree. In the span of a lifetime, the ability to box competitively is only a fleeting moment under the best of circumstances, a small window of opportunity to reach in-

credible heights. I don't want to walk away while that window is still open.

I've been extremely fortunate in the ring, emerging after forty-three fights with my face unmarked, my mind unaffected, my body strong, and reflexes still sharp. If that should change, I'll be the first to know it. And to react by immediately hanging up the gloves forever.

I'll be doing that soon anyway. And when I do, there are so many other windows open to me, so many other ventures to pursue.

I look at other fighters who have nothing after boxing and I shudder at the thought that that could be me.

I've been so fortunate that the right people came into my life to push me back onto the proper path when I strayed. It might have been so different if my mother hadn't inspired me in my early years, if my father hadn't put the gloves on me, if my family hadn't supported me, if Millie hadn't walked into my life, if Richard hadn't provided me with career options after boxing, if friends like Raul and Eric hadn't been watching out for me, if my children hadn't come along to give new meaning to my life.

It's been quite a journey over the last thirty-five years, from humble beginnings to unparalleled fame and fortune. My family came from Tecate and Durango in search of a better life for their children, but in their wildest dreams, they could never have imagined the life I have been privileged to enjoy.

Thrown into a world spotlight I couldn't have been adequately prepared for, I've made my share of mistakes. But I've learned from them and grown to become what is, unfortunately, all too rare, a fighter with a productive life after boxing.

I'm excited about the years ahead. While boxing will always be my first love, I want to continue to expand my reach into a wide

variety of financial endeavors, especially within the Hispanic community.

I have become a highly visible figure in the Hispanic world and I want to use that influence for the common good. I want to help move the agenda beyond illegal immigration to a point where the emphasis is on who Hispanics are, not where they came from. I want to inspire others to feel my success story can be theirs as well.

I used to think being called the Golden Boy referred only to my boxing skill and my income potential. My priorities have changed. If I am indeed the Golden Boy, it is because I am truly rich with the blessings of health, family, friends, and the resources to improve my community.

ACKNOWLEDGMENTS

In the last few months, I have learned that writing a book is like performing in a big fight. You may be the one in the spotlight, but there is a huge support group behind you. Without all those people, what the public sees would not be possible.

In this book, I have pulled the curtain back to reveal all those who have had key roles in my career. Here, I wish to do the same with *American Son*.

I felt I had a story to tell, one that could be appealing and inspirational. I was confident my voice could express some of the emotions, goals, and dreams of Hispanics in general and my generation in particular.

The process of putting those thoughts on the written page began with Richard Schaefer, as is the case with many of the endeavors in my life. He has spearheaded all of my boxing and business ventures, and he did the same with this book.

To coauthor *American Son*, we selected Steve Springer of the *Los Angeles Times*, who has covered me for much of my career. He is a past winner of the Nat Fleischer Award, a career achievement honor bestowed by the Boxing Writers Association of America.

We had an idea, a story, and a writer. Now we had to sell it. That task was taken on by Jack Tiernan of Creative Artists Agency, one of the top talent agencies in the world. Jack believed in this project from the beginning. He took it to Sally Wilcox of CAA's literary department, who in turn got Luke Janklow, one of the finest literary agents in New York, on board.

Luke had a wide choice of publishers to choose from, but he zeroed in on one company, HarperCollins, because of one man, editor Rene Alegría. I can understand why. Rene's passion for and belief in this book has been obvious from the day I met him. I also highly appreciate the efforts of his colleagues at HarperCollins: Lisa Gallagher, publisher of HarperEntertainment; Associate Publisher Lynn Grady; Publicist Jennifer Slatterly; Senior Art Director Richard Aquan; Managing Editor Kim Lewis; Senior Vice President of Distributor Sales Brian Gorgan; and Assistant Editor Melinda Moore.

My own team has been equally important. Along with Richard, Raul Jaimes, vice president of Golden Boy Promotions; Bruce Binkow, chief marketing officer; and Nicole Becerra, executive assistant, played key roles.

My thanks also to my father, Joel, Eric Gomez, Bob Arum, Shelly Finkel, Larry Merchant, and Marty Denkin for their recollections; my sister Ceci for coming up with all the great pictures; and Stephen Espinoza, Jeffrey Spitz, Bert Fields, and Judd Berstein for their legal input.

And, of course, thanks to my wife, Millie, for her support and encouragement.

I take great pride in the many successful enterprises launched by Golden Boy. I am confident *American Son* will further enhance our record of achievement.